THE ART OF THE LANDSCAPE

The Art of
the Landscape

RAFFAELE MILANI

Translated by Corrado Federici

McGill-Queen's University Press
Montreal & Kingston · London · Ithaca

© McGill-Queen's University Press 2009
ISBN 978-0-7735-3508-4 (cloth)
ISBN 978-0-7735-3547-3 (paper)

Legal deposit second quarter 2009
Bibliothèque nationale du Québec

First published by Società editrice il Mulino, 2001, as *L'arte del paesaggio*.

Printed in Canada on acid-free paper that is 100% ancient forest free
(100% post-consumer recycled), processed chlorine free

This book has been published with the support of the Italian Ministry
of Foreign Affairs and the Istituto Italiano di Cultura, Toronto.

The translation of this work has been funded by SEPS –
SEGRETARIATO EUROPEO PER LE PUBBLICAZIONI SCIENTIFICHE
Via Val d'Aposa 7 – 40123 Bologna – Italy
seps@seps.it – www.seps.it

McGill-Queen's University Press acknowledges the support of the
Canada Council for the Arts for our publishing program. We also
acknowledge the financial support of the Government of Canada
through the Book Publishing Industry Development Program (BPIDP)
for our publishing activities.

Library and Archives Canada Cataloguing in Publication

Milani, Raffaele
 The art of the landscape / Raffaele Milani; translated by Corrado Federici.

Includes bibliographical references and index.
ISBN 978-0-7735-3508-4 (bnd)
ISBN 978-0-7735-3547-3 (pbk)

1. Landscape painting. 2. Nature (Aesthetics). I. Federici, Corrado.
II. Title.

ND1340.M49713 2009 758'.1 C2008-906380-5

This book was typeset by Interscript in 11/14 Garamond.

To contemplative souls

O wild beasts, O rocks, O horrid ruins
O uncultivated forests, O solitary grottos
Isabella Di Morra

Contents

Preface ix

PART ONE PATHWAYS

1 Aesthetics of the Environment 3

2 What Is the Landscape? 28

3 The Sentimental Journey 54

PART TWO CATEGORIES

4 The Art of the Landscape 85

5 Contemplation of the Landscape 114

PART THREE MORPHOLOGIES

6 Morphology of Natural Beauties 135

Conclusion The Mirror of the Senses and of Reason 168

Bibliography 173

Index 197

Preface

I may walk through a landscape and feel its charms. I may enjoy the mildness of the air, the freshness of the meadows, the variety and cheerfulness of the colouring and the fragrant odour of the flowers. But I may then experience a sudden change in my frame of mind. From this point on I see the landscape with an artist's eye: I begin to form a picture of it. I have now entered into a new realm, not the realm of living things but of "living forms." No longer in the immediate reality of things, I now live in the rhythm of spatial forms, in the harmony and contrast of colours, in the balance of light and shadow. The aesthetic experience consists of this being absorbed in the dynamic aspect of form.

Ernst Cassirer, *An Essay on Man*, 151–2

This book is a study, a meditation, on the feeling for and the idea of the landscape, something that continues to exist despite the loss of its true source, namely nature, from which we have become sadly and appallingly separated because of a tragic destiny. Perhaps the book is a hope linked to the vain attempt to preserve the memory of the wonder and beauty of nature offered to us in so many centuries. In any case, hope and disenchantment have accompanied me, marking an inner conflict. In every book there hides an idea to which the author remains

attached throughout the writing stage, to the point of making it his motto. For me it is a passage from Giacomo Leopardi, which reads: "We are completely alienated from nature and therefore extremely unhappy" (1898–1900, 1991, 814, 19 March 1821).

The work I present here is an attempt to understand the meaning and value of the landscape as an aesthetic category; that is, as a fundamental concept that, in the domain of human sensibility, both as reality and as value, characterizes and orients complex reflections on the many manifestations of the nature that surrounds us and its representations in art and literature. Through a web of judgments and expressions of feeling, aesthetic experience appears as a form of cognition that opens up a noetic or ontological field. As a measure of the relationships that underlie our judgments as they relate to our sensibility, the aesthetic category tends to reveal the very structure of objects and phenomena, mediating between human intention and the inherent nature of the world. The landscape, which today is more and more tied to ecology, to geography, and to the description and use of the land, is analysed here in terms of its aesthetic value, thereby illustrating its cultural and historical identity. It is interpreted as the evolution of the constant element of a heterogeneous and variable component in which meaning resides, although "identical" in that it is implicit and rooted in the language and life of humankind. The landscape expresses both a sentimental response and a need for abstraction. It is an objective disposition, an internal aspect of creative works that reproduce the forms of natural beauty. We perceive the movement of ethical reality since we celebrate not only the wildness of nature but also the life-space that brings humans together and the site of the contingent and the possible, which Aristotle referred to as *endekhomenon*, a reality within which we can deliberate and which we can transform. The landscape as aesthetic category, therefore, becomes an instrument of philosophy and, inasmuch as it is the product of taste, it interacts with processes initiated by art. In this sense, the landscape can be read as an *affective ethos*.

There is a growing tendency to speak of the art of the land-scape. This means that the landscape is conceived and felt in rela-tion to the pictorial gaze, the act of viewing, the theatricalization of nature, and the visual images contained in travel diaries. How-ever, it is also grasped more broadly in an array of aspects that highlight the figure of the human being in nature, history, and myth; this being has the capacity to grasp and to communicate the mysterious, the inexplicable, and the invisible. In this situa-tion, natural objects, even if they are not objects of human pro-ductivity, can also pertain to artistic expression by virtue of the way in which humans themselves ascribe greater value to the aes-thetic experience of nature.

We can define the landscape in negative terms by distinguish-ing it from the land, space, environment, and nature, and realize that it is an art that comes into existence through the senses, the imagination, reason, and work.

The art of the landscape is a complex of forms and perceptual data that human beings organize as the product of their work and their creative imagination. They shape the landscape through their cultures, improve the contours of the land, design gardens, continue to dream of places uncontaminated by their own presence, provide or invent images of the world, and con-struct a universe of impressions. When they perceive, humans necessarily experience a sensation in representing to themselves these givens, to translate the experience into forms that we can recognize and evoke, and to derive from it a sense of participa-tion and cathartic erasure of the self.

Grasping the art of the landscape can also be a painful process, not only because we must come face-to-face with the nightmare of industrialization but also because of the difficulty of arriving at the very essence of the natural world that surrounds us. Art is the aspi-ration to capture the most intimate part of things. So that physical space might really open up to us, Rilke (1903, Ital. trans. 1945) has shown us an unusual pathway that breaks down the stereotypes of perception and promotes an inner vision achieved through the

subtle force of estrangement. He advises us not to surrender to projective sentimentality and to link the landscape to myth, an epiphany that is part of the nature of human beings. Moreover, we should rethink the idea that the landscape is a modern invention; for the ancients, the landscape was not a specific and separate space because they transformed everything into landscape. Rilke goes on to say that in the ancient images we find on Greek vases we can see that humans, flowers, fruit, shrubbery, birds, and animals form a unified whole. How can we recover that harmony, that sense of a living collectivity? Through the evocation of the myth within the space of remoteness. In such a perspective, we distance the thing from ourselves to be able to approach it in a more serene and balanced way, aided by our memory, which interiorizes things, and by the spirit of solitude, which makes humans strangers to themselves and yet happy. From the fear of a looming, obscure threat emerges a magical, restorative aura.

Rilke states that it is necessary to see the landscape as something far away, foreign, remote, and abstract, which is self-sufficient, so that it becomes a means and an occasion for the emergence of an autonomous art, and something necessary, even if it is distant and very different from ourselves, so that, before our destiny, it becomes a liberating measure (Rilke, op. cit., 30).

In its morphology, the landscape has no fixed rules or techniques. It is not an activity but a revelation of forms owing to the material and non-material intervention of humankind. It is a product of nature, work, perception, and representation. In the art of the landscape we find a fusion of spirit and matter, a correspondence between humans and nature. In this sense, it is possible to say that art and aesthetic category are correlatives here.

In its structure and theoretical premises, my study of the art of the landscape is based on the research of numerous scholars within and outside Italy. However, I would like to acknowledge my indebtedness especially to Rosario Assunto and Massimo Venturi Ferriolo.

PART ONE

Pathways

I

Aesthetics of the Environment

1.1 NATURE

1.1.1 A rhetoric of the ineffable

Near the end of *Combray* (*Remembrance of Things Past*), we wonder how it is possible to speak of or describe the beauty of the world. The answer is that we must overcome the disparity between our impressions and their expression ("le désaccord entre nos impressions et leur expression"). As Starobinski (1999, 157) points out, Marcel Proust introduces the theme of emotion, which needs to acquire the verbal and visual means appropriate to the interpretation of that beauty through the application of a rhetoric of the ineffable. It is an experience of limit that presents a vast array of motifs, correspondences, and spiritual journeys. The landscape is truly captured in the very moment we delve deeply within ourselves, reaching beyond objective representation, where we discover the order of the visible in a complete dissolution of the self.

It is precisely these passages from the image of nature to its representation that interested Gérard Genette in his consideration of the question of aesthetic relationship (Genette, 1994–97, Ital. trans. 1998, vol. 2, 148–9). He analyzed the continuum

that exists, with all its variables and interruptions, between the forms of nature and the forms of art, and he indicated how the concept of the purely natural object, a hybrid entity in that it is the product of a collaboration between man and nature, is the first stage of a process to which art or human beings can always return. There is an irresistible need to pass from one plane to the other, from that of impressions to that of expression and vice versa.

As has frequently been observed, it is evident that natural beauty is already an image in itself since it is always an appearance. To depict it constitutes a sort of tautology, according to Adorno. Objectified as that which appears, presents itself (a notion that, for the most part, refers to the theories of the eighteenth century), natural beauty is erased at the same time. If we follow Adorno's thinking, at the root of perception, *aisthesis*, we find an object that reveals itself and at the same time a subject that projects itself toward the object. The true artist does not imitate the form of things, but rather interprets their essence. Plato already noted that the creative apprehension of a perceived object is one way of approaching aesthetically that which appears. To approach the landscape-object is, therefore, to grasp through the senses that which reality reveals to us through images of the thing itself. From a phenomenological point of view, we can say that all perception is also a projection toward the thing perceived. All perception is, then, intentional and determinative. Perceiving is one way to project oneself toward a certain reality, to synthesize or interiorize it, and to represent it in time and space. In aesthetic experience, the landscape has become an art by virtue of the extension and intensification of the intentional act.

The work of art (both literary and pictorial) creates the illusion of materializing the inner reality of the object. Between the impression of the viewer and the expression of the artist, there is a whole series of changes involving morphology, geographic

structure, and emotions. It is a process of incorporation and interiorization that corresponds to an exchange between subject and object, between the internal and the external. Albrecht Dürer (1471–1528), an artist whose genius places him among the first to express the modern aesthetic valorization of the landscape, said that true art conceals itself in nature, and that only those capable of drawing it out truly possess it (Dürer, 1983, Ital. trans. 1992, vol. 17). We find this idea, expressed in different ways, especially between the eighteenth and nineteenth centuries, in the Neoplatonic vision of someone like Goethe or in the theory of someone like Carus (1789–1869) who, in his letters on landscape painting, speaks of images of the earthly life for a soul, that of the artist, purified by the suprasensible element of natural beauty. The images of such an exalted nature would be called mystical or Orphic, capable of leading to the creation of "an art of earthly life" (*Erdenlebenskunst*). In a text from about 1785, however, Cozens, among others, already noted that the representation of landscapes is superior to the imitation of particular aspects of nature, thereby engaging with the views of Dürer, which were formulated much earlier.

In the moment that it expresses the absolute immensity of natural forms, the landscape appears to be an enigma, as Carchia (1999, 325–31) has noted. It places us before a double stirring of the soul that is only apparently contradictory: the sensation of strangeness or distance, on the one hand, and the feeling that this strangeness is totally our own or natural, on the other. In this complex play of ambiguous allusions, distance becomes inner experience in the sense that a non-human sensation appears alongside our essential being. In this process we are propelled from the visible to the invisible because all landscapes exist in a visionary ecstasy, and because, as contemplators, we want to lose ourselves in the invisible, in domains of feeling and perception, in a state that is neither temporal nor spatial, neither objective nor subjective.

1.1.2 Feeling for nature

In the second half of the eighteenth century, the feeling for nature described by Rousseau emerged as a reaction to the logical-mathematical spirit of the seventeenth and eighteenth centuries and to D'Holbach's theory of nature understood as a mere mechanism. It is a revolt of the senses, of sight in particular. The knowing-how-to-see unifies the aesthetic, cognitive, and moral spheres, to become inner contemplation. The gaze is valorized to the point of replacing a reflective attitude at the base of knowledge. The knowing-how-to-see penetrates the structure and beauty of nature beyond the general or abstract ideas of the *philosophes*. In *Institutions chymiques* (1745, 44) Rousseau writes: "J'entends tous les hommes vanter la magnificence du spectacle de la nature, mais j'en trouve fort peu qui la sachent voir" (I hear everyone praising the magnificence of the spectacle of nature, but I find very few who know how to see it). Here he emphasizes the importance of sight, of the gaze, as an essential instrument in the formulation of a concept or a philosophy of nature. For Goethe, too, love of the landscape passes through the pleasure of a penetrating sight, which is contemplation. Through contemplation, places live in our representations. In his *Theory of Colours* (1808) he states: "Merely looking at a thing does not allow us to progress. Each act of looking becomes a form of meditation, each meditation a reflection, making connections. We can say that we theorize in the moment we gaze carefully at the world" (Ital. trans. 1989, 57).

However, the gaze has an ancient tradition. For the Greeks, nature was dominant, like an immense, living, intelligent being, in their vitalistic and animistic explanation of life. They believed in miracles and magic. They lived in a symbolic world. Homer thought that dreams, vehicles for the communication of the will of the gods, were actually present in Agamemnon's room. Up to the *Roman de la rose* (Romance of the Rose),

nature continued to be seen as magical, with the exception of Aristotle, in whose work we can find the first impersonal concept of nature. The Greeks were the first people to teach us this sense of admiration for the world that surrounds us. It was a gaze from above and not from below, which characterizes Christian asceticism. Theirs was a horizontal gaze capable of embracing both the particular and the infinite. We think of theatre, *theatron*, the verb *theastai*, which is "to look or to contemplate," as Turri (1998) tells us. According to this line of thought, we can shift our attention from human actions to natural facts and say that what happens in tragedy we see repeated in the contemplation of nature. We note a common psychological source, namely, the ritual of catharsis. Human beings are safe from a peril that has been averted. They are not victims, but observe at a distance such misfortunes as natural disasters: volcanic eruptions, floods, storms, etc. They free themselves of events and elevate their spirit above these catastrophes. From the birth of the tragic and the sublime, and all along the path of their development, the principle of distance has been a constant aesthetic element. From Aristotle, Lucretius, and Pseudo-Longinus to Kant, humanity has participated, as a moved spectator, in the drama of life and nature.

An interpreter of ancient thought, Leopardi applied his reading of Plato and Pseudo-Longinus to his meditation on the infinite. For him the flight from *arguzia* (wit) and from the rhetoric of the visible through the gaze becomes an escape from the world in order to experience its essence. He says:

> The eye "feels" the beauty of nature by virtue of a similarity or affinity theorized by the Ionian school, which proposed that like knows like. Along the lines of this similarity between nature and humankind, we discern the existence of the noumenal, an initial sense of the divine immanent in the beauty of nature. The beautiful and the noumenal elicit

emotions, passions, vertigo, wonder, and especially sensa-
tions driven by fear and terror, thereby transporting us out-
side of ourselves into a state of ecstasy. (Leopardi, 1991,
2402–04, 29 April 1822)

The novelty of this point of view, with respect to the thought of
Burke and Kant, lies in the relationship that exists between ec-
stasy and the landscape in the knowing-how-to-see. Further-
more, in a letter to Giordani dated 30 April 1817, Leopardi uses
the phrase "passion stimulated by the sublime" together with
the term *sacer* (sacred), which indicates a veritable flight from
the self, to describe the poetic condition in its relationship with
sensitivity towards nature.

In antiquity and in the Middle Ages, beauty was understood
as order and harmony. It was considered a quality of the uni-
verse and of being. It appeared as objective and metaphysical.
Nature, of which art was believed to be an imitation, expressed
the power of the divine and was the source of all beauty. This
line of thinking survived into the eighteenth century, although
it was on its way to disappearing by then. Toward the end of the
century, natural beauty could still be thought of as an indispens-
able part of any demonstration of the existence of the divine,
starting with the apparent order and perfection of the cosmos,
as we read in J.G. Sulzer's *Unterredungen über die Schönheit der
Natur* (1770). However, in Kant's *Critique of Judgment* (1790)
beauty, both natural and artistic, is no longer an objective prop-
erty; it is, instead, a reflection of the subject's state of mind. In
particular, natural beauty unites aesthetic and ethical elements
in the creation of a feeling or a sensation described as the sign of
a good soul. He writes:

If a man who has taste enough to judge of the products of
beautiful art with the greatest accuracy and refinement
willingly leaves a chamber where are to be found those

beauties that minister to vanity or to any social joys and
turns to the beautiful in nature in order to find there, as it
were, delight for his soul in a train of thought that he can
never completely evolve, we will then regard this choice of
his with veneration and attribute to him a beautiful soul,
to which no connoisseur or lover [of art] can lay claim on
account of the interest he/she takes in his [artistic] objects.
(§ 42, 142)

The advantage that natural beauty has over artistic beauty (here
I am in agreement with Rousseau in detecting echoes of
Shaftesbury) consists in the fact that natural beauty alone arouses
immediate interest and harmonizes with the refined and solid
character of all those who have developed a moral sentiment.

We know that Kant read nature as the feeling for the beauti-
ful and the sublime. On the one hand, autonomous natural
beauty contains within its form an intentionality, by which the
object appears to be open to our judgment, presenting itself as
an autonomous object of satisfaction. On the other hand, the
feeling of the sublime emerges out of a clash between reason and
imagination because, in terms of its form, it is inadequate to our
capacity for representation. The sublime dominates as the most
intense aesthetic sensibility of the eighteenth and nineteenth
centuries, covering as it does, a broad spectrum of tastes and
productive interchanges between the artistic life and the aes-
thetic life. Pertinent to this argument is the following illuminat-
ing passage from the *Critique of Judgment*:

Bold, overhanging and, as it were, threatening, rocks;
clouds piled up in the sky, moving with lightning flashes
and thunder peals; volcanoes in all their violence of de-
struction, hurricanes with their track of devastation, the
boundless ocean in a state of tumult, the lofty waterfall of a
mighty river, and such like – these exhibit our faculty of

resistance as insignificantly small in comparison with their
might. But, the sight of them is the more attractive, the
more fearful it is; provided only that we are in security; and
we willingly call these objects sublime, because they raise
the energies of the soul above their accustomed height and
discover in us a faculty of resistance of a quite different
kind, which gives us courage to measure ourselves against
the apparent almightiness of nature. (§ 28, 100)

1.1.3 Ideal models

In post-Kantian aesthetics, natural beauty is relegated to a sec-
ondary role as the beauty produced by art comes to the fore-
ground. However, in his *Philosophy of Art*, Schelling maintains
that art does not reveal things but ideal models or archetypes, of
which things are reflections. At the same time, in *The Figurative
Arts and Nature* (1809, Ital. trans. 1989), he affirms that in
Correggio, Raphael, and Guido Reni, the artwork rises from the
depths of nature to allow the free flow of the infinite and inner
fullness. Schelling's philosophy has one important theme, which
is that of the "transfiguration of nature into grace": a transfigu-
ration that touches the soul itself, which is released from pain
through the dissolution of the ties it had with the sensible
world. In fact, for Schelling the soul is an ungraspable, yet per-
ceptible, essence; it is the *charis* of the Greeks. As a result, the
beauty of the soul as such is joined to tangible grace. This is the
supreme divination of nature, the first phase in the creation of
an artwork. In addition, the spirit of nature only appears to be
in opposition to the human soul; rather, it is in itself the instru-
ment of its own revelation. Art seeks out the creative capacity of
nature itself, in whose essence it finds its originating source.
Reformulating a philosophy of nature, however, always requires
that we rethink Schelling and his "realist idealism," that we re-
flect on primordial identity, on the physical bond between

humanity and nature, starting with our perception. It is in human beings that things become conscious in themselves, but the relationship is reciprocal. Humanity is the becoming conscious of things. Man is the *Mitwisser* (confidant) of Creation. In this sense we can apprehend the significance of light, which relates to what has been said above concerning the quality of seeing. Light is this subtle thing that penetrates everything and illuminates the field of our gaze and prepares it to be read. In *System of Transcendental Idealism* (1800), Schelling states that light is a kind of concept that floats among appearances and has no objective existence except when it presents itself to us. Light does not know the world, but we see the world because of it. These considerations allow us to understand the integration of the real world with the ideal world through intuition.

Schelling's thought resurfaces in the lectures that Merleau-Ponty gave at the Collège de France in 1956–60, in which the French thinker identifies the foundation for a new philosophy of nature. In his reading of Schelling, perception allows us to return to a state of oneness with nature and to an identity with it, which encompasses our very lives. Life participates in all things whose objectification comes about in an aesthetic perception that does not correspond to any existing object. In Merleau-Ponty's view, this reading of Schelling prefigures in nature an opening endowed with meaning: intuition seems to him to be like the gaze that incorporates itself and the object in the already-open expanse of nature as such. Nature does not appear to him as something outside of him; it is the experience of an identity capable of revealing, in an enduring way, the intimate nature of existence and of the human condition. In this sense, we can see that Merleau-Ponty rethinks Schelling's notion through the idea of corporeality.

The images of nature in general express a need for immediacy and are not subject to conventions, rules, or technical specifications. They are something at once instinctive and concealed.

Natural beauty is indeterminate and indefinable. The meeting of day and night, light and darkness, the seasons in the form of atmospheric conditions, creates a kaleidoscopic play of sensations that pleasantly overcomes us. The wonder of seeing and feeling is born of the sense of surprise. As Leopardi says:

> The feeling we experience at the sight of the countryside or of anything else that inspires vague or indefinite but delightful thoughts cannot be grasped and can be compared to the experience of one who chases a beautiful butterfly without ever catching it. And so, it leaves the soul yearning: this is our most intense pleasure and everything that is certain and well defined satisfies us less than does this uncertainty, which can never fully satisfy us. (1991, 75, Autumn 1819)

1.1.4 The eloquence of nature

Everything happens, however, as though we were obsessed by the idea of a universal language: we tend to believe that an eloquence of nature exists, as Adorno suggests (1970, Ital. trans. 1975, 89–112). It is possible to characterize or define a vista or a landscape – through panoramic points of view and movements, interpreting the things around us by following the flow of images that accompany us and communicate to us – as a network of signs that reminds us of a language. I have already referred to a rhetoric of the ineffable. This experience, rich in images, metaphors, and thoughts, is a sort of rhythmical flow, not unlike music and, essentially, it cannot be reproduced. A nature that is accessible through mechanical reproduction risks having its meaning and value erased. Turner and the Impressionists translated the spirit of the landscape; they did not reproduce it. Subjectivity could not, by passively recording the sensible world, define the pleasure that we experience as if by enchantment, and

that I have called an enigma. It is the dissolution of the self that produces the pleasure.

Nature appears before our eyes like a true spectacle that demands our active or contemplative participation: clouds, lightning flashes, stormy seas, deserts, etc., are scenes worthy of Shakespeare, who has already represented them to an extent. From these manifestations of nature emanates an ungraspable language, a suspended language, consisting of traces, allusions to a secret harmony. There are many different ways to deal with its multiple aspects. The landscapes of Friedrich evoke a romantic atmosphere where natural phenomena take on a mysterious, oracular quality. The paintings of Corot produce a harmony that is not found in the works of Van Gogh. The landscapes of Valenciennes are dreamy, whereas those of Courbet are powerful. While Leopardi imitates the indecipherability of nature's language, Poe confronts it by describing the grandeur and awe-inspiring terror of the maelstrom.

Despite the freedom that *language* enjoys, which is similar to that of music, it is thematically reformulated as enigmatic. Wackenroder (1797) speaks of a superhuman, "marvellous language" as he meditates on the complementarity of art and nature, which permits access to a vision of transcendence. He writes:

> If, after contemplating Christ on the cross in the chapel of
> our convent, I go outside where the sun and blue skies sur-
> round me and the beautiful landscape with its mountains,
> waters and trees moves my gaze, I see before me a world
> that is God's and has its own special quality, and I feel in a
> particular way great things surging within my soul. If then
> I go back inside the chapel and look closely at the image of
> Christ on the cross, an entirely different world, yet still
> proper to God, opens up to me and in a different and spe-
> cial way I feel great things stir in my heart. (1991, Ital. trans.
> 1993, 41)

We have noted in Kant the kind of feeling that the beauty of nature could arouse in a cultivated and refined person. This same feeling now moves a "friar who loves art." We find this aspect of devotional aesthetics in Tieck's novel *Franz Sternbalds Wanderung* (1798), along with a hermeneutical reflection on nature's cryptic language, a language of revelation. It is not God speaking to us; rather, He draws us towards Him through signs; under the mosses and the rocks is hidden a secret language that we can never decode or understand completely, but we think we can always sense. To this *hieroglyph* of nature, in whose intricate interpretation Lea Ritter Santini guides us, should correspond an art capable of grasping and translating that nature into its own allegories. It is in Novalis, however, that we perceive the order of unfathomable depths. The world unveils a mystical grammar, a coded script that is everywhere on display. From the clouds to the stars and from physiognomic features to eggshells, there is an endless flow of signs of this magical, profoundly secret writing. Nature has become a refuge where human beings return to themselves through the language of the rocks, trees, and animals. As Santini (1999) suggests, Schlegel also makes this point and invites the painter to produce his or her works using authentic symbols that allude to divine secrets and the hieroglyphs drawn from the sight of nature. More recently, Van Gogh has characterized this kind of profound participation in the life of nature in a way that sounds rather modern: "I see that nature speaks to me, tells me something, as if I were recording in shorthand. In my transcription there may be words that cannot be deciphered, mistakes, or gaps; but something remains of what those woods or that beach or that figure has told me" (letter from 1882, no. 228, 448).

We can say therefore that, reflecting on the vision of nature offered by the Romantics, nature is the imprint of the human soul. The material and the immaterial come together infinitely and powerfully. As Jünger says, we, too, feel like solitary thinkers on a balcony that looks out on the invisible.

1.1.6 Natura naturans and natura naturata

Not long ago, the notions of *natura naturans* (creative nature) and *natura naturata* (created nature) were reproposed by Dufrenne, who made a case for a new philosophy of nature. For centuries this phrase enjoyed good fortune in the domains of theology, philosophy, and rhetoric. In his *Ethics* (book 1, prop. XXIV, *scholium*), Spinoza defined *natura naturans* as that which is conceived in and for itself – in other words God as uncaused cause – and *natura naturata* as everything that originates in the necessity or in the attributes of the nature of God. For Spinoza, nature is the multiplicity of single events, the properties of matter, which express an eternal, infinite essence, in which nothing is contingent. Dufrenne, however, interprets the twin terms in a non-metaphysical sense, arguing that man and nature appear to be at once separate and united. In this context of relations and differences, he points out that, if we do not create the image of *homo artifex* (man the maker) because man can choose not to intervene in the world through his work, we cannot insist on the image of *natura artifex* (nature the maker), which is an illusion that completely excludes humankind. As we know, nature is the product of culture and history. Consequently, there would appear to be an exchange between the natural and the artificial, between nature and art, which produces, for example, the integration of proto-industrial architecture into the urban landscape. What was once seen as non-natural, once its technical and social functions are exhausted, is reintegrated into the aesthetic paradigms of the urban landscape. In this perspective, nature appears to be generative in humanity, both in the artist who operates to transform it, and in the pleasure experienced by those who lose themselves in contemplation. They find within themselves nature as the power of that originating and spontaneous substratum that becomes the world.

Natura naturans and *natura naturata* have been and continue to be at the centre of the question of imitation, truth, and artifice.

By imitating nature, art creates through the genius it infuses in human beings and, when we speak of that which is created by nature, we are referring to that which is of the same nature as our consciousness and to the world of which we are a part. Therefore, according to Dufrenne, to return to humanity is to experience nature as the world and to generate the possible that manifests itself in the real. In this sense, human beings are themselves nature and creative power. Nature, art, and culture are interwoven and humankind is at the centre of the conceptual pair of *natuta naturata* and *natura naturans*. As Dufrenne states: "Whether it is the existence of the work, the praxis of the artist or the imagination that is the aura of the perceived object, we intuit the *poesis* of Nature all around us … . How can we refuse to think of this tireless presence of the bed in which we are born and which the experience of art continues to reaffirm?" (1981, 48).

The preceding paragraphs clearly establish the fact that nature is an aesthetic norm. Lovejoy (1948, chapters 5 and 6) explores the numerous implications of just such a premise. For him, nature can be understood as the sum of all the things in the empirical world that can be imitated or represented, whether these are facts, behaviours, or emotions; or it can be understood as the search for its essence in objects in their pure form, or as that which has not been contaminated by humankind (for example, *vedute* or views untouched by human hands). At the same time, nature can also be thought of as a system of necessary and self-evident truths regarding the properties of, and the relationships among, essences. It may involve intuitively known principles of beauty, in the variety of its forms, from the simple and regular to the intricate and irregular. Furthermore, nature may reveal itself as an archetype, something archaic and liberating. Finally, the most comprehensive and typical notion to emerge from the eighteenth century is the interpretation of nature as that which is unchangeable in thought, feeling, and taste, and at the same time that which is familiar and personal for each individual; in

other words, uniformity in variety, which is what was proposed in most British philosophy, literature, and artistic culture from Locke to Hume, from a number of perspectives.

In the eighteenth century, illuminated by the thought of two great thinkers, Locke and Newton, various approaches to nature emerge (Lenoble 1969, Ital. trans. 1974): from the biting wit of Voltaire and the various forms of the morbid sensibility of Diderot, Rousseau, and Sade to the exuberance of Bernardin de Saint-Pierre. In these tendencies, feeling blends with enjoyment, from the pleasure of ruins to the taste for travel. The concept of nature is divided into phenomena that are difficult to comprehend. From beneath the much celebrated artifice of social life, shaped by conventions and formalities, resurfaces the exaltation of the simple life, the myth of Arcadia, the pleasure of an untamed nature and the cult of *bergeries* or sheepfolds. Gone are the divine model of the Middle Ages and the hylozoist vision of the Renaissance. The eighteenth century opens with the philosophy of Shaftesbury, for whom the vast panorama of nature stimulates the imagination and inspires humankind to come to know the divine abyss. In "Hymn to Nature," in the treatise *The Moralists* (1709), we find the wonders of nature that elicit a contemplative attitude. A century later, in the Earth-Spirit dialogue of his *Faust* (1808, 1833).Goethe evokes rich and suggestive images, such as the groan of the woods, the driving rain, the crashing sound of a giant fir, and the shelter of a grotto. These sights open humankind to the secret, profound wonders of nature.

For Venturi Ferriolo (1999a, 15), reader and interpreter of the thought of Simmel, nature is a complex concept that embraces both the transcendent, that which surpasses the limits of all possible knowledge, and the immanent, that which is inherent in all matter. Unlike the landscape, nature is the unity of the totality, without parts or contour lines. Landscape, in effect, requires a certain perception of boundaries and must be understood in terms of duration, whether momentary or long lasting. It is an

entity per se, a particular or unique feature defined by its relationship with the indissoluble unity of nature. In landscape nature realizes itself as an ideal that embraces, like the givens that are proper to it, infinity and limitation.

In the course of the development of European art and thought during the last three centuries, a development propelled by a re-reading of the ancients, nature re-enters the landscape, imagined as the ideal of a lost spontaneity. Between the two, namely nature and landscape, there is a continuous interplay through the strategies of taste that we find represented in the aesthetic categories of the picturesque, the sublime, the beautiful, Gothic revival, grace, etc.

1.2 NATURE AND ARCHITECTURE

Nature is often linked to an image of architectural structures. Towns, villages, and hamlets are part of our repertoire as travellers, explorers, warriors, and merchants. From reading war journals and travel diaries we are able to produce an immense catalogue of images of the world, from which emerges a disturbing sense of amazement associated with far-away places, a tapestry of colours and exotic things. For example, we have images of the conquest of Mexico and of the Spanish arrival at Tenochtitlán. In the memoirs from these expeditions, we can almost hear the shouts of wonder that those men must have uttered. Their amazement was such that they thought they had fallen victim to a magic spell, as though they were taking part in a medieval tale of chivalry. Nature is, therefore, related indirectly or directly to architecture. To the eye, however, architectural forms blend with the land settlements or stand out against the physiognomy of the terrain. Lights, surfaces, and the wind arrange objects into a liturgy of sorts where anonymous spectators can admire such sights as Stonehenge, the King Djoser complex at Saqqara,

the pyramids of Egypt, Greek and Hindu temples, the ancient houses of San'a, etc.

Let us concentrate on the 1700s as a point from which to look prospectively toward our modern sensibility and from which to recover retrospectively a sensibility that we have lost. In that century, the neo-Gothic style, the picturesque, and the pleasure of ruins are linked together through various ways of seeing. The neo-Gothic innovations of Vanbrugh, Kent, and Hawksmoor, described in Batty Langley's *Gothik Architecture Restored and Improved* (1747) are part of an aesthetic practice. In reading these instructions, we find an interesting basis for the creation of an aesthetic of the viewpoint and of the *veduta* (view painting). Sanderson Miller built an imitation ruined castle for Lyttleton Park in Hagley. Not far from there, the poet William Shenstone arranged the vistas of Halesowen Abbey for the purpose of making a walk through his farm, The Leasowes, more pleasurable. The grassy terrace at Rievaulx Water Gardens in Yorkshire was constructed for viewing the ruins of the abbey, while at Studley Royal the Fountains Abbey ruins lent an extraordinary atmosphere to the park.

The effects of these various elements, blended together, illustrate clearly the relationship between architecture and nature, a relationship that is confirmed by the very notion of landscape or *paesaggio* (*paysage*) derived from *pagus*, that is, village. The word *paesaggio* itself indicates human presence and the anthropization of the earth. In turn, this suggests the importance of the *veduta* and, subsequently, of the representation of a vast expanse of the land to which aesthetic value is attributed. Observing the landscape is part of the aesthetic experience because, through contemplation and knowledge, we learn to feel the environment and interact with it. The fashion of Gothic *revival*, in which architectural models were reproduced in a picturesque nature comprising real and imitation ruins, expressed the development of taste, from picturesque *vedutismo* to the genuine experience

of an intense emotion inspired by nature. Behind the Rococo falsification and contrived spontaneity, we can discern an effort to give to walks and to the poetics of the gaze an authentic *aesthetic life* in terms parallel to the world of art.

For instance, we must remember that, from 1770 to 1820, amateur tourists of the picturesque actively contributed to the popularization of the aesthetic aspect of the perception of the landscape. Between 1798 and 1806, Rievaulx Abbey was painted by Girtin, Cotman, and Sanby Munn, all of whom adopted a closer and lower viewpoint, whereas Copley Fielding, and Turner, in the 1820s and 1830s, opted for a more panoramic vista. In addition, with respect to the Gothic novel at this time, the ruined monastery, quite apart from any possible political or religious consideration, developed ideas and images originally found in the architecture of gardens and landscapes.

1.3 ENVIRONMENT

The use of the term "environmental aesthetics," a recently coined phrase, has become quite popular. It refers to the protection and valorization of natural beauty against its destruction by industrialization. The practice has close ties with ecological aesthetics as genuine protection of the environment. More than to revive the notion of natural beauty as a manifestation of the divine, within the framework of a recovery of tradition, this field aims to preserve nature and to promote a proper relationship between humans and the environment. Nevertheless, the idea of natural beauty, an intrinsic and objective quality, as it appeared in antiquity and in the Middle Ages, to a certain extent has been reinterpreted and modified in the last few decades by various specialists. In this case, the aesthetic experience does not aim to subject nature to the educated and refined gaze of intellectuals and "amateurs," that is, on the basis of a strictly subjective pleasure, as occurred in the eighteenth century. Instead, nature is

considered objectively in its totality, though not metaphysically. This is true of Hargrove, for whom natural beauty is tied to the existence of the beautiful object, independently of the perception of the subject. In general, equivalences or analogies with the world of art are not sought or established. There is no attempt to find models of natural beauty in the artistic masterpieces of the past or in philosophy. For Carlson and Berleant, for example, we cannot speak of the aesthetic experience of a natural phenomenon using criteria drawn from art and from its strategies of observation. Moreover, for these authors we cannot reduce that experience to contemplation alone. In their writings, they emphasize a participation that involves all of our senses. For Seel, those who appreciate natural beauty realize a unique and moral experience along their journey of "perfecting" the self.

Confronted with the invasive and abusive developments in the natural sciences, judged to be too reliant on quantitative and mathematical criteria, certain thinkers, such as Böhme and Tiezzi, propose to restore the domain of the sensorial. They see the aesthetic as an alternative that does not sacrifice qualitative elements. In Italy, recently, there have been similar considerations within geophilosophy, a discipline concerned with the relationship between human beings and the land they occupy.

The moment that it looks for ideas and structures with which to describe and qualify natural beauty, in relation to different authors and positions, environmental aesthetics, which appears to keep itself separate from art, is, however, forced to resort to the way in which art itself translates our perception of nature, both on the level of conventions and canons (gardens, parks, landscape paintings) and on the level of new, provocative expressions (Land Art, Art in Nature, Earth Art).

The key concern of ecology and environmental aesthetics, that is to say, the conservation, restoration, and valorization of historical and natural sites, leads to the question: Does an

authentic feeling for nature and landscape actually exist? To which landscape should we refer so that we may be able to think this is a truly authentic one after the transformations made by humans or by natural disasters? Today, ecology presents this feeling in dramatic fashion. Humans appear to have always had a feeling for nature, which arises spontaneously. Apart from any political and economic consideration of places (their protection is of great importance for the very survival of the human race), we have the impression that this feeling is innate and that humanity has always egotistically seen itself as being at the centre of a grand spectacle. How does this question of preservation enter into the problematics of the aesthetic? Did an aesthetic feeling for the landscape exist in antiquity?

Through the centuries, we find a symbolic or fantastic reading of natural elements and of the earth, of both cultivated and wild areas. To understand this, we need only look at Etruscan and Roman paintings or at familiar examples in Greek and Latin literature. There we encounter the constant presence of a feeling: nostalgia for a past that is lived as "authentic." This evocation arouses powerful feelings for a lost age. In other words, it may be that we have always been either naïve or sentimental, to use Schiller's felicitous characterization. From the dawn of civilization, we have felt nostalgia for something in the past that we thought was better and archetypal. The moment we felt and thought this way, we found ourselves in a most tragic situation in which only myth could console us. From the destruction of Troy to modern times, we have experienced the cyclical return of sentimentality expressed in specifically mnemonic and mythopoeic terms. To cite only one example from the subject of ruins, which is related to our notion of the picturesque, I would like to recall the famous letter of Servius Sulpicius Rufus to Cicero (45 BCE). Upon his return from Asia, he evokes the spectacle of cities that were once flourishing and powerful, but are now reduced to piles of rubble, essentially as an occasion for

meditating on *vanity,* on the ephemeral and painful nature of human existence. We can also correctly detect, however, a sentimental note regarding the fact that the models of the past remain unsurpassed in our imagination.

If we consider in general the beauty of a hike through the mountains, what memories are stirred within us to reinforce our enthusiasm and emotion? Certainly spontaneity and also the flight of the imagination intervene to intensify feeling. It is always the past that returns to the site of our memory. In *The Ascent of Mount Ventoux* (1336), considered to be the first modern document on the aesthetic account of the landscape, a wonderful fusion of aesthetic experience and philosophical reflection, Petrarch describes a feeling intensified by his recollection of antiquity, in particular the mythic mountains of Greece. The beauty perceived by the mobile gaze and the sensation of vast, unobstructed expanses experienced by the observer/spectator combine with the evocation of Mt Athos and Mt Olympus: incredible images that, in the act of recollection, become sites where it is possible for him to surrender to a lively and profound contemplation. We can then ask ourselves: Where is the authenticity here? It would appear that we are not able to experience profound feelings toward the nature around us without relying on glorious, ancient memories.

This is even more evident in the aesthetic valorization of the Alps, which began in the 1700s. We are familiar with the particular aesthetic pleasure of fear aroused by descriptions and depictions of some places, a pleasure that affects us profoundly. This sensation arises because, quite apart from the real dangers that they present, such places are associated with other forces, like secondary images; for example, the imaginative reconstruction of the adventure of Hannibal crossing the Alps. Several English intellectuals travelled through the Alps while reading books on the heroic deeds of Hannibal to stimulate their imagination and thereby amplify the aesthetic experience of those vistas in a very

intimate, personal, and moving fashion. They found the material for their own fantastic reconstruction in *De secundo bello punico* (88 CE, The Second Punic War) of Silius Italicus, which became for them a veritable guidebook. Turner's *Hannibal and His Army Crossing the Alps* (1812) is the product of this perception, shared by so many intellectuals of the period. But the success of this response can also be found in an earlier work, now lost, by Cozens, exhibited in the Royal Academy in 1776. The campaigns of Hannibal combined with the theories of Burnet on the biblical flood and with Salvator Rosa's paintings of hermits and bandits. Influenced by these vivid portrayals, "romantic" travellers, enthusiasts, and sentimentalists of different decades, contributed to the cult of the ascent or the climb as an aesthetic and moral experience.

Where, then, is authenticity to be found? It seems to involve a continuous invention of things inspired by mythology, history, art, or literature, by solitary walks, as well as by the exploration of the remotest places (for instance, exotic India and the Far East).

On this question of the authenticity of aesthetic perception of the landscape, two other examples come to mind: Palazzo Piccolomini in Pienza and Linderhof Castle. The first is a grand model of the Renaissance in which architecture and landscape, building and environment, are perfectly integrated. The natural environment is constituted as an "aesthetic object," as is the form of the structure, which is designed in such a way that the arcaded loggia frames the Tuscan countryside (Val d'Orcia, Mt Amiata, the Fortress of Radicofani). For Keller and Assunto, this view may very well have determined the complex orientation of the entire palace; it may well be the case that the entire building was erected with this scenery in mind. We also discover how the architecture deliberately establishes a certain relationship that promotes a reciprocal action, the result of culture, civilization, and history. This interdependence of features is of such importance that any alteration of the natural surroundings

would entail an irreparable mutilation of the aesthetic object as a unity formed by the building and its environment, a violent alteration of its formal values. The second example is the spectacular effects created by an artificial grotto in Linderhof Castle of King Ludwig of Bavaria, and by the view from the king's bedroom. From a seated or reclining position, the king could contemplate romantic landscapes through a window that functioned like a picture frame around a verdant nature (the changing beauty of the woods, the waters, etc.). Whereas in Pienza we find a Renaissance utopia, in Linderhof we discover the extravagant pleasures of sentimental kitsch.

1.4 SPACE

The landscape is space; not the green, organized space we find in the cities of the last few decades and not limitation, living in an area defined by boundaries; neither is it geographic space, nor a neutral site in which to assemble objects, bodies, and structures. It is not the quest for a semiotics of space or proxemics; it is not a field that can be defined geometrically or mathematically; it is not simply extension or amplitude, nor the expression of a causal logic, nor the ideal place capable of containing our perceptual legacy and all finite expanses. The landscape is not narrow, broad, circular, dense, sharp, or round. It is not even space as expression of a metaphysics of the imagination, such as that formulated by Bachelard. At the same time, it can be said that it is not "the space that increasingly provokes modern man" (13) according to Heidegger, and not the space that, for Heidegger, takes hold of human beings to the point of inspiring fear and anguish, echoing Goethe: the space that pertains to the domain of archetypal phenomena, behind which the void seems to lurk (Heidegger, 1969, Ital. trans. 1984). Finally, it is not the space represented in the thought of philosophers from Pythagoras to Kant.

Space and landscape, according to Turri (1974), are defined differently from both a disciplinary and an operational perspective, even if one cannot do without the other. The landscape is partial and subjective and is not useful in the organization of space. It does really require planning, unlike space, which does not, since it is a more direct, immediate, and utilitarian intervention: "the landscape allows itself to be lived; space allows itself to be designed." Turri (1974 and passim) also observes that, during the sixteenth century, the concept and the perception of the landscape in the modern sense of the term did not exist (at best, there was disinterested contemplation for the pure pleasure of the soul). What dominated, instead, was the *paese* (country), which was something similar to what we today would call territory or environment, which did not really belong in the aesthetic sphere. Rather, it pertained to the more empirical realm of anthropic space, the expression of so-called material culture. It is only then that space begins to acquire a semantic, perceptual, and behavioural connotation tied to the transformation of natural or geographic reality, which leads to the modern notion of the landscape.

1.5 TERRITORY

The landscape is not reducible to territory, that is, an extension of the earth's surface that remains the same in spite of changes to its appearance. Territory is a geographic, political, and social expression, whereas the landscape retains symbolic and affective meaning. The figure of the landscape artist, imagined by geographers, is tied to the notion of territory on the basis of his or her knowledge in the fields of botany, arboriculture, forestry, geology, architecture, etc. The landscapist is expected to safeguard the environment and to plan the so-called green spaces. However, the landscape does not require any such intervention. Territory has biological and psychophysiological implications; it is also a

behavioural phenomenon tied to the organization of space. In their social activities, human beings are territorial animals and they act in conformity with cultural models. Beliefs, perceptions, and symbols have relationships with certain visible forms. The morphology of the territory is also a social morphology, as we can see in the principles governing the organization of the city.

The landscape cannot be represented by territory even when we think of it in relation to the lives of people, underscoring the undeniable biological, historical, and cultural legacy that we need to save and protect. We can say, then, that it is the environment that somehow defines territory biologically and culturally. Understood in this relationship, the environment provides the setting in which humans can live. The landscape, however, is not even synonymous with our environment, whether original or transformed. As Assunto (1976) reminds us, it is, instead, a complex network of forms tied to the tradition and the myth of the first garden, to the search for a beautiful place (*eutopia*), to the illusion of happiness (*eudaimonia*), and to the attainment of a paradise of wonders.

Before the image of nature, our mind translates laws into feelings, mathematical relationships into emotions, to produce an instant dream or a dream to pursue. Territory, then, can inspire in us the idea of vastness. Goethe recognized that excessive magnitude in nature ceases to be sublime because it surpasses our ability to confront it and threatens to annihilate us. This situation triggers the anguish of humans caught between two opposing perceptions: the infinitely vast and the infinitely small. The sense of disorientation felt in the presence of the infinite corresponds to the type of emotional and spiritual experience originally described by Pascal, from which appears to derive the entire movement toward reason and taste: "For in fact what is man in nature? A Nothing in comparison with the Infinite, an All in comparison with the Nothing, a mean between nothing and everything" (*Pensées*, no. 72).

2

What Is the Landscape?

2.1 PHILOSOPHY OF THE LANDSCAPE

Before an unbounded nature, before the images of its countless particulars represented in our mind (from trees and torrents to fields of sunflowers and rolling hills), before nature's "spiritual physiognomy" that corresponds to the full spectrum of our most intimate feelings, then, we are convinced that something exists that transcends this vast, extremely rich panorama of disparate elements. To our conscious minds, that something takes the form of all-enveloping, diffused totality, like an uninterrupted flow of emotions and perceptual data, an affective irradiation. That something is the landscape. It is more than the sum of the parts, of the individual fragments of our perception scattered along the temporal continuum of our sensibility. It is more than the attraction of psychic processes. It is the spirit of an infinite and magical connectedness of forms. The idea of the landscape develops in history, but also in the individual, through the effects of time and space joined together in the rhythm of lines and surfaces that human beings know how to compose almost instinctively.

Every epoch and every civilization seems to have produced culturally its own landscape. In ancient Greece, humankind and nature were united by virtue of a magical and animistic mentality. In medieval Europe that unity assumed the form of

Christian transcendence; and in the modern age, the separation of man and nature has led, instead, to what I have been calling the landscape through the evolution of the gaze as determined by the principles of scientific discovery and of the history of art. This process has passed through various stages. Burckhardt correctly highlighted the aesthetic discovery of the landscape in the Italian Renaissance. What is more, in terms of the graphic representation of space, between the eighteenth and nineteenth centuries scientific maps still existed that, true to a subjective impression, depicted mountains or lakes with a certain degree of optical distortion (photography and other scientific instruments later corrected the perspective). Yet, despite everything, the landscape attracts our attention like something beyond time and beyond all these opportune, necessary distinctions and judgments, if we think of it as tied to a living nature. We cannot, certainly, overlook the enormous importance of history, language, and culture; nevertheless, the physiognomy of the landscape, as an expression of places, material givens, memories, and feelings, is represented as an absolute. Even a momentary feeling for a particular natural beauty always appears to us as a more or less important emotional experience that can be identified with the universal *en kai pan* (the identity of the particular with the whole). This is why I am tempted to say that both the ancient past and the future draw forth this feeling.

I am also inclined to think that the spiritual act, consisting of a visible unity and a state of mind, which Rehder discusses, occurs almost spontaneously in human beings. The landscape is a spiritual form that fuses vision and creativity because each act of seeing creates an "ideal landscape" within us. The first humans and the ancients who have gone before us, transformed our capacity to see and to feel, beginning with a common awareness: participation in the life of the world. This is the unifying psychic process of aesthetic experience, something that is given immediately and is the effect of both the act of seeing and the act of feeling. Simmel called this spiritual response the *Stimmung* of

the landscape, in the sense of a going beyond the opposition between *physis* and *psyche* already noted by Schlegel (*Berliner Vorlesungen*, 1801–1802) when he studied the affective gradations that emerge from the perception of distance and light. The various perceptual phenomena form a unity whose main property consists of a broad range of psychic responses that go from the domain of the emotions to that of art and from the domain of reception to that of intuition (Simmel, 1912–1913, Ital. trans. 1989). We usually behave like artists, though in a less elaborate or technical way, when we observe and select objects with a creative attitude. The landscape is understood and interpreted in accordance with the image of the world that we form. In this same spirit, we are led from the aesthetic to the artistic. He writes: "Where we really see a landscape, and no longer as the sum of individual natural objects, we have a work of art *in statu nascendi*." The *Stimmung* of the landscape has two meanings in modernity: the ideal of the infinite in the vision of the Romantics and the scientific explorations of Alexander von Humboldt. For Humboldt, the features of the landscape, the mountain crests, the mists in the atmosphere, the darkness of the woods, and the torrents crashing through the crags, all have an ancient and mysterious connection with the comfortable life of human beings.

Although it changes with the sensibility of our age, the *Stimmung* of the landscape appears to be modern and ancient at the same time. The landscape is a modern invention only to a certain extent. The way to understand this complex, profound, and immediate affective disposition is still through the landscape per se and not simply through the landscape in the images produced by painting and its techniques of representation. We have always admired the beauty of the cosmos and of its representation, without denying the importance of the revolution in optics that, as Assunto has noted, can legitimate a critique of the landscape that parallels the critique of art. In this perspective,

human beings become artists the moment they accept nature within the framework of contemplation and imagination.

A delicate or sublime network of forms, the landscape is the expression of an ethical reality that pertains to the life of humankind, to the realm of the accidental and the possible, to a reality that human beings have the capacity to change. To relate another of Simmel's useful thoughts, nature is, instead, the infinite connection of causes, the unending cycle of birth and destruction of forms, the kaleidoscopic unity of becoming, expressed in the continuum of temporal and spatial existence. However, the landscape, as spiritual form, embraces within its own limits the infinite, and so it integrates and communicates nature's most noble meaning.

A single act of feeling and seeing unifies in a profound way natural landscape and artistic landscape, as stated above. Moreover, the aesthetic discovery of the landscape antedates advances in painting and poetry. It is through these discoveries, as Assunto has shown (1973), that we transform into aesthetic objects those things that were pure and simple objects of nature. The constitution of the natural landscape as an aesthetic object is the work of human beings and of their history. It is humans who transform the landscape into an aesthetic idea. At the same time, what we might call the art of the landscape is the product of human activity or, rather, an image, a dream of human beings. For these reasons we consider every alteration of the morphology of the natural landscape to be an irreparable mutilation of nature, which has become an aesthetic object. This is because every landscape preserves a mythological, historical, or cultural memory. Each injurious intervention on its formal values entails a modification of the very essence of the place. To destroy a landscape is to destroy all that has been said about that site in poetry, and all that the culture and art of humankind have done to it.

In Klages (1973, Ital. trans. 1998, 39) we find an emotional defence of nature against progress, which has been destructive of life. He hopes to see a change within the soul of humans, one that does not depend on political power. He deplores the disappearance of the primordial enchantment, when earth, clouds, waters, flora, and fauna formed a "spellbinding *whole* that envelops the life of the individual as though inside an ark, integrating it with the grand becoming of the universe." This message illuminates for us a profound feeling of the human spirit.

Out of our meditation on the ancient and the modern, but also on the meaning of productive activities in the garden and in culture, a "critique of seeing" is born. It is a critique linked to the question: Is it I who brings about the real beauty of the things around me or is it the things that reveal their beauty independently of me? From the 1700s, this question has been answered through the range of categories of taste: beauty, grace, the sublime, the picturesque, the *je ne sais quoi*, and the neo-Gothic. Along with great historical-stylistic paradigms like the Classical, Baroque, Rococo, and Romantic, these complex ideas are closely tied to the reception of the landscape as an aesthetic value and to our feeling for nature. In fact, every landscape belongs to human beings, to their activity, to their freedom, and to their existence as craftsmen who create, modify, construct, and transform the physical world by means of their talent, imagination, and technology.

Understood as a site of contemplation, the landscape can be thought of as itself the product of art, an effect of human work and feeling produced freely. The landscape is a manifestation of human freedom in nature, according to Ritter (1963, Ital. trans. 1994). But Ritter emphasizes the epiphanic aspect of the landscape as a manifestation of nature through contemplation. Beyond history, where technical transformations prevail, human beings can recover the lost unity if they eschew utilitarian objectives. Interestingly, he states that, "sacred" nature has become a

"lost" nature. Beyond the quest for these lost or forgotten values, he does not advocate a search for the naivety of the ancients, but rather for a unity achieved through the aesthetic mediation of poetry and the figurative arts, corresponding to the awareness of the rupture (*Entzweiung*) between humanity and nature recorded since the time of scientific observation and the perspective revolution in painting, from the fifteenth century onward. For Ritter, the landscape is a universal concept, conceived by modernity and in modernity, and consistent with the theory of the cosmos, beyond hegemony and subjugation, beyond the metaphorical Ptolemaic system (nature as landscape) and the Copernican (nature as the object of scientific study). During the Enlightenment, the first theorists of the landscape, such as Hirschfeld and Girardin, began to think along these same lines.

We can understand that the reality we see is not only aesthetic; it is also ethical. Influenced by Spranger's works on the morphology of culture, Schwind (1950, Ital. trans. 1999) asserted that the landscape is a work of art comparable to any human creation, but much more complex. While a painter paints a painting and a poet writes a poem, an entire people create a landscape, which is the great reservoir of its culture and contains the imprint of its spirit. In writing these words, the author has kept in mind the unifying element, mentioned earlier, that demonstrates continuity across different epochs. From the time of Herodotus, it has not been a matter of describing a natural portion of the earth's surface but rather an ecumene that embraces people and cultures. As Kerényi (1937, Ital. trans. 1996, 17–32) also explains, the spirit seeks out the landscape; there is a very close relationship between them. Nature and culture interpenetrate each other in the sense that the landscape educates and inspires the creative act. Reinterpreting the category of emotion (*Ergriffenheit*) formulated by Frobenius, Kerényi points out that such a state of mind allows us to eliminate distances,

bringing the past that lies concealed in the landscape nearer to us, thus allowing us to embrace the distant memory of mythological figures.

It is a common opinion that the landscape is an absolutely modern concept linked to the development of painting, from the Renaissance to the scientific discoveries and to the aesthetic experience of travel. As a result, we are able to recognize a picturesque, a literary, a geographic, and an imaginary landscape. This leads us to conclude that the landscape is a cultural construct or, more specifically, a historical invention, essentially the work of artists, something between the art of garden design and Land Art, as suggested by Roger (1997). The aesthetic problem of the landscape, however, cannot be explained solely in terms of the landscape considered as an object of artistic representation. We must also take into account the relationship between humanity and nature in the complexity of human experience. The landscape is a relative and dynamic entity wherein, since ancient times, nature and society, the gaze and the environment, constantly interact. The act of observing is decidedly modern, but what the observing teaches us may be ancient. In the *Oeconomium* (*The House Manager*) of Xenophon (430–354 BCE), a veritable guidebook for the country gentleman, in which we find Socrates' praise of agriculture, we also find an actual definition of the landscape. There are references to *paradeisoi* filled with all the beautiful and good things of this world. A *paradeisos*, Venturi Ferriolo (1999a) tells us, is a beautiful landscape, an example of the harmony between human beings and nature, capable of arousing wonder and pleasurable sensations. It is anthropic; it belongs to the totality of human activity and involves the useful as well as the beautiful. The landscape is nature transformed by humans in the course of history. It is a tradition rooted in the distant past. For the Greeks, every aspect of life was suffused with landscapes, as Rilke has noted.

In the history of Western thought, the setting for Plato's *Pha-edrus* constitutes the physical paradigm of the ideal landscape. This theme, which is so evident in the studies of Curtius, has recently been highlighted by Carchia, who connects it with the myth of the immortality of the soul and with the idea of the world as epiphany. According to this view, the space outside the city, outside of history, is a space of enchantment and rapture, and the spectacle that we discover there is an archetypal one that leads us to the essence of nature. At the end of their walk outside of Athens, Phaedrus and Socrates stop at a place that reminds them of the myth of the rape of Orthia by Boreus. But, here is the passage:

> By Hera, it really is a beautiful resting place. The plane tree is tall and very broad; the chaste–tree, high as it is, is wonderfully shady, and since it is in full bloom, the whole place is filled with its fragrance. From under the plane tree the loveliest spring runs with very cool water – our feet can testify to that. The place appears to be dedicated to Achelous and some Nymphs, if we can judge from the statues and votive offerings. Feel the freshness of the air; how pretty and pleasant; how it echoes with the sweet summery song of the cicadas' chorus! The most exquisite thing of all, of course, is the grassy slope; it rises so gently that you can rest your head perfectly when you lie down on it. You've really been the most marvellous guide, my dear Phaedrus. (Plato, *Phaedrus* 230 b–c, 6)

We then witness the reluctance of Socrates, who claims to have nothing to learn from the trees and the fields only to go on to praise his interlocutor for having succeeded in connecting the natural surroundings to his desire to know. Before getting up, Socrates offers a prayer of thanks to the divinity of the place for

the wisdom received. This represents the first philosophical reflection on the landscape as an aesthetic space.

For the ancients, a place was always connected to sacredness. Ritter (1963, Ital. tran. 1994, 38) explains that even Petrarch's ideas of transcendence, formulated during his ascent up Mt Ventoux, in their Neoplatonic and Christian form belong essentially to tradition, that is, to the theory of the cosmos that, from the earliest times, is identified with philosophy. To turn to nature as landscape presupposes the historical existence of these ideas. The "cosmos" is the "order of the world" and for the first philosophers, as well as for Aristotle and for Hellenistic thinkers who came after him, the cosmos referred to the primordial concept of *physis*. Nature always understood in its totality is the foundation of all that exists. This is why, from a philosophical standpoint, contemplation (*theori*) of nature means that the spirit turns towards totality, towards the divine, which contains everything within itself. Only in this way is it possible to understand why Aristotle called the Ionian philosophers of nature "physiologists" and also "theologians." Those who speak of nature are also those who "assemble in the divine." The discovery of the landscape comes out of the relationship between theory and tradition. As Ritter states, however: "The free contemplation of the whole of nature – which for centuries, beginning with Greece, was the only subject of philosophy – finds a new structure and a new form in the spirit's interest in nature as landscape" (Ibid. 43).

This occurs in Petrarch at the point when nature becomes landscape for those who contemplate with feeling, when things appear to us stripped of practical purpose, and when our sense of oneness with nature dissolves.

Philosophical reflection opens the way for an aesthetic of the landscape, understood as the product of civilization and art. This aesthetic is at once history, criticism, culture, conservation, education, and work, on a pathway that leads from ancient

Greece to our present world. It is an aesthetic that transforms humans so that, by knowing how to see, respect, contemplate, and promote, they may be led back from the level of mere reception to that of a vital and profound participation – beyond the consumption of green zones, the logistics of "leisure time," and simplistic solutions to environmental impact in the face of the tragic destiny of the earth.

2.2 CULT OF ANCIENT AND MODERN PLACES

As Venturi Ferriolo contends, any parcel of land can become an archeological site for our contemplative spirit. This is true because the spirit of contemplation stimulates us to perceive and to search for the hidden presence of history and culture, to discover durable evidence of ineffable beauty behind those forests, fields, and rock formations. According to this line of thought, human beings create the world. Originally farmers and gardeners, we have become demiurges. In the Hebrew Bible human beings are the custodians of the place of God and at the same time they protect His lands. Out of that image a whole host of activities and projects has emerged through the ages. In a manner of speaking, nature is disassembled and, through its elements, it offers an object that transcends it. It is the landscape created by human beings who, through their labour, their freedom, and the play of their imagination, modify the world around them by transforming the physical environment. The landscape should be thought of as the depository of the transformations brought about by human beings, the depository of the parts of nature as a whole. Human productivity is to be understood, then, as having two meanings: on the one hand, it is the expression of taste in the selection of places in accordance with different social and cultural ideals; on the other hand, it is the expression of activities, cultivation, and urbanization. The

first meaning is aesthetic and the second productive, thereby overcoming the clash between the beautiful and the useful. One possible bridge between these two concepts could have been and perhaps should have been landscape architecture but, in the face of the ever-increasing rate of destruction and invasiveness, it has not yet achieved its goal. The only opposition to the destruction of the environment has been the preservation and protection of more or less large areas of land.

A place may have many different aspects and meanings. In Aristotle's *Metaphysics*, we read that, "being has many meanings, but they all relate to the same term and to only one nature" (III, 2, 1003a, 33–35). These words lend support to my personal view that, even when no specific word exists to describe it, the land-scape can still exist in a sensibility that manages to convey its sense and value. Roger (1997, 57), a critic of the position taken by Berque, recently dealt with this issue without being overly concerned about terminology.

The Greeks had no word for the landscape, but they used a variety of expressions and terms that reveal a profound love for nature and for the "spirit of the place." In Homer we discover the perception of the beauty of the landscape (*Homeric Hymns*, III, 225–28) and the idea that a place could also be understood as a space from which to enjoy a panoramic view (*Odyssey*, X, 146–47; 97–98). I do not think that we can call the landscape of ancient Greece "proto-landscape" as Berque (1995) has done by making a distinction between societies tied to the landscape and societies not tied to it. A recent representation, the landscape is in reality an ancient idea associated with the feeling of wonder aroused by contemplation. According to Venturi Ferriolo, we must appreciate the difference between *paesage* that derives from *pays* (town) and picturesque *paysagisme* or landscape architec-ture. Although the latter is important in its modern meaning, we must also be aware of the landscape independently of the discovery of techniques of visual dislocation in the pleasure of

observing. This is a new fact that determines what comes next: the appearance of an aesthetic feeling that, in the modern age, is separate from philosophical theory; that is, from the above-mentioned theory of the cosmos whereby humans and nature are part of the same totality.

The transformation of nature into landscape coincides with the nostalgic image of an age whose perfection we cannot equal. Vernant tells us that:

> For the "physicists" of Ionia, positivity has immediately penetrated the whole of being. Nothing exists that is not nature or *physis*. Human beings, the divine, and the world form a unified, homogenous, whole universe on the same plane of existence. They are parts and aspects of one and the same *physis* that operates everywhere through the same forces and exhibits the same life force. (1962, Ital. trans. 1978, 95–6).

It is something that excludes the very notion of the "supernatural." The archetypal, the primordial, is stripped of its majesty and mysteriousness; it now has the reassuring banality of familiar objects. We might say that every form of the landscape is a mirror image of the world, a reflection of the gods. Grottos, trees, and springs display the life of a unified cosmos of which they are an integral part. As Venturi Ferriolo also states (1999c, 18), citing Plutarch, cults are nourished by the divine that haunts a place, dominating it and establishing its sacredness there. Plutarch shows us that nature is alive when Pan is alive; the screeching owl is Athena; the mollusk on the shore is Aphrodite; the gods inhabit their biological forms. However, he also points out a change: crags, thickets, and sites would become symbols. In the mental representations of the ancient world, we find a fusion of religion and nature, as Strabo also makes clear. In addition, the people of that age engaged in a particular kind of contemplation based on

the interpretation and illustration of nature, to which they gave the name *manteia*. We also should not overlook the value of painting itself with its depictions of the countryside, ports, fields, sacred woods, hills, beaches, and rivers.

But to return to the *Querelle des Anciens et des Modernes* (quarrel of the Ancients and the Moderns) natural beauty arouses the sensation that something is irrevocably past, a loss that modern humans have replaced with feeling and the ideal. In antiquity, every place was the kingdom of a god, the object of a cult or memory operating through successive cultural layers. Grottos, trees, shorelines, and rock formations were the physical sites of oracles. Myths and legends provide us with the framework for such a fusion, describing as they do places enveloped in an aura of enchantment and mystery. We can understand this process, for example, by reading Pausanias. In his narrative, the descriptions of Greece are enriched by references to the beliefs of an ancient religious cult, so much so that we are inclined to see him as one of the first sentimental travellers. He describes the physiognomy of Greece in the second century CE, as he evokes ruined cities, crumbling temples, pedestals without statues, the vestiges of times immemorial overgrown with ivy. He also offers us powerful images of children crowned with wreaths of grain, men carrying flaming torches, women mourning the slain Achilles at sunset, litanies of Persians with their strange head-covers, priests chanting, bronze lamps lit before statues of oracles, sacred woods, skies afire with the light from bonfires on Mt Kithairon, where statues of oak, decorated to look like brides, are thrown into the flames. These scenes have a descriptive power like that of picturesque or romantic travellers on their Grand Tour of ancient Greece. Here the stagnant water sleeps in the marshes of Lerna among tufts of grass and swaying poppies that lead into Hades. The shores of Elysium are the place where Orthia was raped by the North

Wind and taken as his bride. The various landscapes, mountains, caverns, chasms, plains, streams, lakes, seas, trees, and flowers exist because they are dedicated to a divinity or inhabited by a spirit. A variety of flower blooms in Salamis on the death of Ajax, a plane tree is planted by Menelaus before he sets off for the war, and dark caves indicate the hiding places of Pan and the nymphs. Even more strongly linked to pure and disinterested contemplation are the mountain pass through which flows the river Ladon as it descends Northern Arcadia to the plain, the Asopos river that flows through the reed patches, the paths that wind through the vineyards bordered by mountain crests, the shaded footpaths used for summer walks along the seaside, the oak stands of Phelleo, and the forest of Boiotia. The whole earth is a site of cult worship, the abode of human beings, where ruins already produce a nostalgic feeling. Dione Crisostom describes what remains of the great square of abandoned Thebes and the cities of Euboia, reduced to pastures, where the *gymnasium* has become a flowery field.

The ancient places of cult worship were selected for their morphological features as well as for a certain indefinable *quid*; they were places dear to the gods in which they built their terrestrial homes. Thus Apollo, the god of oracles and the beauty of the sun, is a figure rich in associations and mysteries that make shrines dedicated to him powerfully attractive. This is also true of the myths of the "Great Mother," with her physical attributes: oaks, springs, caverns, and grottos, not to mention those places that were passageways to the underground world: fissures in the earth, crevices, abysses, and caves with no apparent bottom (Avernus). More recent places of cult worship are born out of the same magic and spirit of identification. They are sites for the apparition of angels, Madonnas, saints, and ghosts. An aura of ghostly presence emanates from Delphi and Dodona, from the Clitumno Sources in Monserrat to Mt Sant'Angelo and Findhorn.

2.3　VARIETIES OF LANDSCAPES

It can be said that every writer and every painter corresponds to a particular landscape: for Stevenson and Conrad it is the South Seas, for Gauguin Tahiti, for Melville the ocean, and for Cézanne Aix-en-Province. We would have an endless list if we matched artists and places on the basis of certain categories, as a way of identifying a variety of geographic types using such terms as romantic, symbolist, metaphysical, etc. The two are always interconnected. The same mountain or coastal inlet, for example, may be described or painted differently by different artists and writers. We have de Saussure's Alpine landscape and the formulation of the pre-romantic idea of the sublime, and Humboldt's discovery of the strange beauty of deserts and steppes, a characteristic of a romantic naturalist sensibility. There is also the exotic landscape imagined by Europeans of the 1700s, as tropical, where nature is free, good, and generous (that of Bernardin de Saint-Pierre) and the Far Eastern landscapes of the curio and of *chinoiseries*, typical of Rococo style and of the aesthetic of grace proper to the period. In addition, we have the Roman countryside of romantic taste, with its lakes and villages, and the Venice of eighteenth-century *vedutismo* (view painting). Thus, a spectrum of poetic and scientific investigations emerges, as well as a variety of aesthetic ideals linked to cherished places: from the gulf of Naples to the fogs of the North, the panoramic vistas of Petrarch, Boccaccio, and Tasso, the "lake" poets, and the Flemish symbolists. The panorama extends immeasurably, even to the domain of the picturesque, from Poussin and Lorrain to Rosa, Friedrich, and Turner.

Each aesthetic discovery leads, in turn, to a transformation of taste and culture. Since taste is subjective, we do not know which landscape to privilege: those of Scotland or Ireland with their mysterious charm, or those of Tuscany with their luminosity; those of eighteenth-century *vedutismo* (view painting) or the

romantic ones; those that are barren and hostile or those that are rich in vegetation; the regular landscapes in the serene image of a revisited classicism or the irregular ones of picturesque taste. The discovery of ever new types of landscapes is another demonstration of the way human beings humanize nature, a process whereby the Alps and the deserts no longer appear as hostile environments, but become the sites of novel forms of beauty.

From the dawn of civilization, the landscape has been associated with images in painting or literature, in response to what mythological stories suggest to us. As stated above, the landscape may be read as a work of art. Nature moulds forms in the human mind, forges events that change along with the movements of the subject, with matter (earth, water, mountains, meadows, etc.), and with climatic conditions and the seasons. In this way, we obtain a sort of succession of poetics, from the more explicit ones, which pertain to the spirit of art, to implicit ones, which pertain to the spirit of the earth. Over and above the vision developed in the arts, the art of the landscape itself is an integral element of the most elementary form of aesthetic perception, stimulating as it does the receptive capacity of humans' creative tension and force, which are important to the imagination.

In the interplay between nature and feelings, the entire fabric of seeing unfolds. Foscolo (1798, *The Last Letters of Jacopo Ortis*) gives us a dark and frightening image of the Alps: "Nature lies here solitary and menacing and drives all living beings from her realm." Manzoni later depicts the picturesque grace of that "section of Lake Como." But, before the 1700s, feelings were not as vivid. Interest was tied more to the environment or to the village than to the landscape. As Camporesi tells us (1999), in Italy literary descriptions dealt with things, people, and products. From these emerges an image of merchants and fairs, shops, trades, metallurgy and engineering, of artisans and farmers at work. Interest in the mountains and in the countryside, on the part of such artists as Leonardo, Piero della Francesca, Giovanni

Bellini, and Andrea Mantegna, appears to stem from scientific curiosity about the land and the rocks, from the mysterious charm of mines and sulphur. In the fifteenth and sixteenth centuries the study of painting existed alongside the study of alchemy. In the treatises, works of art, and literature of the period, streams, canals, gulfs, ponds, lakes, valleys, woodlands, and mountains were seen as enigmatic geological paradigms. The landscape, then, did not appear to be autonomous and did not evoke any specific emotional response. With the exception of Tasso and his mysterious or magical places, it is only in the seventeenth century that the landscape acquires a form of representational autonomy in painting. In this interpretation, Petrarch's early account appears to be an isolated case because he no longer presented the town as objective reality but, rather, the landscape as a subjective factor through strategies of seeing.

Other theories hold that the landscape is nothing more than a decorative element in painting. For example, Milizia (1797) subdivides landscapes into depictions of aspects of the countryside as they really are, actual sites embellished through the concept of imitation of natural beauty (for example those of the Flemish painters), and ideal places that call for creativity. Such great artists as Titian, Poussin, Carracci, Domenichino, and Mengs paint excellent landscapes without being landscapists, states Milizia; otherwise, they could not be painters at all, either of landscapes or still lifes.

In general, throughout the centuries, the tendency has been to connect the landscape and landscapism with the development of art. From the time of the Renaissance, we see a growing interest in perspective realism, while other artists (Altdorfer, Grünewald, Polidoro da Caravaggio, Niccolò dell'Abbate, Salvator Rosa, etc.) paint imaginary landscapes, and still others are inspired to paint "ideal" landscapes (Giorgione, Titian, Lorrain, the Carracci brothers, Domenichino, Poussin). We must also keep in mind landscapists who pursue the "natural"

(Constable, Corot, Courbet, the Impressionists). However, with the Impressionists, Seurat, Divisionism, Cézanne, the first Cubist works, Futurism, and Surrealism, there is a new direction that eventually leads to non-figurative currents in contemporary art and to the end of landscape painting. Although considered to be an inferior genre up to the first years of the 1700s, when de Piles (1708) finally gave it full recognition in his *Cours de peinture* – where, among other things, he made a distinction among "heroic," "pastoral" and "rustic" – landscape painting was looked upon favourably by such Italian painters and writers as Leonardo, Varchi, Pino, and Baglione. This art form enjoyed particular success in Great Britain, where notions of the picturesque and the sublime were reproposed following their favourable treatment in the mid-1500s. In the 1770s, Alexander Cozens invented a new technique: the monochrome landscape drawing.

Paralleling the development in landscape painting are the role and function of gardens. If we think of the strategies of viewing that promoted the experience of pleasure derived from solitary vistas immersed in nature, the garden must be fully appreciated. The beautiful vista or *veduta*, the mobile gaze, the various techniques of perception structured by garden architects are instruments used in conjunction with those of painting. The garden is an integral part of the landscape, as evidenced by the discussions on its relevance to painting or architecture in the eighteenth century.

If we want to draw a comparison, we find another interesting observation in Assunto (1988), for whom the garden is an example of concentrated aesthetics, whereas the landscape is diffused aesthetics.

Today, uniformity prevails over variety of landscapes, which has always been acknowledged. In recent years the countryside and the city occupy a hybrid space that has lost the soul it always had. Places no longer have an identity since they are identical, from Europe to North America and the Orient. This is the result of abandonment, indifference, uniformity of style,

rejection of the beautiful, which is material culture, a product of human work, constructed through the ages on the basis of symbolic, visual, and technical processes where ethics and aesthetics converge. When it loses its historical, cultural, and environmental points of reference, an area or a city risks deteriorating into hideous disorder and abandons the path of civilization. The country, the city, and spaces in general, are destined for obscurity and nothingness once their history and culture are lost.

In the face of the present global catastrophe, efforts are being made to harmonize the natural and the industrial landscapes in an attempt to restore to the earth the dignity of its forms. Against the irrational exploitation of the earth's resources, the project is to restore to our environment its value as a work of art through conservation and restoration projects.

2.4 GARDENS

The garden evokes the image of a place of quiet, a tranquil retreat, for silent meditation on the beauty that presents itself to the eye. It is nature shaped by human beings to exhibit their spirit by using the various techniques of agriculture, arboriculture, hydraulics, and architecture to create an environment in which to live and at the same time enjoy the world that surrounds us. The garden is a living meditation and, as such, is opposed to the current program for the consumption of green spaces. It is perfect integration into the landscape. The disappearance from view of boundary walls around properties and the use of the *ha-ha* by Kent and others in early eighteenth-century England clearly indicate a desire to produce a vista that extends towards the horizon, reaching for the infinite. The *ha-ha* was a trench along which a wall was built for protection. This device allowed the gaze to reach into the distance and the view of the landscape was similar to the pictorial code in a close relationship with picturesque taste, which was at the time a way of seeing and

feeling nature in its spontaneity. The *ha-ha* made its first appearance at Stowe garden (c. 1725) in Buckinghamshire and soon became quite common. The construction of villas on high ground is another way to understand this movement of the gaze by locating it in architecture. Gardens and the surrounding countryside, forests, and cultivated fields constitute an uninterrupted whole. Furthermore, the garden has always served as the ideal model for agriculture.

The archetypal garden is Eden, which permits us to understand the garden's symbolic value and leads us to amalgamate myth and poetry. It makes us responsive to the mystery of origins and to the separation of land and sky, out of which the garden emerges. It is this myth of separation, according to Baridon (1998, 19), that is revived in the work of the creators of gardens. They assume the role of an organizing God; like gods or demiurges, garden architects turn chaos into a cosmos. They do so by following the laws of nature, imitating its inner workings and transforming it through human genius and work. As we read in Sulzer's *General Theory of the Fine Arts* (1792), the art of the garden derives directly from nature, which is itself an accomplished gardener. Human beings have learned to bring order to their habitat through imitation, by making more beautiful the earth that is already rich in species of all kinds.

Entering a garden inspires a sense of beauty, but it also stimulates wonder at what humans have been able to draw forth from nature. The garden is the art of artificially producing a natural landscape in which we want to assemble all the beauties of Flora as conceived by a given culture or civilization. What dominates here is the dynamic relationship between the natural and the artificial. In the history of humankind, a great variety of gardens exists: Babylonian, Egyptian, Greek, Roman, medieval, Moorish, Renaissance, Baroque, geometric, English, Gothic, Japanese, Chinese, etc. We admire the harmonious symmetry of the Italian sixteenth-century gardens, the cult of the supernatural

and the disquieting presences in the Parco dei Mostri at Bomarzo, the architectural rigour of the French gardens of the seventeenth century, and the pleasure of the irregular designs of eighteenth-century English country gardens. From Buontalenti and Le Nôtre to Vignola and Brown, gardens reveal the spirit of the times in the same way that painting, literature, and architecture do. As a result, Louis XIV evokes the image of Versailles, Rousseau that of the poplars of Ermenonville, medieval Persia that of the flowery cloisters of its miniatures. By observing gardens, we come to perceive and understand the rituals, beliefs, and lives of peoples and epochs. In the utopia of Renaissance Italy, we find an ideal model of the garden in the *Hypnerotomachia Poliphili* (Poliphilo's Struggles for Love in a Dream, 1499).

A unique pleasure is aroused by the garden, which safeguards fundamental needs and rhythms, and stirs the most profound feelings of the human soul in the play of light, water, and plants, as Grimal (1954, Ital. trans. 1993, 17) has argued. Its charm, which originates in myth, is filled with religiosity and draws to it salutary forces. In the frescos at Knossos, an expression of pre-Hellenic culture, the king moves among irises. Later, the medieval garden is infused with mystical symbols. In the culture and literature of the period, the garden is the site of initiation and spiritual catharsis linked to an impression of delicateness and grace that arises from the site. We should also recall the cloister gardens, with their perfectly planned sacred space, and the philosophical-chivalrous gardens, places of enchantment and luxuriant vegetation. The latter is described in Chrétien De Troyes's *Erik and Enide* (c. 1170), in Alano di Lilla's *Anticlaudianus* (1182–83), and in Guillaume de Lorris' *Roman de la rose* (1282–83).

Belief in magic and religion gradually gave way to aesthetic and compositional factors, from the scenographic illusionism of the theatrical stage typical of the Baroque, to the sweeping panoramic vistas of landscape gardening, driven by a valorization of spontaneity in nature, which occurred in England, promoted by

Bacon (1625, Ital. trans. 1965) a century earlier. There are also theories related to French geometric design, such as those of Mollet (1652), Rapin (1665), and Désailler d'Argenville (1709); others tied to the picturesque, like those of Walpole (1771), Chambers (1772), and Repton (1803); not to mention those of Hirschfeld (1779–85) and Silva (1801). More recently, among the many technical treatises, we should mention those of Jekyll, Page, and Porcinai. Tommaseo (1857), in referring to the *art of the garden*, makes an observation that remains important for us. He states that the city and the countryside must be designed in such a way that each part corresponds to the whole, in equilibrium and harmony, so that the world stage might one day be a place of happiness for us.

Kant defines the garden as a kind of painting, as free play of the imagination. For him it is: "nothing else than the ornamentation of the soil with a variety of those things (grasses, flowers, shrubs, trees, even ponds, hillocks and dells) which nature presents to an observer, only arranged differently and in conformity with a certain idea" (1790, § 51, 167).

For other philosophers, such as Schlegel, the garden cannot be considered an art form *per se*, while Hegel thinks of it as an imperfect and hybrid art, an appendage of architecture. For Schleiermacher, instead, it is an autonomous art that has links both to painting and to architecture. Beginning in the 1800s, the garden loses its importance and finds itself relegated to the minor arts; and yet, the pleasure that is recognized as a fundamental part of life cannot be extinguished. We still live with the echo of powerful and lasting memories, namely, the perfection of the landscape in Alcinoö's garden in the *Odyssey* (Book VII, 114–31) and the Eden described by Milton in *Paradise Lost* (Book IV). According to Assunto, the garden is not a model of artistic mimesis but an ideal landscape: "Total concurrence of reality and the idea that is contemplated as the model of every real landscape: the beauty of real scenery that always resembles

the ideal garden-landscape that mythology and poetry have
placed at the origin of all landscapes – at the origin and at the
end of a final redemption of the earth" (1988, 43).

Let us not forget that human beings were born in a garden,
the womb of life.

2.5 URBAN LANDSCAPE

The city, too, is landscape. We can leave it by going into nature
(you will recall an earlier reference to the stroll of Socrates and
Phaedrus), exchanging the urban for the rural, but we can also
enter the city to live in it and contemplate its architectural forms.
All architecture is landscape-like and promotes an educational or
paedeumatic relationship between the environment and the hu-
man spirit. Our gaze and our body engage in a contemplation
that is between internal and external, between what is external
and distant, on the one hand, and what is internal and more inti-
mate that unfolds before our eyes, on the other. There is a close
relationship between the aesthetic experience of the natural envi-
ronment and that of the urban landscape. In the same way that
humankind lives on the earth so, too, it lives in the city.

Urban areas large and small might be the realization of Re-
naissance or modern utopias, but the city or metropolis, with its
squares, neighbourhoods, buildings, and monuments can be
disorienting and might inspire a whole host of impressions.
Balzac (*Ferragus,* 1833–35) describes Paris as the most delightful
of monsters. However, it matters little whether it is Fielding's
London, Baudelaire's Paris, D'Annunzio's Rome, Nietzsche's
Turin, Kafka's Prague, or Ruskin's Venice. We could also pro-
duce another, much longer list if we were to associate cities and
paintings. What should be stressed, though, is the attraction of
a place as a site in which to live, work, and experience pleasure.

From its origins, the city has been a principle on the basis of
which space is organized and represented in response to societal

criteria and ideals. Architectural and urban structures correspond either to the domain of culture or to the more abstract domains of philosophical thought. In *Gothic Architecture and Scholasticism* (1957), Panofsky shows us a formal analogy between the *summa theologica* of medieval scholasticism and the cathedrals: intelligible systems constructed with identical methods. Both are characterized, among other things, by the rigorous separation of the parts, by the explicit clarity of the formal hierarchies, and by a harmonization of opposites. In the Renaissance, geometry, perspective, and mathematical order harmonized with the emerging requirements of communication and the art of warfare. Irrespective of the geometric form, whether it be Filarete's star or Dürer's checkerboard, the ideal cities are secluded, enclosed spaces. Thereafter, open space prevails and the image is reconceived as a field of forces expressed as functions and the flow of forms.

Ancient, medieval, Renaissance, and Baroque cities provide the comfort of a human and ideal reality of urban and architectural forms in which we can place ourselves. They are a refuge from the devastating power of the new cities and their suburbs, which very often give us example of chaos. In the face of the modern misfortune, Assunto's suggestion or invitation is still valid: to flee from the city of Prometheus, which is founded on economism, productivism, and scientism, and to return to the shelter of the city of Amphion, where music and song accompany the rational act of building.

The beauty of cities that reclaim the values of the society that produced them is of a different kind. According to Romano (1993), the urban centre, like a biological organism, can undergo rapid, successive mutations as the result of the play of chaos and necessity, as the new biologists tell us.

Every century can produce a social movement that is destined to give a stable form to a long period that comes after it. The ancient city, with its temples and theatres, its squares and gymnasia, lasted a thousand years up to the Middles Ages, just as the

European city, from its beginnings in the eleventh century, has endured to the present day. However, as has occurred and continues to occur, the phenomena of continuous change alter models that appeared to be unchangeable.

To inhabit a city aesthetically means to understand the visible and structural characteristics of houses, public buildings, monuments, and squares. Rooms that open onto patios or onto the street, the horizontal or vertical extension of building projects, and the circulation network that connects avenues and squares, correspond to a dynamics founded on sensitivity and taste. In the distribution of masses and materials, there is a precise link to the spirit of storytelling that, from the very first graffiti, has been with humankind. We can consider the city to be a text made of stones, a graphic invention, a network of symbols and meanings with grammatical and syntactical elements for a rhetoric of space animated by many recurring features.

Ideal labyrinths open up, within which we can move for the pleasure of the aesthetic life. I am thinking of the importance of walks in the city and in the country. In the urban hybrids, there are no places that we can really call flower gardens, vegetable gardens, paths that can take us through open spaces as we admire the art of organizing rural or urban space. How many writers have paused to describe the pleasure of walking, which is today spoiled by the traffic or by the unaesthetic layout of places and streets! From ancient times, walking as we contemplate the landscape has been one of the highest expressions of taste. Philosophy, garden, city, and landscape are the roots of our civilization, and not only ours. To observe at the level of things and of our dynamic synaesthetic perception, in an analogical flow of the senses, transported as if by a natural rhythm, with no buildings that clash with the methods of construction that we have had for centuries (materials, colour, dimension), and no industrial sites or telephones lines to spoil the rhythm, is to rediscover our most profoundly human way of feeling.

As Le Goff has explained, the urban imaginary contains the marvellous, if we think of medieval or Renaissance cities. In this case, the imaginary is a complex of representations, ideas, and images through which an urban society paints for itself its own portrait. It is a figure with two faces: one is material, consisting of structures and aspects; the other is mental, consisting of artistic, literary, and intellectual representations. In the medieval vision, we have an urbanization of the image of Paradise. Bonvesin della Riva describes Milan, a city that had such an image.

3

The Sentimental Journey

In the recent history of the West, the question often arises as to what the journey means in the context culture and art, entwining as it does ancient and modern themes, memories of the past and present reality. Irrespective of destination, whether real (such as Rome, Naples, Sicily, Greece) or imaginary (such as Shangri-La, Lilliput, Aleph, Pallas), the journey has been an instrument of aesthetic exploration in the quest for the authentic and the pure, as opposed to the disfigured image of earth.

It can be said that all travellers are sentimentalists, including Goethe, despite his piece (1787) against sentimentalism and the vogue of the English garden. This applies more to travellers of the second half of the 1700s than to those of the first half, who were more descriptive. Sentimentality was a typical quality of the traveller, his inner source of strength, and it stimulated the search for the other and the elsewhere. It was a quality that also corresponded well with the figure of the *connoisseur* and the "amateur." The latter, who did not tolerate conventions, moved towards freedom but also towards arbitrariness, with the disadvantages, advantages, and risks that we can imagine. Like a

romantic traveller, the "amateur" lived by a kind of *Witz* or an original, carefree spirit, propelled by a spasmodic inspiration caused by the unfortunate clash between the enthusiasm of creativity and the desperate wretchedness of human life. This figure finds its way into various poetics of Romanticism, where it is viewed either favourably or unfavourably, from Goethe, Moritz, and Wackenroder to Schiller, Schlegel, and Jean-Paul. It permeates the climate of European aesthetic culture. During these years London hosted the respectable *Society of Dilettanti.*

Enthusiastic "amateurs," travellers therefore translate reality into feeling, sometimes in exaggerated form and at other times in appropriate balance with reason. An important element in the formation of the mentality of the gentleman, the *virtuoso,* according to Bacon (*Of Travel,* 1625), the journey has slowly become an aesthetic and spiritual itinerary in which a rich bouquet of romantic and, then, symbolist reflections flourishes.

In general, the literature of the Grand Tour comprises a description of facts and observations, an *ante litteram* travel guide, a psychological projection of states of mind and reflections inspired by the charm of the places visited. Travel diaries from the first half of the eighteenth century translate the models of an Enlightenment aesthetic that presupposes order and selection in the mind of the traveller in conformity with the principle of unity in variety, whereas those of the second half of the century emphasize the emotional, melancholy, or sentimental aspect. As Attilio Brilli (1995, 38–44) indicates, it is really Laurence Sterne who ushers in the vogue of the "sentimental traveller" with his *Sentimental Journey through Italy and France* (1768). Here, he composes a parody of travel literature and its conventions. The sensibility of the narrator and the subjective element, therefore, are emphasized beyond the norm of classical restraint. With Sterne's journal we have a transformation in emotion and feeling that breaks with the model of the first travel journal, which was rather pragmatic and detached. According to Brilli, the

sentimental traveller participates in the flow of accidental
events, the details of facts and things encountered, the pathos of
unfamiliar scenes, and he reintroduces this play of adventurous
fiction that is excluded from earlier journals. In this way, the
Enlightenment point of view is altered. Now, from Sterne to
Washington Irving of *Tales of a Traveller* (1822) "we are travel-
ling into human nature" (59). Sterne, in fact, shifts the attention
from the external, that is, the panorama of usages and customs,
to the internal, by projecting emotion, spirit, and melancholy
onto the world. Brilli goes on to point out that, as a result of
these modifications in the storytelling attitude, we see the inner
fragmentation of the individual, an overlapping of states of
mind. Consequently, the anecdote, the vignette, and the chance
encounter evoke pathos and irony. From 1770 onward, this new
dimension of the sentimental, "amiable humourist" establishes
a product of high literary value, initiated by Addison and
Richardson, and continued by Austen.

During this century nature is tamed, including its wildest
parts. As stated above, the landscape harmonizes with the moods
of the travellers. At the same time, a new relationship is estab-
lished between people and nature through the reformulation of
the concept of the sublime and the development of the pictur-
esque. It is an entirely new charm in relation to the idea of a
beautiful nature, which is to say, nature perfected by the fine arts
for the purpose of utility and pleasure according to which imita-
tion does not involve nature itself, but nature as it can be imag-
ined by the human spirit. The image thus created is not the
graceful form of gardens, but the product of a selection of char-
acteristics taken from nature and perceived henceforth as though
they were nature itself. Even the picturesque representation of
desolate, melancholy views of the Roman countryside or dra-
matic scenes of waterfalls, volcanoes, or ruins changes, fusing as
it does with new descriptive elements. The landscape is revealed,
instead, in painting and literature through a variety of effects and

tones that determine the emergence of a new "romantic" sensibility. Travellers feel themselves attracted by the local, historic, ethnic, and artistic particularities of different countries. From this comes the intention to present a heterogeneous range of psychological reactions, sketches, and descriptions.

Numerous places have been described or painted: Italy, Greece, France, Spain, the Rhine region, Scotland, Ireland, and the new continents. It is a vogue that changes with the epochs and the generations. First it is Italy; then the taste for travel slowly comes to prefer other destinations. There is, subsequently, the discovery of underground landscapes, such as those of Jules Verne, then aerial views, such as those of Saint-Exupéry. Places present themselves to us from multiple points of view. The traveller is an "amateur," a *connoisseur,* who practises drawing, watercolour, and more recently photography, with the pleasure derived from capturing the spirit of the place.

The feeling for the landscape is, generally speaking, the expression of affect united by a common and participatory emotion. Through the act of contemplation, feeling makes the object correspond to the imagination, without interposing intellectual or affective mediation. We might think of it as a direct impression or as a miraculous manifestation of the object projected towards the subject, whereby the two become one. It is an attraction, an absorption into which the observer sinks, a grace that conceals sites chosen by the mind or the heart, and the result of the amalgamation of external and internal images. It makes no difference whether it is the garden of Tasso's Armida, Milton's Eden, Pope's grotto, Staubbach Falls, which were so dear to Goethe and others. The landscape and the imagination develop together, like enthusiastic and generous friends. This is why we are able to understand the language of the trees and of the water, which conveys the sweet or dramatic sound of time. This is because we are swept away by a pleasure that comes from the "natural magic of the imagination," to use a phrase by Jean-Paul, a magic that resonates

in Coleridge, where he states that he prefers the mind's eye to the picturesque eye. The feeling for the landscape changes, beginning with Girardin's revolution in painting and Hirschfeld's balanced, sentimental garden, and reaching the depths of human sentiment. We see the development of the romantic with its tormented, surprising, unusual, and subtle forms comprising cliffs, waterfalls, secluded spots, and deserts.

The traveller cannot escape the charm of the place and prefigures the relativism of taste. He or she feels like Palladio in Venice, Winkelman in Rome, and Goethe in the cities of the Rhine valley. But it is Rome that captures everyone's attention; it is the homeland of choice. Following Luther's visit in 1510, Rome was no longer so much the *Civitas Dei* (City of God), as the place that fuses nature and history, antiquity and culture. As De Seta tells us, the traveller interested in the morphology of the site and in its legends, customs, and art replaces the figure of the pilgrim. Madame de Staël's *Corinne* (Book IV) attests to this affection; it is a romantic interpretation of Rome that is destined to become an aesthetic breviary for many travellers in the first half of the nineteenth century.

In terms of the places, evaluations may vary or even contradict one another; all these appraisals, however, have a common theoretical assumption. The praise of Inigo Jones and Goethe for Palladian architecture is not shared by Ruskin, who is hostile to it. Benjamin Constant's negative assessment of the Würzburg residence does not establish a valid criterion for the rejection of the Baroque. The observations of De Brosse on the mosaics in the cupola of St Mark's cathedral in Venice and those in the Baptistery in Florence are not unanimously accepted. All of this is part of the evaluation of taste, which varies with the individual.

The landscape cannot be separated from archaeology, from which a special aura emanates. Consider the monuments scattered in the countryside, especially the immense patrimony of antiquities and the natural beauty to be found between Rome

and Brindisi, a 560-kilometre stretch of land that tells a two-thousand-year story. Everywhere in Italy we discover large or small itineraries of places that, in part, were stages of the Grand Tour taken by intellectuals. However, following this rapid review, which elicits countless memories, I would like to pause to mention at least one site that appears to epitomize the meaning of the discovery of the landscape through the voyage.

Mario Praz (1975, 283–93) reminds us that this discovery occurred in the 1600s, between Rome and what were then its environs. This symbolic and unique place contains many others, as you can understand. It is the Pussino valley beyond the Milvian Bridge, near Acquatraversa, the equivalent of the Serpentera wood at Olevano Romano, or the hill at Recanati in Leopardi's poem "L'infinito." He writes that this small parcel of land is the cradle of the modern landscape. The entire countryside around Rome deserves that honour, but it is here that tradition chose to celebrate the discovery of the landscape as art. Praz explains that it took centuries for painters to come to understand that the landscape not only served as a backdrop for a spectacle, but that it could itself be the spectacle. At a certain point, the landscape ceases to be something added to the human figure; rather, it is the human being that becomes an emanation of the landscape. This is the revolution in visual art that is born in the painting of the first half of the seventeenth century. It is precisely between Rome and its environs that we find ruins, grottos, temples, and waterfalls, which have become today idealized in painting. In that period of transition from Mannerism to Baroque, a cascade could elicit as much interest as a temple. With the aesthetic effect of their fragmented compositions, ruins served as platforms to justify paintings of autonomous landscapes. In Rome, Praz goes on to say, they discovered that the unity of a landscape did not consist of the most panoramic view possible, as was the case in the work of Joachim Patinir (c. 1485–1524) or in that of the Flemish painters; rather, unity was to be found in an architectural

concept, in relation to which even a small portion of the land-scape could become a self-sufficient and necessary whole. The ruins of Rome, the picturesque spots, the waterfalls of Tivoli, and the grottos contributed to this discovery as much as the country-side with the effect produced by its precise yet soft lines. This is a countryside that excited François René de Chateaubriand who, in a letter from 1804 to Fontanes, speaks of the beauty of the ho-rizon, from the softness of the plains to the gentle contours of the mountains, the play of water and land, the light, and the colours. He says that the light of Rome is the light in a Lorrain painting. In a letter to Goethe from the same year, Humboldt describes the difference between this place and his own land. While here all is calm and serenity that fills the individual with clarity of mind and a sense of objectivity, his homeland promotes emotionalism, makes people withdraw into themselves, makes them restless and melancholy, in other words, "sentimental." These remarks pro-vide us with two illustrations of the sentimental status of the landscape and affirm its variety. Praz goes on to recall Annibale Carracci's Mary Magdalene, in a desolate landscape in the Lazio region that becomes itself the protagonist in the sense that it ex-presses and sublimates the state of mind of the penitent. He evokes this image while thinking of the notion of the landscape as a state of mind, which had a profound influence on the aes-thetic culture of the period as well as the one that followed. We encounter this idea a quarter of a century later in Milton's *L'alle-gro* and *Il penseroso* (1632), where the line of the horizon, the slopes of the hills, and the treetops become "sentiments." But its highest achievement is to be found in Poussin's *Landscape with Saint Matthew* (c. 1643–44). The setting is the Pussino valley, mentioned earlier, also known as Acqua Acetosa.

It is here that we encounter the spirit of the place, its ideal im-age, with an obsessive valence, even though it is free of the aura of classicism and is not yet disturbed by the fear of the sublime, as reformulated by Burke. The landscape was felt to be populated by

divine presences and plunged into an illusion, in any case grandiose, of eternity and heroic exaltation. Poussin, Lorrain, and Joachim von Sandrart devoted themselves to its discovery.

In the first decade of the seventeenth century, Adam Elsheimer (1578–1610), with his *Aurora*, had preceded these artists, contemplating something out of the ordinary in the crystalline air of Rome and in a sky devoid of allegorical associations, rather than in the earthly spectacle. He taught us to observe the sky through the filter of profound feeling and intimate participation. From this lesson originates a trajectory followed by many artists between the eighteenth and the nineteenth century. Lorrain follows this same line of development, adding the lesson of Poussin, who admired nature. He is responsible for this elevation of the countryside to the level of the sublime by means of more idyllic tones and he fills with a magical light the landscapes of Carracci and Domenichino. As Praz tells us, we are captured by particles of golden, paradisal light, a light that invites us to dreams and to a sweet melancholy. It is an affective point of departure for Turner when he seeks to immerse his forms in an auroral clarity. Praz invites us to reflect on the art itself of the landscape, not so much to underscore the pictorial revolution of modern feeling as to advance an aesthetic theory.

From the disaster of places produced in the last century, mutilated, disrupted tracts of land remain, as though stricken by the devastating intervention. Myth is buried and degraded. Like migratory peoples in search of new homelands, we too, sentimental travellers ourselves, feel compelled to move before the advancing horror. We move several kilometres, sometimes only a few, to find the peace or the miracle of that primordial place.

3.2 VIEW PAINTERS AND TRAVELLERS

Those who take solitary walks for the pleasure of contemplating the nature around them find themselves immersed in one of

Rousseau's reflections. In his "Seventh Walk" (1782) in *Reveries of the Solitary Walker*, the philosopher from Geneva writes: "The more sensitive the soul of the observer, the greater the ecstasy aroused in him by this harmony. At such times his senses are possessed by a deep and delightful reverie, and in a state of blissful self-abandonment he loses himself in the immensity of this beautiful order, with which he feels himself at one. All individual objects escape him; he sees and feels nothing but the unity of all things" (108). As they move from place to place, our wanderers lose themselves in the view of the landscape, rather than search for it in the pathways along mountain slopes and in their own passionate gazes that disturb a calm reverie.

Within the domain of taste, the mobility of the subject entails changes in perception and in the aesthetic appreciation of the surroundings. As William Gilpin reminds us in his various travel notes, the discovery of nature begins with descriptions that change as the observer climbs, descends, goes on foot, or on horseback, or rides in a carriage. This is a mobility that multiplies the "effects" of viewpoint. The scene also changes even independently of the spectator in concert with the mist, the fog, the heaviness or thinness of the atmosphere, the colours of the sky, the light of the sun and the moon, etc. In this way, the traveller's mobile gaze, just like the change in atmospheric conditions, ensures that a detailed observation of animals and the land (mountains, cliffs, rivers, hills, woodlands, paths, houses, barns) coincides with forms, colours, and categories. Moreover, the relationship between light and shadow is analyzed as a function of emotions and passions. We are drawn to these conclusions by the watercolours and sketches of travellers who, to their literary transcriptions of their impressions, added the product of their technical and pictorial talents, to which they dedicated themselves to immerse themselves fully in the beauty of nature and to capture it more intimately.

According to Gilpin, the eye of the picturesque observer turns away from both industrial sites and orderly, cultivated fields, or manicured gardens. The eye of such a spectator prefers, instead, natural as opposed to artificial vistas. Eighteenth-century travellers on the Grand Tour (let us not forget Italy's own Verri, Baretti, Angiolini, Martinelli, Della Torre Rezzonico, De' Giorgi Bertòla) were picturesque travellers, but those described by Gilpin, who never visited Italy, have a completely local taste. He travelled to England, Wales, and Scotland. Gilpin's example is valuable as an initial aesthetic exploration of the landscape, in the same way that those of Rousseau, Price, Knight, and many others are.

In the encounter of the physical eye with the mental image, with the potential adaptation of the landscape to the artistic ideal, we discover the pleasures of the traveller endowed with a picturesque taste or overcome by sublime vertigo. Between the 1700s and 1800s, in the various writings on landscape painting or on natural beauties, the observer and the artist are placed on the same plane and there is a tendency to demonstrate that a correspondence exists between the "character" of the place and the state of contemplation of the visitor who, under the power of strong impressions, writes, annotates, and sketches. In short, from the viewpoint of the first aristocratic tourist, to observe nature also meant to capture its image in sketches and water-colours, to describe it in a journal or letter, or to conjure it up in our minds.

Visual experience and the literary text have been two sides of the same coin, as De Seta (1999) affirms, while he analyzes both the images of the view painter and the traveller, the landscape painter and the observer of landscapes. These testimonials, spanning three centuries, can be reduced to a network upheld by this bipolarity between visual images and verbal images. The experience of travellers may be read as the founding principle of

a history of European consciousness in which literary forms meld with iconographic forms. Among the many examples, of particular note are the travel diaries of Gilpin with their descriptions and watercolour illustrations, Goethe's *Italian Journey*, where sketches and watercolours accompany the letters, and Karl Friedrich Schinkel's *Journey to Italy*, comprising notes and watercolours. As De Seta explains, a high degree of syncretism was involved. In general, pen and paintbrush together became the instruments with which to make understood the imaginary or the fantastic, which becomes real the moment it is painted or narrated. In this way, real experience comes into close contact with artist forms. The tradition of the journey, as an artistic legacy of human understanding and knowledge, comes to a close in the last century with the advent of mass tourism.

Between the second half of the sixteenth century and the beginning of the seventeenth, the practice of travelling slowly became an institution for the formation of the ruling classes of England. The French, the Dutch, Germans, Swedes, and others from all the countries of Europe joined the English. An ever-increasing number of tourists arrived in Italy with each passing decade. De Seta informs us that, during the Enlightenment, "tourists" constituted an itinerant academy unprecedented in Western civilization, dedicated to the study not only of the classics and of antiquity in general but also of different worlds. At the same time, a common European sentiment was born, already noted by Montaigne and then underscored by Doctor Johnson, a feeling that takes shape despite religious conflicts. Initially, the focal point was Rome; then attention shifted to Naples, Herculaneum, Pompeii, Paestum, and Sicily. The ancient, the exotic, and the folkloric made up the spectrum of aesthetic pleasures. All travellers to Italy saw their trip as the evocation of a myth that blended the memory of the classics, Latin poets, and legends with the images of the Roman ruins that painters such as Piranesi had provided. Intellectuals and

painters saw the journey itself as a myth. Travellers and view painters experienced a common emotional response to the landscapes visited. They included De Brosses, Addison, Berkeley, Gibbon, Knight, Goethe, I. Jones, Poussin, Lorrain, Robert, Fragonard, T. Jones, Wright of Derby, Ducros, Hoüel, Hackert, and Corot.

History begins anew, without the dramas of past wars, but with a sense of discovery and nostalgia, in a sentimental periodization or an imaginary reconstruction. De Seta writes:

> We can say that conquerors have never found themselves conquered as in this case: an old notion that recalls the words uttered by the emperor Hadrian when he arrived in Athens. In the modern age, the cities of Rome, Venice, Florence, and Naples assume the role that the city of Pericles or Phidias played for the divine Hadrian, which is to say, a multiplicity of splendours that have their enthusiasts who are sometimes severe or even scornful, but in any case always passionate and able to give to the landscape and to cultures distinct identities. (Ibid., 18)

The Grand Tour represents an essential component of the transformation in the taste of the countries of origin: the seascapes of Vernet, the Coliseum of Cozens, the Tivoli cataracts of Fragonard, the Roman ruins of Hubert Robert, the Vesuvius eruptions of Pierre-Jacques Volaire, or Joseph Wright of Derby, Hackert's Lake Nemi, and many other sites that comprise the image of the *Bel Paese* (Italy) in the European imagination. Such view painters as Van Wittel, Panini, Piranesi, Carlevàrijs, Canaletto, Bellotto, and Guardi give us a new vision of the world. The term Grand Tour appeared in the lexicon of travel literature with Lassels' *An Italian Voyage* or *Compleat Journey through Italy* (1697), and declined in use after the Napoleonic wars, when attention shifted to other Mediterranean countries and other continents.

For instance, there are the "picturesque" travels to India by Hodges as well as by the Daniell brothers, whose journals were published between the end of the 1700s and the early 1800s, as well as the "geographic" explorations of Humboldt.

I have been discussing view painters, but it is also important to remember the visionaries who facilitated the transition from picturesque scenes to romantic descriptions. Brilli (1995) explains that, among these, the figure of William Beckford stands out for his ability to combine the picturesque ideal of Gilpin with an exaggerated sensibility that anticipates romantic aesthetic principles. His *Dreams*, printed in 1783, but not published until 1834 under a different title, outlines methods of description that are related to vision. These are a parody of travel literature and a transposition of picturesque taste that extends to Lady Morgan, to the Italian journals of Samuel Palmer, and to certain writings of Ruskin. Brilli (49) explains that, beyond the deliria of the imagination, what remains fundamental is the adherence to a sort of visual imagination and a compositional skill that makes every scene and every detail appear to be frozen in a pause or perspective of picturesque taste. In this, we find what De Seta has noted, that is, the correspondence between verbal images and visual images. In the case of Beckford, Brilli adds, the analogy we find there between descriptive prose, picturesque scene, and chromatic sensibility derives from the lessons in watercolour learned from Cozens, thereby inaugurating a romantic literary current that, through Turner, expands to include Ruskin. Beckford does not overlook the taste for the coarse, the irregular, and the intricate, but he does so in favour of linking together emotional suggestiveness and description, in the process going beyond both the optical effects produced by the so-called Claude (Lorrain) glass and the neoclassical canons. This is a romantic dynamic, in the style of Wordsworth, as Brilli (50) defines it. In William Beckford's journal, the description of an Alpine crag crystallizes his ideas and style, offering us oeneric

but powerful images in the tradition of Salvator Rosa. Only Beckford, the author of *Vathek* (1786), can give us such a depiction. We find there waters crashing against jagged rocks, a golden glow of twilight through foliage, and a suggestion of serenity: the illusion of another, cheerier world, the conquered darkness of these retreats among terrifying mountains.

The picturesque traveller is gradually transformed into a romantic traveller interested in delving into the memory of the place, its mythology, recalling remote epochs and civilizations. The romantic traveller abandons the search for the picturesque to arrive at the enchantment and dramatic dimension of the imagination.

From the discovery of places, initiated by Mannerism and continued into Romanticism and Impressionism, we learn that all of our feelings are echoed by, find a correspondence to, or are mirrored in, the spectacle of nature. Through an endless play of forms, lights, and colours, those of earth and the sky, amid the splendours of dawn and dusk, painting depicts the true value of an aesthetic sentiment that we all share, something inextinguishable and eternal.

3.3 THE SURPRISE OF THE MOBILE GAZE

Bernard of Clairvaux (*Letter* 106) observed that we would find more in woodlands than in books because the trees and rocks teach us things that no teacher can. This is a useful idea, not only for the study of nature but also for aesthetic education. The invitation to learn from nature is implicitly an invitation to contemplate it so that, once we have uncovered the laws regulating its forms, we may penetrate the miracle of its beauty. This is truly a living miracle of things and of transformations that unfolds before us almost unexpectedly. To search for and uncover the characteristics of the landscape in its very essence, however, requires the exercise of a gaze trained to perceive and to differentiate. This activity calls for dedication and love, in which

melancholy and nostalgia blend, as we can plainly see in many scholars and philosophers, particularly in the 1700s; and it is especially true for Rousseau, who rightly recommended that we observe and contemplate. Let us learn to love nature, to seek it out, to study it, to know it, and to admire its beauty, he urged (Rousseau, 1781, Ital. trans. 1994, 165). Nature endows its forms with elegance for the "delight of the eyes and the wonder of the imagination." The botanist admires in ecstasy this divine art and "the walk is his only task."

The pleasure of ecstatic observation, to which Rousseau refers, stems from the surprise of a mobile gaze and from the quality of observing objects close up or from a distance, which is achieved by turning the head or by moving. Walking, but also drifting in a boat over water, is an instrument of the enthralled gaze.

From this, we can understand the impulse to flee the city and its convulsive rhythms, its constantly shifting and confusing images. As we read, by way of example, in Schelling's *Clara* (written between 1810 and 1811), the city rejects nature; it is not capable of eliciting in human beings the effect, the joy of genuine emotion, which is produced, instead, by the simplicity and richness of the countrside. From the second half of the 1700s, we find a desire to flee to pursue the ideal of a self-regulating and uncontaminated nature. In *Walking* (Thoreau, 1851, Ital. trans. 1989, 60), Henry David Thoreau recalls an extraordinary sunset. He is walking in a field near the source of a small stream when the sun, a moment before setting after a cold and gray day, acquires an unusual transparency on the horizon and the sweetest, clearest light covers the dry grasses, the tree trunks, and the leaves of the oak trees on the hill. At the same time, the shadows of people walking lengthen eastward on the ground, as though they were the only things untouched by the rays of sunlight. Imagining such a light an instant earlier would have been inconceivable, says Thoreau; and the air was so warm and

serene that everything converged to make that field a paradise. Here we have a good example of the way in which, through the movement of the gaze and of the human body, a phenomenon can, unexpectedly, arouse astonishment in us.

The psychological time required to perceive the things around us, therefore, is tied to variations in the movement through which different angles of observation emerge together with different kinds of synaesthetic pleasure. Movement affirms corporeal experience; it involves other senses – hearing, smell, and touch – not only sight. A continuous play of sensory and cognitive experiences develops in time and space. Walking, swimming, horseback riding, boating, cycling, and flying are ways of experiencing the landscape aesthetically. The forms around us configure themselves in sequences endowed with a variety of rhythms. As we can experience directly, and as depicted in paintings and in other art forms, the landscape changes its appearance in the same way that a song does. We experience a surprise of sight and sensation in such activities as a solitary walk or an airplane ride. This effect is caused by the kind of movement we perform as well as by other factors that are independent of us, such as variation in the weather and the seasons, but also by variations in light, colour, wind, and temperature, or changes tied to cataclysmic natural events (volcanic eruptions, hurricanes, earthquakes).

The birth of a modern aesthetic of the landscape is to be found in certain motifs in *landscape gardening* and in the theory of picturesque taste, but certainly not in Baroque exaggeration of these motifs, the sentimentalism of ruins, the pleasure of catastrophism, the ambiguity of *improvement*, or the trends toward mannerist affectation and superficial or fantastic ornamentation. Rather, it originates in the sensibility that those discussions on what to do, how to shape and observe the landscape developed along the controversial path taken by eighteenth-century taste and that of subsequent centuries. In terms of the object of

the seeing and all that is associated with it (views, belvederes, panoramas, techniques of perception, etc.), we discover point of view as the basis from which to capture the beauty of nature in its variations, once we have abandoned the strictly historical context of the picturesque eye and have selected instead that of the internal, let us say Romantic, eye as an unquestioned instrument of aesthetic evaluation of the environment. As stated several times already, the viewpoint, in its optical specialization, brings about a new way of seeing; however, the angle of observation must be considered as only one of the primary aspects of the aesthetic of the landscape. If we reflect on the past, on the origins of our contemplation, on mythology, and on the theory of the cosmos, we find that such a gaze has existed for quite some time, even without technical inventions (belvederes, etc.). Antiquity offers us models, invites us to meditate on the value of memory, and helps us to project our future.

In Europe, in the last few decades, the countryside and the city have come to occupy a mixed, hybrid space without a *soul,* the soul that they have always had. It is the end of the identity of places, which are the same everywhere, from Europe to North America, from to Africa to the Orient. Amid degradation, indifference, and uniformity of style, the rejection of beauty has established itself, the beauty that consists of material culture, of human work, which was for centuries based on the symbolic, visual, and technical recognition of the landscape in a convergence of ethics and aesthetics.

Ancient beauties were not merely expressions of art and philosophy. To lose the memory of a place is to lose the memory of beauty that is consubstantial with the spirit of the land. A different organization of space, a structural rethinking of work in the countryside, but also the use of limits as a way of resisting the current uniformity of places, could be one possible solution. It is urgently important to imagine a virtual map of the memory of this beauty and not simply to provide literary guides to cities

and towns, so the feeling for the landscape, in its various forms and cultural and artistic connections, will not die. In this context, the gaze is not excluded, but it is more metaphorical and becomes the interpreter of origins.

I have already spoken about the importance of taking walks in the city and in the country. In the urban hybrids, places that can be called flower gardens or vegetable gardens, with paths that we may take to admire the art of rural space, urban space, and the like, are becoming more and more rare. So many writers have described this pleasure of taking strolls, a pleasure that is now deadened by traffic and by the unattractive layout of places and streets. To walk contemplating the landscape has been one of the highest expressions of the aesthetic life since ancient times. Philosophy, the garden, the city, and the landscape are the points of origin of our civilization, and not only our Western civilization.

As it is not disconnected from memory, the gaze is not separate from the location of artworks. We cannot consider moving all artworks from their original sites to shut them up in museums, thereby betraying their meaning and function. Piero della Francesca's *Madonna del Parto* in Monterchi, for example, is surprising, linking as it does landscape and art. The Madonna was kept in a small country church and should be returned to that site. The artwork and the landscape form a world in which we are immersed and in which we move through our gaze. To accept the erasure of that relationship is to opt for aesthetic mutilation.

The point of view is an instrument with which to qualify an object; it is an extremely refined instrument for contemplation and theorization: it selects, excludes, brings closer, distances, compares its object to the cultural models that construct both the self and all that exists. With their movement, human beings weave relationships through a strategic organization of perceptual data. The image of valleys, mountains, woods, cultivated fields, architectural monuments, etc., prepares us for a perception of the land that is at once universal and particular, allowing

us to understand in synchrony with fields of vision that change. Pasolini was well aware of this, since he was a defender of the aesthetic valorization of the landscape, which excludes the hybrid and anonymous character of new cities, as they are unable to convey the basic quality of communal living. Pasolini, whose artist's eye was trained to see reality through the lens of a camera, stated in a television interview in 1974: "There is, in the image of the modern city, a feeling of irritation, pain, humiliation, and anger brought about by the profound disruption of form and style." He added that producers of historical films, like him, sense the contemporary horror of the decline of our civilization and of our sensibility. Looking closely at the city of Orte, the movie director considered the incompatibility of modern buildings that have no relationship with things that time has laid down and represented: mediocre houses designed without imagination. This is the situation throughout the world as the new disfigures the historical architectural patrimony. Pasolini leaves a message for us: we have the responsibility to protect the relationship between the city and the landscape by preserving both the form of the city and the beauty of nature. In Pasolini's view, the situation in Italy had been catastrophic and irreversible for many years already.

The surprise of the mobile gaze guides us through spaces. It is the dance of our perceptions and emotions that encounter the forms of the things in which perceptions, feelings, and objects appear, come to life, and change together.

3.4 MODALITIES AND INSTRUMENTS OF AESTHETIC PLEASURE

Over the last three centuries, techniques of observation have been developed with which a number of poetics can be equated. Trained by the development of painting (*vedutismo*, landscape painting), photography, and cinema, our eyes integrate these

ways of presenting and representing the landscape as an aesthetic object. As we know, this is a modern version of an ancient outlook.

Following the fashion of the Grand Tour in the early 1700s, young English gentlemen were affected by ruins, whose dignity appeared wrapped in an unsettling atmosphere. Driven by an excited imagination, they gathered in their minds these relics, like *connoisseurs*. They framed their objects (ruins, rocky arches, mountain vistas, stormy seas, etc.), organizing images charged with feeling, developing the chosen composition, a particular angle of observation, the way a painter does; they used the concept of the window or picture frame to highlight the object. This was one way of aesthetically enlivening monuments or those fragments of nature isolated within a great catalogue, a sort of reliquary of aesthetic pleasure. Framing was also a technique for evoking them nostalgically. After these figures, all "amateur" travellers would follow this example of aesthetic taste. The compositional principle used was related to painting techniques and was eventually transmitted to photography and cinema. These gentlemen, however, reflected and brought to bear their formal study of painting. There is no question that the great landscape paintings of the seventeenth century were in their hearts and perhaps acted on them subconsciously, but they were also affected by the invention of the window as an instrument through which to observe, especially as it was deployed by the Flemish masters. Placed within a painting, which itself can be thought of as sort of window on the world, the window, in a sort of double effect, invites us to enter naturally into the landscape, breaking down the three-dimensional image of traditional perspective. This (along with the mirror) is an important discovery by the Flemish school, even if is not entirely clear that it transformed the "land" into landscape, as Alain Roger claims. This is a device used to isolate parts of the world around us and, at the same time, to increase their aesthetic value. Eighteenth-century "amateurs" transferred

this optical strategy from the domain of painting to that of the aesthetic life, making it curious and sentimental. The window on the landscape (its borders and cross-pieces that sometimes divide the space depicted) becomes almost a stereotype of romantic painting and is present later in many literary descriptions.

The motif of the frame and the window implies a *veduta* or view, which is to say, the reproduction of an aspect of the natural world. The *veduta* is a motif that refers to the depiction of a place by means of perspectival composition, which is the instrument through which reality is understood and transposed, by the workings of human reason, to that depiction. Although *vedutismo* or view painting has varied in the course of its development, the *veduta* itself remained grounded in the same definition across almost four centuries: "the mental image of an external reality that is unknowable and perceived through the necessity of rational laws" (Stefano Susinno, 1974, 5–6). This definition does not always make a clear distinction between view painters and landscape painters or between view painting, which is associated largely with the 1700s, and landscape painting, which pertains more directly to universal themes of a nature that is more or less untamed. In fact, alongside the better known Van Wittel, Panini, Piranesi, Marieschi, Canaletto, Bellotto, and Guardi, the first English travellers to Italy are view painters at heart, as are de Saint-Non, Houël, Hackert, Knight, Vivant Denon, Goethe, Schinkel, and many others who came after them. It is the sentimental journey that brings with it this fascination for *vedute*. The whole of reality becomes organized as an immense repertoire of antiquarian taste.

These concepts constitute a way of defining, perceiving, and arranging the landscape. In the English garden of the mid-1700s, we find not so much, or not only, the integration of ruins or the installation of artificial ruins, but the affirmation of the aesthetic dimension of the *veduta*. Humphry Repton, who succeeded Lancelot Brown, designed Rievaulx Terrace (1758) in

Yorkshire for Duncan III, with the aim of laying out a rural es-
tate not by incorporating ruins but by building a grassy terrace
from which to view what remains of Rievaulx Abbey, a twelfth-
century monastery. It is a "panoramic vista."

In this case, the *veduta* is transformed architecturally into a
belvedere. It provides a pleasant panorama from an elevated
point, a building, or a terrace. The Belvedere Courtyard in the
Vatican Palaces complex, designed by Bramante between 1503
and 1504, is a famous example. However, even before that date,
in Europe as well as in other places, Yemen for example, it ap-
pears that rooms on the upper levels of buildings were used to
provide the pleasure of just such a view. Especially in the Italian
villa and garden, comprising observation points, wings, and
backdrops, the belvedere allows the eye to take in the entire
scene at a single glance. A rigorous balance between the natural
and the architectural, the "organic" and the "abstract," is
achieved by Palladio, whose villas, with their colonnade arms
and pranoi-belvederes, exhibit a rhythmical opening up of the
visual field that tends to replicate nature itself. Whereas in the
English garden the panoramic view is part of a whole that does
not preclude the discovery of ancient trees, woodlands, fields,
pergolas, ruins, or a Chinese pagoda, here the walk is continu-
ally punctuated by surprises in a play of the imagination.

In picturesque tourism and in the English landscape garden,
we find a paradox, which Andrews has pointed out: on the one
hand, nature untouched by human hands is celebrated, and, on
the other hand, there is a tendency to "embellish" (improve) the
appearance of these newly discovered, untamed sites. The para-
dox also helps us to understand that the transformation of the
countryside in a manner corresponding to the idylls of Theocri-
tus and the eclogues of Virgil is clearly an exaggeration. Ancient
mythology is filtered through the imagination, the Claude glass,
and the architecture of the land. Pastoral poetry, which is typical
of the period, fuses with the taste in vogue, converting rural

simplicity or harsh wilderness into artificial adornment. Refer-
ring to Hanway's journey into the Scottish Highlands (1775),
Andrews (1989) says that the only thing missing for him to
imagine himself in Arcadia is an Aminta figure.

The idealization of pastoral scenes in Pope, Phillips, Gay,
Goldsmith, and many others after them, inspires a sense of
peace, calm, and innocence by combining nostalgic and utopian
feeling. In such a cultural context, poetry and painting reverber-
ate against each other like strings, architectural gardens flourish,
and a taste for visual texture establishes itself. The aesthetic dis-
covery of nature becomes distinct from the models of classical
revival, even though the old principle of *concordia discors* (har-
mony in discord), adopted by Pope, does not disappear. This is
a dynamic principle of controlled tensions, a delightful play of
contrasts and analogies. To illustrate the variety of attitudes that
are either inspired by classicism or deviate from it, we need to
consider James Thomson's *Spring* (1730) in which we find the
description of a view of the property of George Lyttleton at
Hagley, in Worcester. Thomson calls it "British Tempè" in hon-
our of the ancient Greek ideal locus of rural beauty. In so doing,
Thomson pursues the Arcadian dream of a Parnassus on the
Thames, to which he adds a picturesque spirit.

In addition to the *veduta* and the belvedere, we must include
among the modalities and instruments of aesthetic pleasure, tech-
nical elements that bring the view closer to a vision or a dream,
even though the objective is absolutely realistic, to offer the true
spectacle of nature: the panorama and the diorama. This involves
"fantastic" anamorphosis, that is to say, the distortion of the vi-
sion by means of optical instruments. The result is a simulacrum,
something between reality and illusion, as Milner explains it.
While landscape painters create before our eyes a concrete world
through which they communicate to us the pleasure, and some-
times the pain, they experience in inhabiting that world, optical
instruments and their electromagnetic equivalents take us into a

world of simulacra, which are ever expanding with no apparent limits, but with the risk that our contemplation is manipulated and our identity altered. At a certain point in history, the expansion of the city demands a different design when we consider the multiple points of view that are created. Accompanied by Chantelou on the hills of Meudon, Bernini in 1665 makes the point that Paris seems to be "a mass of chimneys" that lacks a harmonious interlacing of voids and solids. It is from these years onward that the vogue for the *veduta* and the belvedere, which probably also implies a transformation of the city and the country by taking into account these viewpoints, becomes more widespread.

The *panorama* is the production of a synthetic, complete image of the city, which becomes more common toward the end of the eighteenth century. This is a spectacular representational technique, a veritable revolving stage for the eye. The spectator is placed on a platform surrounded by a vast cylinder on which landscapes are painted, scenes reproduced in their minutest detail to create the illusion of reality. One of the first and most important painters is R. Baker, with his panoramas of Edinburgh, Paris, London, and many other European cities. The most striking feature of his panorama is the elevated viewpoint and the vastness of the vista. He often felt the urge to see the city by climbing to the top of a bell tower in the main square. The desire to find the highest possible spot from which to enjoy a beautiful view was already in the soul of visitors at that time. The panorama fulfills this desire, both technically and artificially. By extension, it has come to designate a particularly vast landscape, requiring an elevated viewpoint.

The *diorama* was invented by Daguerre, together with Bouton. It consists of several large, painted, transparent canvasses hung vertically and placed at different distances. When illuminated appropriately by light projected from sources hidden from the spectator, the canvasses create the illusion of a landscape seen from a particular perspective.

Daguerre sought to achieve a degree of imitation of nature never before attained through the techniques of traditional painting. In *La Vallée de Sarnen*, the viewer, if we accept Dubbini's account, could see a valley slipping into darkness during a sudden storm, and the surface of a lake reflecting the darkening sun and the advancing shadows as, in the distance, on the mountain tops the snow becomes more luminous against a black sky.

The wonder of optical illusion reinforces or clashes with, depending on the circumstances, the wonder of the aesthetic perception of nature.

3.5 EXPLORATIONS AND PILGRIMAGES

Throughout history, beauty has been described in all its varieties by explorers and pilgrims, though with two different aims: one scientific and the other religious. Their travel notes and accounts also communicate the taste for adventure, the adventure of a particular aesthetic perception.

As a devotional practice that involves visiting a shrine or a sacred place to perform a ritual there, the pilgrimage is a means of observing unfamiliar lands and people, environments, and customs. Whether it is a trip to Delphi, Benares, Eleusia, Santiago de Compostela, Jerusalem, Lhasa, Lourdes, or Mecca, the itinerary, especially if studied across the ages, from antiquity to the present time, offers an immense body of useful descriptions with which it is possible to create a map of countries, people, and customs. However, if we exclude those rare cases in which a remarkable literary or pictorial effect is achieved, the accounts are more specifically related to the faith of the pilgrim. In this instance, the pilgrimage has more of an allegorical or metaphorical function, even if it is grandiose as in Dante's journey, in the *Canterbury Tales*, or in Rembrandt's *Supper at Emmaus*. In our own time, we have a surprising example of the evocation of a pilgrimage in Luis

Buñuel's surrealist, ironic, and paradoxical 1969 film *La Voie lactée* (The Milky Way). Behind these cults there are traditions and myths transcribed in different forms: sacred texts, bestiaries, inscriptions, treatises on physiognomy, dance, gestural language, etc. These constitute a chorus of voices and accounts, something exceptional that lies between quotidian experience and the power of dreams. In general, we need to consider the pilgrimage as an ancient form of knowledge or as the free encounter of culture and language. There is a solemnity in the collective or individual journey of the pilgrims, determined to find places that disclose mysteries. It might also be that the routes marked by the *menhir* monoliths, like those we find in Britain, were sacred itineraries for pilgrims in the Stone Age. In medieval iconography, the pilgrim usually wears a hat with large brim folded downward at the back and forming a peak on the front; he carries a walking stick and a knapsack. His distinguishing attribute is the shell on his hat, on his knapsack, or elsewhere. He often has a pumpkin that serves as a water container.

In this context, we need to pause to examine scientific exploration more closely in order to grasp another way in which the notion of the pilgrimage generates the aesthetic. In this way, we learn to see ourselves as cultured tourists roaming through ancient ruins and unfamiliar landscapes. At the same time, an entire literature and an aesthetic of the exotic develop.

Among the scientific explorers, Humboldt deserves special mention. His famous, *Kosmos* (1845–58), an important study in geography and natural science, specifically addresses the aesthetic feeling for nature; more generally, he gives an artistic dimension to the landscape in his writings and journals. His work has always been considered among the earliest important examples of the history of criticism. In 1807 he began to publish his monumental work, *Voyages aux régions équinoctiales du Nouveau Continent*, in 35 volumes, complete with tables and charts. In the early part of the nineteenth century, his *Scenes of Nature*

(1808) provided an extraordinary image of the contemplation of natural spectacles in which feeling acquires great value and from which a seductive power emerges, a product of the creative genius at work in literature and painting. At the same time, he brings us scientific knowledge as well as the legacy of humanity, through his description of deserts and steppes, the cataracts of the Orinoco, and the highlands of Cajamarca. In Humboldt, we encounter once again Kant and Schiller's concept of the sublime in nature in the correspondence between the limitless (the ocean, the sky) and the impressions of the senses. Humboldt also emphasizes the contemplative study of nature, beginning with the *veduta* when, for example, he speaks of panoramas wrapped in mists, describing them as full of mystery, and of the anxiety that the infinite arouses in us. According to him, the diversity of nature's aspects is represented by the variety of feelings and thoughts that it inspires. The landscape is historical and cultural, a network of relationships that affect the whole of human experience. In this sense, we can understand how Humboldt could call Kant's mathematical sublime contemplative sublime (*Kontemplativerhabene*). The attraction of nature is joined to the unknown and to the perturbation of sight. His wonderful descriptions reveal a profound wisdom, as seen in the following passage:

> Those who travel the oceans and lands of this vast world are haunted by the monotonous, sad images of the lacerations caused by humans – indeed, as does the historian who examines events across the ages. Therefore, those who try to find serenity amid the discordant scenes gladly look deeply into the silent life of plants and the sacred natural forces or abandon themselves to an innate instinct, turn their gaze skyward toward the distant stars that in undisturbed harmony continue their eternal motion.
> (Humboldt, 1808, Ital. trans. 1998, 269)

In another passage, in which he relates philosophical reflection to the quest for origins, he states:

> The natural history of philosophy transcends what a simple description of nature requires in that it does not allow a sterile accumulation of isolated facts. Therefore, the inquisitive spirit of humankind should be allowed to wander occasionally beyond the present, into the shadowy past, intuit things that cannot be identified clearly and delight in the ancient mythological knowledge, which recurs in different forms (Ibid.)

Finally, let us not forget that explorer-geographers of non-European regions have made a remarkable contribution to scientific descriptions and to the aesthetic of the landscape as well, and I am not referring only to Marco Polo and Humboldt. For example, there is Xu Xiake (1587–1641), whose travel journals provide us with important observations on the beauty of the places he visited. He is the greatest of the Chinese explorer- geographers from the end of the Ming dynasty. In the course of his peregrinations, conducted mostly on foot, he too explored places that were unknown in his day. His descriptions of mountains reveal a passion for the surprising, an intellectual curiosity, and a blending of facts and emotions. Here we also discover how certain natural beauties, linked to emotions never before experienced, are transformed into literature and produce a new form of art.

PART TWO
Categories

4

The Art of the Landscape

4.1 EVOLUTION OF THE AESTHETIC CATEGORIES

Beginning with ancient Greece, unrestricted contemplation of the totality of nature fell within the domain of philosophy, but, with the passage of time, this totality died. The landscape separates itself off from the theory of the cosmos and, in human representations, nature is perceived through it. This constitutes a loss in the form of a laceration and regret, which we often find evoked in Romantic poetry. Henceforth, the landscape is seen as invention or as a substitute for nature.

Natural beauty, a quality of the universe consisting of harmony, order, and serenity, splits into a number of aesthetic categories. A specific space for an aesthetic different from beauty in the strict sense opens up. Particularly in the 1700s, after a long process in which taste underwent several transformations, we witness the emergence of reflection on the sublime and grace, as well as description of the picturesque and the Gothic Revival.

As Cassirer has taught us in his *An Essay on Man* (1944, Ital. trans. 1968, 263–4), beauty must be defined in terms of an activity of the spirit as it pertains to a special orientation of the faculty of perception. It is not merely a subjective process; on the

contrary, it is a necessary condition for the perception of an objective world. The artist's eye is not a passive organ that merely records what it sees. It is a constructive eye capable of elevating the beauty of things. The sense of beauty results from the fact that we recognize ourselves in the dynamic life of forms, a life that cannot be intuited except through an equally dynamic process that unfolds within us and that corresponds to it. This polarity has generated diametrically opposed interpretations. On the one hand, we have the discovery, or the elicitation, of beauty from nature and, on the other, we have the negation of any relationship between the beauty of nature and the beauty of the landscape. In his essentialism, Benedetto Croce related the aesthetic appreciation of a stream or a tree to the domain of rhetoric and not to the theoretical universe of intuition-expression. Perhaps, Cassirer argues, the contradiction can be resolved if we make a distinction between organic and aesthetic beauty. The aesthetic beauty we perceive in the works of a great landscape painter is different from the one we can perceive without the direct mediation of art. This distinction is useful even if it serves primarily to allow us to understand that the process of perception, as indicated, is a continuous transformation of these two states: the immediate pleasure of the senses and the imagination, on the one hand, and pleasure mediated by artistic culture, on the other. It is somewhat risky to merge the aesthetic beauty of the landscape with landscape painting and with the affective world from which it derives.

One of Kant's reflections can once again orient us in this discussion:

Independent natural beauty discovers to us a technique of nature which represents it as a system in accordance with laws, the principle of which we do not find in the whole of our faculty of understanding. That principle of purposiveness, in respect of the use of our judgment in regard to

phenomena, [which requires] that these must not be
judged as merely belonging to nature in its purposeless
mechanism, but also as belonging to something analogous
to art. It therefore actually extends, not indeed our cogni-
tion of natural objects, but our concept of nature, [which is
now not regarded] as mere mechanism but as art. This
leads to profound investigations as to the possibility of such
a form. (Kant, 1790, § 23, 84)

Our gaze modifies our consciousness and sensibility in confor-
mity with the criteria of taste. We are always agents of aesthetic
reception and aesthetic qualification, even when we find our-
selves in completely unexplored forests. What we observe is the
undeniable product of the human capacity to feel and to orga-
nize objects. We are artists, creators of the vision that appears
before us. From the dawn of our civilization, the landscape has
been connected to images created by painting, to descriptions in
literary texts, and to theories formulated by philosophy. Mem-
ory similarly preserves our sensory perceptions, along with all
artistic and cultural representations.

The sight of a beautiful landscape has always fascinated us, but
it is our assessment of it that changes, as does the language we
use to describe it. To express appreciation of a particular place
means to propose a certain level of affective interpretation, of
profound emotions that have been filtered through sophisticated
discussions on taste across epochs and different worlds of art and
culture. To define a landscape means to face the problem of aes-
thetic evaluation in accordance with the parameters of our col-
lective, historical, and individual memory. Every reflection on
the landscape conceals a relationship between the reality of places
and the determinations offered by the aesthetic categories that,
in referring to things, present themselves in the form of a theory
of the landscape. By the very fact that they are evaluated, real
landscapes are the practical expressions of those theories. We are

all absorbed in what appears before us, once the illusion of a living and objective spontaneous nature collapses. When it materializes, the illusion is the product of Baroque and Rococo fantasy. It belongs to the realm of style where excess is the norm.

4.2　WONDER

The visible world is rich not only in beautiful or ugly things but also in extraordinary things. Our soul experiences a feeling of exultation when we are touched by the charm of the exceptional or by perfection. In the face of the phenomena of creation, we are overcome by a sense of disbelief and amazement, to the point of being speechless. Such is the stupefaction, *thauma*, or wonder, the prerogative of the gods and the rapture of humankind. Pseudo-Longinus already alerted us to the fact that useful and necessary things are always accessible to humans, whereas extraordinary things evoke wonder in us.

Homer's description of the island of Ogygia, the abode of the nymph Calypso, provides us with the first example of such a feeling. The poet describes the amazement of Hermes gazing at his surroundings. We find ourselves at his side near a grotto in which a luxuriant thicket grows. We see alders, poplars, and fragrant cypresses as well as vines heavy with grapes. Birds with large wings nest among the trees and screeching gulls fly overhead. Four springs of clear water, flowing in different directions, draw our attention. Nearby are fields of violets and celeriac. Here, as the saying goes, even a god, if one were to appear, would fall under the spell, observing with a heart full of joy. The messenger himself, Hermes, stops to admire the scene. In this passage, Homer has joined together the two concepts of *natura naturata* and *natura naturans*. The image of beauty is born of the experience of surprise. We do not expect to find ourselves in such an extraordinary place. The landscape reality illustrated here is echoed in Ovid (*Metamorphoses* III, 157) who, however,

uses the word *ingenium* to describe the valley of Gargaphie, rich in pines and cypresses, behind which there is a dark cavern dear to the goddess Diana. Here nothing is the product of art. On the contrary, nature simulates art through its own creative capacity. As has been stated, this is a theme dear to humanists, who revisit the ancient myths when they establish a relationship between the artificial and the natural on the basis of the imitation and invention of nature.

Together with this profound poetic enchantment, we cannot fail to identify those works created by humans that have been considered to be true works of genius, the product of human work. Here, wonder is tinged with fear. The reference is to the Seven Wonders of the Ancient World: the Pyramid of Keops in Egypt, the statue of Zeus in Olympia, the Temple of Diana at Ephesus, the Colossus of Rhodes, the Lighthouse of Alexander on the island of Pharos, the Mausoleum of Halicarnassus, and the Hanging Gardens of Babylon. These are marvellous illustrations of spatial plasticity, the fusion of architecture and nature, of sculpture and natural surroundings. To these we could add other works capable of inspiring a similar sense of awe.

As a theory of the cosmos, contemplation can be interpreted as a state of wonder. As Venturi Ferriolo (1999c) explains, there is a relationship between *thea* (sight) and *thauma* (wonder). The process of knowledge coincides with the state of wonder that evokes it. Plutarch recognized that the principle rests on seeking (*to zetein*) and that of seeking on wonder (*to thaumazein*) and doubt (*aporein*); and this is why all questions regarding a god are enveloped in an enigma and demand a rational explanation of purpose and cause (Plutarch, *Delphic Dialogues* 385c). In the history of ideas, wonder is a potential instrument of mediation between the gaze of the subject and intellectual reflection. It is also the first act of that enigma of the landscape of which I have spoken, and it is a condition of contemplation situated between myth and philosophy. In a passage from his *Epimonides* (986c–e), Plato presents the

paradigm of the first observer who, initiated into beauty and variety, contemplates and admires the cosmos because he or she is inspired by a love of knowledge and a desire to know all that it is possible for mortals to know. As well, in the *Theaetetus* (155d) there is a discussion of the wonder experienced at the sight of things that, by virtue of being looked at, provoke the feeling of vertigo; this makes Plato say that, "wonder is the feeling of a philosopher, and philosophy begins in wonder."

Wonder enters the sphere of the non-verisimilar, but also of the monstrous, of that which does not allow itself to be applied to a familiar cultural paradigm. The *thaumaston* (the wonderful) can be *teratodes* (the monstrous) as in the horrifying aspect of the Cyclops. In this case, the marvellous is negative. As a result, we find a veritable catalogue of phenomena and affective states: surprise, fear, curiosity, attraction, desire, torpor; a fusion of art, religion, and speculation. We admire marvels of various kinds: those of divine provenance or those produced by machines or robots, from eclipses to volcanic eruptions. Vision pertains to the realm of illusion, of the pursuit of fascination. The term "the marvellous" also has a powerful and important meaning on the metaphorical level and is destined to acquire the sense of "the decorative" as determined by poetics.

Aristotle (*Poetics* 1460a, 12–18) also identifies the role of the marvellous in narrative, listing its characteristics: the unexpected, the surprising, and the illogical. In the sixteenth century, this concept is expanded in the works of Trissino, Castelvetro, and Patrizi. It also appears in Tesauro and Gracián in the context of a discussion on *acutezza* or acuity, *ingegno* or inventiveness, and passion for the unusual or the extravagant. Marino and Chiabrera share an interest in the incredible as opposed to the verisimilar, and it becomes an ideal in Baroque then Romantic poetics. In 1740, the theories of Breitinger and Bodmer appear. A fantastic world rich in "Gothic" bizarre elements then infuses Romantic taste. Tieck writes on the concept

of the marvellous in Shakespeare, and Schelling considers it an innovation of the modern epic. It comprises a wealth of images and ideas that appear in literature and the visual arts, until its decline in the twentieth century when, apart from Surrealism, which gave it a particular interpretation partly connected to subconsciousness, it appears to be almost exhausted.

Wonder applies to *marvellous* landscapes, especially gardens and landscapes understood as places of illusion. Jurgis Baltrusaïtis demonstrates this to us when he reviews the symbols, myths, allegories, and artifices of human invention at the dawn of our current artistic culture, born in the philosophy of the Enlightenment. He invites us to reconsider the eighteenth-century point of view and to propose a broader and different theory grounded in the imagination and fantasy. As a result, alongside the aesthetic of the landscape and beauty and art as free, spontaneous representation of the nature around us, we find an aesthetic of the landscape understood as a machine for the production of illusions.

The appreciation and valorization of the English garden in Baltrusaïtis show the garden to be the extension of a desire for wonder that, though present in antiquity, manifests itself especially from the Renaissance to the Baroque and Rococo. The landscape is, then, an image of the world within a vision of totality, eternity, and beauty tinged with nostalgia or melancholy, which are feelings unquestionably related to picturesque taste, situated between the sublime and grace. Illusion is understood here as a microcosm within a philosophy of the world or view of our affective origin in nature, in the light of a humanity filled with hope.

With all of its strange configurations (from the Oriental pavilion, the rustic barn, and the pyramid to the grotto), the English garden (Rousham, Claremont, Esher, Carleton House, Chiswick, Stowe, and others), in its fusion of exoticism and wildness, is a "cabinet of wonders," humanity's fairytale and dream. It is an

extraordinary experience of the imagination and of the senses that, as Baltrusaïtis pointed out in 1962, is a source of genuine pleasures for the eye. Let us recall Johann Zahn's *camera obscura*, whose internal mirrors brought about the play of various images of nature. Here, the garden appears as a fantastic architectural structure, a magical and oneiric vision.

To illustrate the interconnectedness of all of these ideas and their importance, I offer three examples: Shaftesbury's hymn to nature (1709, Ital. trans. 1971), which speaks of art that reveals itself in all of nature's works, a secret site of wonders; the hymn to the spirit of the earth in the scene titled "Woods and Caves" (composed between 1788 and 1790), which we find in Goethe's *Faust*, where we read, "in my soul deep secret wonders are disclosed"; and Wordsworth's *The Prelude* (Bk. 6, vv. 635–38) in which the poet writes: "Tumult and peace, the darkness and the light / Were all like workings of one mind, the features / Of the same face, blossoms upon one tree; / Characters of the great Apocalypse."

4.3 THE PICTURESQUE

In recent years, there has been an effort, from different perspectives, to emphasize the importance of the picturesque in the formation of eighteenth-century taste. Various studies have sought to re-evaluate this notion along with other more familiar and less discredited aesthetic concepts, such as the sublime, grace, and the neo-Gothic, which developed at the same time.

The aesthetic ideal of the picturesque was defined in explicit terms towards the end of the 1700s in the writings of Gilpin, Price, and Knight, although it was already present, before being formulated as such, in the debates on art and literature, creative genius, technical-stylistic inventiveness, and the sensibility of this entire century. In direct competition with classicism, the picturesque passed through the Baroque and Rococo, sharing

the unbridled imagination of each, and found itself at the door-step of Romanticism. The picturesque corresponded to the taste of the sentimental traveller, the *connoisseur* on the Grand Tour, the refined and cultivated intellectual, the painter capable of discovering the various beauties of the landscapes, and the na-ture-loving philosopher. Towards the end of the eighteenth cen-tury, theorization of the picturesque meant full recognition of its aesthetic value, even if the reasons for which it was admired were already beginning to become stereotypes. By then, the pic-turesque had performed its highest historical function, which was that of introducing a totalizing and sentimental vision of our surroundings, and it was starting to dissolve in the novelty of a taste that was changing, on the one hand, into the Roman-tic sublime and, on the other, into the obsession with sketching odd or particular objects, which also expressed a certain aspect of Romanticism. After this, we may say that it developed into Biedermeier and kitsch.

The picturesque found its place within the ferment of eighteenth-century aesthetics, between the feeling for ruins and the delight for the strangest curiosities, between the pleasure of the extraordinary and enthusiasm for the Orient or the exotic in general (India, China, Japan, the Middle East). Above all, it in-spired the aesthetic discovery of the landscape and the human environment, as well as the valorization of painting, in an inter-dependence of art and the senses, with the aim of renewing the ancient formula of *ut pictura poesis*. In this way, itineraries of the imagination became fused with literary, pictorial, and architec-tural itineraries to form a very rich tapestry of ideas that formed the basis of a lively debate on nature and philosophy. It cannot be denied that the picturesque, initially pictorial technique in Vasari, subsequently a mode of feeling, and eventually an aes-thetic ideal, provided an absolutely modern view of the world at the dawn of the Industrial Revolution.

A rereading of it, correctly distinguishing it from the romantic, even if it is impossible to imagine the romantic without the picturesque, invites us to consider the reasons for an aesthetic of the landscape whose validity, urgency, and necessity are further confirmed by the disquieting image of a suffering or dying nature. The principles on which it is based (observation, feeling, understanding of the entities that appear all around us in terms of variety, interconnectedness, irregularity, the coarseness of a pathway that leads to "effects" by way of objective logic or by association) represent a way of seeing, reading, and contemplating the landscape, which allows the picturesque, often said to be artificial because of the improvements it is intended to bring about, to be the vehicle for a universal feeling. All of the senses are deliberately involved in the experience, but on the basis of the theory of the picturesque eye, which is mobile and not static.

The picturesque has not been so much merely artifice in the service of caprice as a conscious sense of joy in aesthetic perception. It has not been limited to a style of painting, but has tended to assert itself more broadly and to penetrate into social life. It has not been limited to the domain of the decorative, but has also reflected elements of Enlightenment philosophy. The ideal that it proposes has certainly been rather ambiguous and has been a much discussed topic, as Ruskin later points out, but, nonetheless, it has proved to be perfectly capable of dealing with different forms of knowledge and professions in an age of great transformation.

Beyond the debate on the architectural garden and the pictorial garden, the *picturesque* appears to be linked to the themes of the sublime and the *romantic*. Having said this, it is important to indicate its complex origin, which posed problems of interpretation for scholars in the first half of the eighteenth century. The wonder of the picturesque provides the ambiguous equivalent of the emotions of the sublime and the romantic noted above. Gilpin, for example, inherits and makes his own this

fusion of the three terms when he claims to be guiding his pic-
turesque traveller along itineraries of *romantic* tastes in *romantic
scenery,* which is something extraordinary between calm and ter-
ror, wishing thus to describe walks through architectural ruins
where a mysterious ingenuousness reigns, solitary and unusual
landscapes, rare vegetation, and lakes whose beauty seems to
sleep in the lap of horror. This notion, in turn, inspires the cri-
tique of Price (1794) who sees here the impossibility of distin-
guishing between the beautiful and the picturesque. Price,
instead, wants to make that distinction, saying that Gilpin iden-
tified the picturesque with "pictorial romantic" art, an expres-
sion that allows us to understand perfectly the degree to which
the feelings of the picturesque, the beautiful, the sublime, and
the romantic were interconnected in that period. However, in
his *Poem on Landscape Painting* (1794), Gilpin already provided
a maxim that perhaps allows us to go beyond this debate and to
come to the heart of the matter regarding the possibility of an
aesthetic of the landscape involving the pleasure of perceiving
the multiform beauty of nature. He maintained that there
would be no progression if the imagination were not inflamed
in the presence of that beauty. He was thus starting with an in-
terest in a harmonious disposition towards landscape painting
where an interchange occurs between the natural eye and the
picturesque eye. In the end, he wanted to explain how a man
with picturesque taste had experienced nature authentically be-
cause he had the ability to grasp its inherent genius.

 Thus we consider the imagination in relation to the aesthetic
perception of nature, as it is produced by the artist and by the
observer in a perfect interaction comparable to that between
subject and object. Gilpin also recognized the difficulty of find-
ing an image of nature that, for its simplicity and beauty, could
be thought of as genuinely picturesque. In nature's work there is
always a degree of coarseness. Nature "never gives us a polished
gem." As a result, the amateur never sees nature as it is, but as it

could have been. In the image of mountains, lakes, and cascades, there are "deformities" that the trained eye would like to seek out and correct aesthetically (see *Observations Relative Chiefly to Picturesque Beauty*, 1786).

The great inspiration for picturesque taste and the picturesque ideal was Salvator Rosa, a name that recurs in the travel journals of the period. To give only one example, Horace Walpole wrote two letters (1736) in which he mentions Rosa himself as he describes the sight of precipices and mountains that inspire terror, torrents that glide among the stones, boulders, rumbling or thundering sounds, overhanging forests, cataracts, raging rivers, etc. This demonstrates that behind the sublime hides a love of the picturesque, ruggedness, dangerous variations in the terrain, diversity, irregularity, and deformity (irregularity, variety, intricacy, roughness, abruptness, harshness). In an account of one of his trips, Rosa (*Odes and Letters*, ix) uses the term "picturesque" (this would be in the second half of the seventeeth century); he does not do so to attribute value to certain techniques used in painting, but rather to declare a state of mind and an idea. From the pictorial representation of giant trees, stormy skies, grottos, boulders, dramatic seascapes, and extraordinary scenery, there emanates a primordial feeling for nature that reveals a spontaneous quality of the emotional response. As he himself writes, the picturesque is a mixture "of horror and the familiar, of flatlands and steep crags." We find this very same sensibility in certain pleasures of the imagination that, in Great Britain, combine elements of the sublime and elements of the picturesque to reveal the wonder of vision and representation, and not terror as in the sublime. In all of his itineraries, concerned with revealing "picturesque beauty," Gilpin discusses the associations between sensations and images, the way in which these emerge from the coarseness of uprooted trees, the harshness of surfaces, and the techniques of sketching and drawing. On the basis of this encounter of subject and object Gilpin finds a justification for his

"picturesque beauty," because he sees nature itself as a prefigura-
tion of the picturesque.

Richard Payne Knight organized his *Analytical Inquiry into the
Principles of Taste* (1808) by combining the viewpoints of associa-
tionism and subjectivism. According to his theory, the pictur-
esque does not have an objective quality and does not reveal
itself because it is present and concretely discernible in the exter-
nal world (as Price has said, essentially), but rather because it
acts on the mind of the observer who moves slowly towards
these domains of sensibility and taste with a gradually increasing
capacity for feeling and knowing. It is the association that con-
stitutes the picturesque: the combinations and gradations of
colours and tints, the irregular masses of light and shadow pro-
duce an array of ideas and emotions in which an exchange oc-
curs between images of art and images of nature. This comes
about as a result of the activity of two senses: sight, which acts
directly; and touch, which operates unconsciously. In Knight's
interpretation, combinations are superior to things, to single ob-
jects. These elements have allowed certain critics to express judg-
ments on Knight's modernity. From Hussey to Hipple, critics
agree, for the most part, that he has given us a theory founded
on light, colour, and abstract forms that relates as well to aspects
of Turner's late works, from the standpoint of composition.

In his *Inquiry*, Knight sees Burke as being responsible for the
popularization of bad taste and he also reproaches him for not
having made a distinction between sense and sensation. In this
criticism, which appears in several passages of the text, we find
once more his theory of pleasant ideas stimulated by the sight of
various landscapes, ideas juxtaposed to the senses: the legitima-
tion of the primacy of visual properties and of judgment over
the inappropriateness of *smoothness* applied to vision as a tactile
quality. Having rejected Burke's argument that smoothness,
smallness, and harmony are aspects of the beautiful, Knight also
tries to distance himself from Reynolds' idea of consonance,

Addison's principle of decorativeness, and Montesquieu's notion of contrast. He aims to promote a theory that overcomes the frailty of form, the sinuous line of contours, and the delicateness of colour. His idea of beauty is based on relativism.

Jurgis Baltrusaïtis (1977) has stated that fantastic landscapes and real landscapes are extensions of each other: the fantastic landscape follows the real one like a shadow, developing in the same direction and in response to the same forces across the centuries and in different environments. In his opinion, it is throughout the 1700s, and only in gardens, that we have the pleasure of being guided by scientists and philosophers whose descriptions are of great value to all epochs, and apply to painting as well. As far as the "excesses" and "effects" of eighteenth-century aesthetic pleasure are concerned, he maintains that landscapes come together in the garden like the marvellous objects in a cabinet of wonders or a sort of outdoor *Kunst-und Wunderkammer*, a fable or dream of humankind. The reference to Gilpin and to the picturesque is absolutely pertinent if we continue in our study of the relationship between the garden and the landscape. The same Baltrusaïtis describes Gilpin's wonder when, adopting multiple points of view, he admires the caloptrical grotto at Stowe (*A Dialogue upon the Gardens at Stowe*, London, 1745–1749). He makes his own the expression that defines these gardens as "an excellent epitome of the world" (122). Such observations radically challenge the conventions of modern aesthetics, which have strong ties to Romantic criticism, which is opposed to the illusionistic machine, because it is too similar to Rococo style.

4.4 THE SUBLIME

Hume transposes the concepts of distance, vastness, and the sublime to the psychological domain of associationism. In general, he prefers to use the word *vastness* above all, rather than

sublimity. Hume's prudence is clearly attributable to the age in which he lived: in the eighteenth century, many theorists of the sublime attribute meanings to this concept that lead to philosophically problematic ideas, such as infinity and the power of God. Hume maintains that all of our ideas derive essentially from our immediate impressions and that no sensation can be transformed into mental content. For his part, Burke (1757–1759, Ital. trans. 1985, Part IV, Section X) makes a distinction between *vastness* and *infinity,* and he attributes to infinity the power to cause a *delightful terror.* In this way, he opens up the luminous abyss of the sublime, which has profoundly influenced conditions affecting art, criticism, philosophy, and taste, inspiring themes dear to the Romantics and paralleling the development of the neo-Gothic and the picturesque towards Romanticism. There is a progressive affirmation of the subject over the object, with a generally anti-metaphysical attitude that is increasingly tied to empiricism and associationism. Along these lines, in about the middle of the century, anti-classical motifs dominate, even though antiquarian taste, with its passion for the study of the ancients, curiosity, and archaeological discovery, develops in parallel; so much so that the arts are affected by the so-called Greek Renaissance, which then expands to include interest in the Roman world and exoticism, alongside a new way of thinking about the Middle Ages. It was an eclectic world influenced by the Rococo, by an exalted love for the bizarre and the mysterious, a world affected by what we would call today something of an obsession with intertextuality. There was a fondness for idyllic, serene Arcadia, and for a free, untamed nature; people contemplated the spontaneous landscape and expected to improve it to make it more varied (*improvement*); they were fascinated by oriental art and, at the same time, revered the Middle Ages, and so forth, deriving great pleasure from intruding, transforming, and superimposing. Those were times when grace insinuated itself like a vague *je ne sais quoi.*

In English eighteenth-century aesthetics, the sublime expresses not only curiosity, although it could be happily pathological, but also terror, in the form of a discovery of intuition, genius, and agitation of the spirit. As Burke observes in his *Inquiry* (1757–59, Ital. trans. 1985), humanity is in a state of entrancement before all that is powerful and infinite. It is in the mental space that passions and deliriums are kindled. The sublime presents itself as obscurity and indeterminacy. It is not limited to the effects of light and shadow, or to the psychological *chiaroscuro* of the image of the world, because it extends to the fascination of darkness. The sublime is a *serious passion*. In 1785, the anonymous author of *Inquiry Concerning the Principles of Taste* wrote: "Where pure grace ends, the majesty of the sublime begins ... The sublime is the pinnacle of blessedness bordering on horror, deformity, and madness: a peak that disorients the mind of one who dares to look beyond."

We see the power of the imagination unleashed in the realms of dreams, the night, the unknown, and the hyperbolic. Such a revolution in taste was marked by the popularity of Pseudo-Longinus' treatise in the first decades of the Age of Enlightenment. In this short treatise from the Hellenistic era, enthusiasm appears as a quality of the creative spirit. We read that the magnanimity of the spirit transcends the rules of style. Burke takes up this principle in a new interpretation that corresponds to English taste and produces a radical aesthetic formulation of terror. The sublime is a vortex of creative transformation and aesthetic pleasure to which we can feel a fatal attraction. The sublime provides a key that permits us to understand better the passage from a rational ideal to a naturalistic one.

Pseudo-Longinus' theory of the sublime exerted a noteworthy influence on the quarrel of the Ancients and the Moderns, conducted even in Great Britain. There were supporters of both sides of the argument: on the one side to defend the Ancients, and on the other, to affirm the originality of genius and to resist

rules. Around 1730 a strong current privileging emotion begins to take hold, in the form of cemetery scenes, forbidding castles, crumbling abbeys, etc. We find the ecstasy of melancholy in Thomas Gray, the sense of desperation in Hugh Blair, and the poetics of descriptivism in James Thomson. Towards the middle of the century, the Neo-classical models lose ground; in their place we find a freer artistic theory in which the thesis of Pseudo-Longinus, regarding the exaltation and divine inspiration of a genial passion, is confirmed in a new and clear fashion. This theory focuses on the enthusiasm of the mind for this elevation and for expressive magnanimity capable of enslaving and of striking the audience "like a bolt of lightning." However, we must not forget that, if in these years it enters the language of criticism, thereby being read in an original way, the term was already in vogue from the end of the seventeenth century in the context of fashion, used by the nobility and the cultivated bourgeoisie.

The sublime acquires definitive philosophical clarity in Kant's *Critique of Judgment* (1790) where the author speaks of a dynamic and mathematical sublime in his vision of the immensity of nature, expressed in terms of power or vastness, which becomes a true ideal in Romantic aesthetics. In a rapid review of texts that takes us from England to the continent, we can say that a classical, a Neo-classical, a Gothic, and a Romantic sublime exist. The sublime is theorized differently by such figures as Dennis, Addison, Kames, Gerard, Kant, Wordsworth, Schiller, Hegel, Schopenhauer, and others. We must remember, however, that for Kant the experience of the sublime is the experience of humankind's liberation from nature, whereas for Wordsworth it is the experience of a participation or immersion in nature.

Therefore, we must consider the success of the sublime in terms of its extensive infiltrations into and exchanges with other terms. From the early eighteenth century, Addison (*Remarks on Several Parts of Italy*, 1705) uses the term *romantic*, but still in the sense of "sentimental," and he relates it to a landscape that,

appearing wild or desolate, is a suitable setting for stories rich in imagination. James Thomson (*Seasons, Winter*, 1730) speaks of a wild, romantic countryside. Here we find, then, elements of the picturesque and the sublime blended with a sensibility whose first important signs now appear and which, as it develops, culminates in Romanticism proper. In *The Pleasures of the Imagination* (1712, eighth instalment) Addison cites the treatise of Pseudo-Longinus favourably and considers the notion of the sublime in his non-Aristotelian opposition to rules. He defines it as pleasurable horror ("a pleasing kind of Horrour"), reflecting a way of describing certain feelings towards nature that he himself had noted upon seeing the Alps during his journey to Italy. At more or less the same time, Berkeley expresses similar views. In the *Dialogues Between Hylas and Philonous* (1713) we read the following:

> Look around. Are not the fields covered with a delightful verdure? Is there not something in the woods and groves, in the rivers and clear springs, that soothes, that delights, that transports the soul? At the prospect of the wide and deep ocean, or some huge mountain whose top is lost in the clouds, or of an old gloomy forest, are not our minds filled with a pleasing horror? Even in rocks and deserts is there not something of an agreeable wildness? How sincere a pleasure it is to behold the natural beauties of the earth! (151)

In their interweaving, the sublime and the picturesque spring from the aesthetic evaluation of nature and from the analogy between art and nature. Behind such concepts, following the current of a new interpretation of Pseudo-Longinus, hides the surprise of the non-ordinary, passion, and free and violent emotion that expresses itself in art, not through the intellect, nor through a need for clarity and order, but rather through an unusual form of imitation. Nature is accessed internally in the

creation of forms that act freely and spontaneously for the plea-
sure of an impassioned spirit.

The sublime theorized by Burke should be distinguished
from the beautiful, and also from the sublime as it is formulated
in French Neo-classicism. Its most important definition entails
the ideas of pain, danger, terror, passion, and awe. The founda-
tion is psychological, as opposed to the "grand beauty" of Nicolas
Boileau and such followers as Dryden. In Burke's sublime, the
human spirit is transported outside itself by images that are
striking because they are ambiguous and obscure.

In this new interpretation, the sublime does not become part
of the contemplative spirit, disinterested in the beautiful, nor is
it characterized by tenderness and composure but, rather, by the
frightful, the shocking, the horror inspired by contemplation of
the infinite, by terrifying things like the void, darkness, light,
eternity, power, vastness, solitude, and silence. This notion of
the sublime is based on an examination of the passions and an
acute analysis of the laws of nature and of the senses. What is
thus emphasized is an emotion that is a mixture of terror and
surprise, which is typical of this love of the things that disturb
us. Burke states: "Everything that is in a sense frightening ... is
a source of the sublime; that is to say, it produces the strongest
emotional response that the spirit is capable of experiencing."
He goes on to add that we must never come too close to the
danger and pain, and that there must always be a certain dis-
tance between the subject and the object.

Burke refers to Milton's Paradise in affirming the majesty of
God as supreme light. This is an important aspect of the gradual
transition from the picturesque to the sublime. Walpole had al-
ready dealt with this fascination with shadows, so dear to Burke,
in his *Castle of Otranto* (1764), a novel in which the picturesque,
through the use of a strategy of terror, becomes the sublime An
admirer of Rousseau and a master of the Gothic, Walpole would
go on to develop this idea in his *Essay on Modern Gardening* of

1771. The guiding principle consists of assisting nature while concealing human artifice, human work. Once again we are confronted with an interpretation and the practical evolution of an idea of Pseudo-Longinus, according to which nature is said to be delighted when it allows the art hidden within it to be made visible. In the English garden, we have the application of precepts that we find in the treatise *On the Sublime*. It is a revolutionary passage in the complex process of the imitation of nature through the power of passion and free imagination. Painting, poetry, and gardening are fused together by the gaze and by contemplation of the landscape, and they are tied in part to Salvator Rosa and in part to Lorrain, between the Baroque and Classicism. In an anonymous work from the period (*The Rise and the Progress of the Present Taste in Planting*, 1767) we can find a historical account of English eighteenth-century taste. It is said that we can trace back to Blenheim, Croome, and Caversham the style of Rosa and the inspiring grace of Claude Lorrain, along with cascades and lakes, such as those depicted by Ruysdael. To paint the works of nature, rendering the variety of each of its enchanting vistas, would require the ability of Poussin, the sublimity of Milton, and the passion of Dryden. Born to valorize nature in all its beauty, sublimity, and grandeur, Lancelot Brown was granted immortal fame by the Muses.

In France, as we can understand from painting, attention appears to be directed more to the aesthetics of elements, through the breaking down of the image of nature, than to the pleasure of psychological terror. Between Roger de Piles' *Cours de peinture par principes* (Course on the Principles of Painting), 1708, and de Valenciennes' *Eléments de perspective pratique à l'usage des artistes, suivis de Réflexions et Conseils à un élève sur la Peinture, et particulièrement sur le genre du Paysage* (Elements of Practical Perspective for Artists, Followed by Reflections and Recommendations on Painting and Landscape Painting for Students in Particular), 1808, a particular way of understanding the sublime materializes.

A study of the power of nature in all its details emerges. The iconography is that of water and sky, earth, and fire, and abysses in which we lose ourselves. We find a typical example of this attitude in Volaire's image of fire; the eruption of Vesuvius becomes the site of a grand spectacle of nature, as in Valenciennes where his gaze is immersed in the colour pattern of the clouds. Courbet's *La Vague* (The Wave, 1870) is a later example; with the problematization of our concept of the horizon, the viewer is denied a privileged point of observation.

4.5 GRACE

For Homer grace evokes divine beauty, something that is fleeting and amazes; a splendour that, through bodies and matter, touches the human being and brings out that which is hidden and profound. A sign of inspiration, innocence, and spontaneous beauty, grace appears throughout history with the lightness of a dance of transformations, reviving each time the secret of a great and tender enchantment. From paganism to Christianity, it is the expression of perfection and nobility produced effortlessly; the delightful transition from the finite to the infinite. Lightness counteracts the dreadful; the smile counteracts horror.

In Dante's representation, theological grace is based on a poetics of nature. This process corresponds to that of the ennoblement of earthly grace. Dante's terrestrial iconography, an expression of the mystical worldview of Christianity, has elicited different responses. As Assunto (1973) points out, we see formulated here the aesthetic idea that we find in the *Adoration of the Lamb,* also known as the Ghent Altarpiece (c. 1423), a painting by the Van Eyck brothers, whose inspiration draws on the same New Testament source, namely, the prophecy of the heavenly garden in the book of the Apocalypse. This is an example of a grace that appears in nature, a happiness that pertains to the perfect joyfulness of the world.

For the whole of the eighteenth century, beginning with
Leibniz, the ideal of grace is celebrated in art and nature as the
opposite of the sublime, which is characterized by images of
wild and inaccessible places. Instead, the gracefulness cultivated
by Rococo Neo-classical taste appears in the form of a *delightful*
nature, deriving pleasure from the whimsical and the trivial
(Watteau and Fragonard). It is the pleasure of contemplating
while allowing oneself to be swept away by the sweetness, the
softness of the lights, and by the colours of the water and the
earth. Leibniz (1714, Ital. trans. 1967, prop. 88) saw nature as re-
deemed by celestial and terrestrial grace. In the second half of
the century, Neo-classical aesthetics repositions the image of
ideal beauty, between sky and earth, between past and present,
in an unbroken perspective. Antiquity is depicted as the lost
Paradise of nostalgia and as the Promised Land of "repatria-
tion," to use Assunto's expression. This ideal of the retrospective
gaze is indeed guided by grace, as theorized in Germany by
Winckelmann and Schiller, and in Italy by Bertòla and
Cicognara. In addition to the theme of quietude and harmony,
we find the suggestive power of antiquity that institutes an au-
thentic model, an uncorrupted one that promotes a particular
interpretation of the sublime within a classical spirit.

In considering an aesthetic devoted increasingly to the land-
scape, I am moving away from the sublime and its exaggerated
surges of modernity to shed light on other interpretations and
possible ways of thinking. There may in fact be, through various
pathways, an extension of intersecting forms and categories, a
graceful sublime or a sublime grace, without ignoring the im-
portant mediating role of the picturesque. In Assunto's analysis,
the centrality of the "aesthetic categories," beauty as a category
with inexact boundaries, has always had to be founded on grace.
When he discusses the institution of nature as expression of
grace, Assunto envisages it in a "game" designed to distinguish
profane grace from theological grace, all the while returning to

the essential notion of an "absolute beauty" capable of holding them together and, at the same time, coexisting with the freedom of nature. But the circles become wider and multiply because, in this extension of forms and concepts, Assunto also discovers a *grace of nature* and a *sublime nature*. The first draws from a repertoire that, from Dante's *Paradise*, goes on to include Neo-classicism, passing through the late Gothic of the fifteenth century. In this way, nature is led towards grace because grace perfects nature and allows the sacred to emerge from the profane. *Sublime nature*, instead, is represented in Ossian, Rousseau, and Schiller, and it produces the state that we recognize as the free play of passion, sentiment, and fantasy.

In general, we can say that grace in nature, in art, and in the shapes of the human body, indicates an innate or acquired property that is strictly tied to the rhythm of the composition. A light, delicate, mysterious, and unexplained aura emanates from beauty. We have been educated and influenced by this aesthetic sense that developed from the Renaissance to the nineteenth century, from Castiglione's *sprezzatura* (nonchalance) to the Neo-classical "gift from heaven." Grace, however, has some surprises in store because of its precious and concealed aura. For Félibien, towards the end of the seventeenth century, beauty was linked to proportion and grace, as well as to the expression of stirrings within us, while for Hogarth, in the mid-1700s, it was applied to the marvellous drawing of a "serpentine line." Meanwhile, Winckelmann affirms that it appears as "the pleasing according to reason," avoidance of affectation in favour of "the simplicity and tranquility of the soul." Assunto guides us through the different eighteenth-century models and influences with skill and intelligence, staying well clear of cultural and philosophical stereotypes. He takes us into places where grace is revelation or into that less graspable place of beauty already identified by Bacon. Where is the error here? Far from affectation and gallantry, grace, as Winckelmann and Schiller were

aware, manifests itself in an aura of dignity and composure, without its image weakening in the least at the crossroads of various aesthetic categories, but instead increasing its fascination, enchantment, and innate magic.

Assunto analyzes the unique interconnection between grace and sublimity in Neo-classicism through the theories of Bertòla and Cicognara. For Bertòla (*"Saggio" sopra la grazia nelle lettere e nelle arti* [Essay on Grace in Literature and in the Arts], 1822), grace is the perfect blend of fineness, subtlety, delicacy, voluptuousness, and mystery, and it contrasts with Baroque wit (*acutezza*). Cicognara (*Del bello* [On the Beautiful], 1834) marries grace and simplicity, refuting Burke's interpretation of the sublime. All of this, as in the various theories that have been referred to here, influences our image of the landscape. The grace of the human being and that of nature are fused in a single symbolic image in which the finite and the infinite quietly trade places. Excluding as it does the tension of the sublime, grace is the desire for joy, the enigma and pleasure evoked by ambiguity, according to Rilke's interpretation. Grace requires the suspension of action; it seeks out silence to enter into contact with nature, which offers itself to all of our senses. It is the instant that embraces duration, the feeling that all places are one place, the domain of the smile and of perfection. It is the movement of our body and of our gaze when we engage in the life of the world: the casual, detached elegance of things.

Grace as participation and movement appears as a richness that is always available but insufficient, as a perfect but unstable equilibrium. Above all, it is a gift, an antidote to pain. As Schelling states (1809, Ital. trans. 1989) it fuses the celestial and the terrestrial, and establishes a balance between the human and the divine. Grace is the correspondence of the spirit of nature, free from constraints, and the human soul. The soul dissolves in the sweet, tender, delicate aura, incomprehensible but perceptible to all, neither sensible nor spiritual, of a "lovable essence," where the soul and

body are in perfect harmony: "The form is the body, the soul is grace, even if it is not the soul per se but the soul of the form or the soul of nature" (42). The spirit of nature does not oppose the soul, but reveals it; the beauty of the soul is united to tangible grace. In the painful conditions experienced by humans, grace intervenes at the moment when the spirit of nature is transfigured by the soul, which breaks its bonds with the sensible world. Grace avoids all that is repugnant and false, and transforms pain, terror, and death into beauty, absolute purity, and inner plenitude.

Enveloped in an aura of grace, the landscape is a site of rapture. We find there a spontaneous harmony between the works of humankind and the natural rhythm of things, which is capable of evoking the sweet wonder of an earthly Paradise.

4.6 BEAUTY

As already noted, Burke distinguishes between the beautiful and the sublime. The first stirs love by working through the senses; its properties are smallness, smoothness, variety, fragility, and colour in the appropriate doses. The sublime, instead, is that which is vast, rough, dark, and massive; it is a "kind of tranquility tinged with terror."

To understand natural beauty, we must not consider only a psycho-physiological image. Usually contrasted with artistic beauty, it is well anchored in the collective consciousness and it also appears to have a certain value in the eyes of those philosophers who argue in favour of making a distinction between the form of art and the aesthetic experience, an experience in which the pleasurable and the contemplative dimension of the world re-emerges. In the eighteenth century, Kant (1790, English trans. 1951) draws a distinction between *Naturschönheit* (natural beauty) and *Kunstschönheit* (artistic beauty), recognizing the autonomy of the former; in idealist philosophy, the latter prevails, as we have seen. This distinction reflects the old opposition

between art and nature; nature may be represented as an innate aspect of the manifestation of art, which is connected to the originality of artistic genius, or may be interpreted in terms of inferiority or superiority. For Hegel the beautiful resides in nature, but in the sense of dissolution, because art, which conflicts with nature, "idealizes," he says, its contents and materials, changes and recomposes them with its own forces, which are agents of freedom, autonomy, and infinity. Hegelian objectivism acknowledges that nature is beautiful; this awareness, however, necessarily passes through philosophy in the well-known rational process that produces a self-conscious synthesis. The beauty of nature, in its vital tendency towards a place of harmony, is then considered as an imperfection that does not allow itself to be grasped in an (ideal) illumination. In *Lessons in Aesthetics*, Hegel (1842) writes: "the beauty of art is the beauty that is born – born again, that is – of the mind; by as much as the mind and its products are higher than nature and its appearances, by so much the beauty of art is higher than the beauty of nature" (4).

The ideal of beauty that is born of an aesthetic theory of the landscape and that can be considered a universal good, a quality we intuit as common to all beings, is an object of contemplation through which humans comprehend and are comprehended by nature. In this view, life assumes a form whose purpose and justification are self-contained. When we are moved and when we admire all that is beautiful, we have the sensation of being almost infinite ourselves, like nature, to which we feel we belong. And so an epiphany of the visible unfolds in which the beautiful, the useful, psychological rapture, and human work are closely interconnected. At the same time, we sense that human work is a part of this ideal. The subject dissolves in the vortex of sensibility and in the intuition of forms.

The argument also involves theological questions, evoking the myths and foundations of cultural traditions. To the anthropological aspects of the issue, however, are added aesthetic

aspects. Within the context of a discourse on a rediscovered and renewed ideal, we need to imagine both a beauty that soothes – a Muse that calms, in contemplation – and a beauty that disturbs or a Muse that goes beyond contemplation, made feverish by the desire that comes with experience, in a continuous and intense élan of the self, moving between the states of interiority and exteriority, between mystery and reality. In its various manifestations, beauty transcends function and, to use Assunto's apt expression, unites the *voluptas* of the senses with a *delectatio* of contemplation that, in the end, acquires the form of a momentary *beatitudo*. In this way, beauty is present at the same time in the brevity of actual existence and in the image of an imperishable autonomy of being.

From these reflections, an aesthetic of the landscape is established, one that tends towards an exchange between the ideal and the real world. Venturi Ferriolo (1992) guides us through these arguments as he considers, in particular, the relationship between the landscape and the garden, recalling Kant's view that "a natural beauty is a *beautiful thing*: the beautiful in art is a *beautiful representation* of a thing" (81). He deduces that what is truly beautiful through the *genius loci* (genius of the place) lies between the formal garden, where there is representation, the art of landscaping (the imitation and control of nature), and the landscape garden, where we have the garden as nature. Venturi Ferriolo goes on to clarify that in the landscape garden the idea precedes imitation; it exists in our consciousness before it exists in art, because of the symbolic and unconscious persistence of the original myth that identifies the garden with nature itself: the myth of the Great Mother. The garden and the landscape present themselves to us to be admired in their essential qualities. In this sense, we can once more turn to Kant for a final clarification. Before art does, nature makes us participants in its beauty. From this, we can understand the importance of the *genius loci* as we move through nature and live it in its totality and its enigmas.

The landscape and the garden appear through the image of something multiform and as a network of relationships. Aesthetic appreciation cannot be limited to the identification of this or that aspect of the morphology of the land, as it appears in the pictorial transformation or the architectural alteration of sites. Even the pairing, important as it may be, of Poussin-Lorrain and Salvator Rosa-Ruysdael, as a canonical expression of the aesthetic valorization of the landscape, cannot be the only point of reference that can help us to understanding how the aesthetic categories intersect with the history of taste. Only by thinking of a certain level of interaction between art and philosophy can we bring into focus the landscape of the soul and the soul of landscape. Schiller dealt with the question by taking up arguments that had been proposed by Addison, Pope, Thomson, Dupaty, Saint-Lambert, and Walpole, and by trying to find a solution among the picturesque, grace, and the sublime. He hoped to remove the garden from its subordination to architecture by revealing the link that exists between aesthetic judgment and teleological judgment, along the lines indicated by Kant.

The beauty that inspires the observer in a classical-ancient garden is an ideal beauty, a beauty consisting of order, elegance, and symmetry. In such a world, all things have the imprint of an ordering intelligence. This is an ancient idea that resurfaces in the Renaissance and later in the classicism of Poussin, along a path of development that ascribes qualities to places and allows for a poetic elevation of nature to the status of an idea.

The question of ideal beauty as a model of real beauty reappears in early Romanticism. Its most profound meaning is conveyed to us in the *The Oldest Systematic Program of German Idealism* (1797), in which we recognize Hegel, Hölderlin, and Schelling. Here, the idea of Beauty unifies all others in a fusion of the self and nature. Being itself is Beauty and poetry is seen to spring from nature.

Like landscape, the garden, at once essence and ornament of the earth, is an elevated, irreplaceable pleasure of the senses and of the spirit. That which is pleasing in the landscape or in the garden is illuminated by a light that emanates from the enchantment of a Promised Land, a Paradise dreamed by humanity and preserved in the great magical-religious traditions. It is the memory of and hope for a timeless joy.

5

Contemplation of the Landscape

5.1 THE ART OF THE LANDSCAPE AS AESTHETIC OBJECT

In art, contemplating is different from doing. In my mind I can produce images of landscapes derived from the models provided by Western civilization or I can admire the beauty of the forms independently of these models. As does the garden, the landscape arranges natural images for my mind. The art of the landscape is, in a sense, already made, even though it is in the process of transformation. It obeys the laws of the physical modification of the land, but also the laws of human sensibility and invention (cultivation, management, and so on).

The landscape presents itself to our faculty of perception and to our imagination as an aesthetic object; it appears as an immense sculpture or architecture of the cosmos, a limitless visual expression of lines and contours, an unending dance or a rhythm of forms, a poetic language of signs or a marvellous spectacle with no prologue or epilogue. The landscape imposes itself on our consciousness and on our capacity to feel in the fullness of its aesthetic qualities, intentionally offering up, as an ideal site for human work and imagination, the natural object

contemplated. According to Assunto (1963, 273), a critique of the landscape as a pure and simple natural object finds justification in the production of humans: production for the purpose of giving to the layout of sites a precise aesthetic configuration that reflects the ideals of culture and society, or production whose purpose is the expression of sensibility and imagination.

Places live in our representations through the pleasure of contemplation. As Goethe states in his *Theory of Colours* (1808), the simple act of looking at an object does not allow us to move forward; contemplation belongs to a form of theorizing based entirely on sensation. Almost a century later, Simmel (1912–1913, Ital. trans. 1989) recognizes, as I have underscored, that the landscape is nature that reveals itself aesthetically, "spiritual form," or a range of psychic tones that proceed from the domain of the emotions to that of the arts, and from the world of reception to that of intuition and action. It is a way of seeing and feeling that places us in a position to anticipate what occurs in painting and poetry. In this sense, nature as infinite connection among things or uninterrupted birth and destruction of forms, presents itself aesthetically in the landscape, prior to the developments in art produced by humanity. It is through such a revelation that we transform into aesthetic objects what were once pure and simple natural objects.

Deep feeling for the landscape, as we know, is often linked to painting: the picturesque and the sublime in the eighteenth century were the most appropriate categories for describing that feeling. Between their dominance and their decline, from Classicism to Romanticism, we find several reflections on the genre of "landscape painting": von Hagedorn (1762), Gessner (1770), Sulzer (1772), Schiller (1795), de Chateaubriand (1795), Cozens (1785), Steffens (1801), Runge (1802–03), Fernow (1803–06), Friedrich (1803), von Kleist (1810), Carus (1815–24; pub. in 1831), Hackert (1806), Müller (1808), Schinkel, and others. This critical

attention extends across Europe, with important contributions from Russia as well. If the age of the picturesque is represented by Salvator Rosa, that of the painters of ruins by Piranesi, Panini, Marieschi, Ibbetson, Loutherbourg, Gainsborough, Sandby, Day, Seel, Cotman, Hearne, and Volaire, the age of the sublime is represented by Cozens, Füssli, Friedrich, Turner, Wright of Derby, and Martin. We often find the mixing of different aesthetic themes, listed above, which gradually disappear during the nineteenth century in the wake of another great transformation: that of the Impressionists and *Macchiaioli* up to the Expressionists, Cubists, and abstract painters: Cézanne, Monet, Gauguin, and Morandi; but Previati, Segantini, Klimt, Kandinsky, and Mondrian also legitimately belong on this list.

What is most important, beyond this range of reflections on landscape painting, which are a sign of the growing passion for the new feeling for nature, is the network of relationships between the world of forms and the human imagination. From a sensibility that is still essentially eighteenth-century and tied to the picturesque, we inherit the following statement by Chateaubriand: "Let us guard against believing that our imagination is more fertile and richer than nature" (44), which causes us to think of a more recent, related, but contrary, pronouncement by Baudelaire: "It is true: the imagination creates the landscape" (58). We also find aesthetic reflections on these matters in various novels, essays, travel journals, etc. They are definitely linked to the sensibility of the *connoisseur,* the vogue of the Grand Tour, the new way of conceiving and designing gardens and cultivated areas, the damage caused by the Industrial Revolution, and progress in the natural sciences. This entire phenomenon transforms even more those concepts that were already in great use during the preceding centuries, such concepts as the imitation of nature and *ut pictura poesis,* articulated in a series of categories that range from curiosity to terror, and from the elusive *je ne sais quoi* to the lightness of grace.

Every aesthetic reflection on the landscape conceals a relationship between the reality of places and the descriptors offered by the aesthetic categories that, in referring to objects, produce a theory of the landscape of which real landscapes are the practical expression, because they have been subjected to judgment. Prior to being formulated conceptually, the idea of the landscape, as indicated above, is formulated in art and, before that, in our soul. What emerges is a vision of nature grounded in beauty and expressed through different poetics. However, it bears repeating that, as the relationship between reality and thought, as the form of nature, and as an aesthetic object, the landscape is itself art, because it unites utility and beauty.

The landscape can be considered an aesthetic object and can also be critiqued as though it were a product of art. It is the result of the work and the creative imagination of humans; nature moulds forms in the human mind and imagination, and forges events that change according to the rate at which the subject moves, climatic conditions, seasons, and materials (from water to desert, from rocky terrain to grassy fields). Among the objects in nature, a kind of choreography of sensory knowledge is created. Due to the varied forms of the plastic beauty of the earth's surface, our movements, our impressions, and their relationships, we are able to align aspects of the eighteenth-century and romantic sensibility with those of contemporary ecoartists. Interventions on the "territory" can reveal aesthetic strategies rooted in the eighteenth century.

Assunto maintains that a veritable critique of the landscape is legitimate in that natural landscapes can be considered to be among the *beautiful things*. Some might argue that artworks are produced by humans, whereas landscapes are not. This would entail, however, falling back on the metaphor of a *natura artifex* or of a *Deus artifex*. As beautiful things in the material sense, that is to say, material things that can be the object of an aesthetic judgment, landscapes are in reality human products in

the same way that paintings, statues, etc., are. We must understand the analogy between a work of art and a landscape. The latter is a product of humanity, even though it may be independent of the operational process in the strict sense.

We are led to think, retrospectively, that certain aspects of grace, the picturesque, and the sublime extend back into history and also pertain to strategies of seeing and feeling that appear much earlier than in our own civilization. A type of Roman fresco appears to have traces of a visual, contemplative system tied to aesthetic pleasure that, in terms of vision, is organized around the concepts of irregularity, variety, intricacy, coarseness, or proportion and harmony. Even in antiquity we can find a taste for the beauty of the landscape as the object in its diversity and at the same time the impressions of the subject, beyond any allegorical meaning. Evidence of this are, in Rome, the decoration of the summer triclinium of the Villa Livia at Porta Prima (30–20 BCE) and triclinium C, part of the left wall, of Villa Farnesina (now in the museum of Palazzo Massimo alle Terme), which was executed between the end of the Republic and the Julio-Claudian period. Here we obviously do not find ruins or an exhibition of sentimentality, but we do discover, behind a well-kept garden, the pleasure of a clump of wild vegetation. The strategies of the painter coincide with the taste and sensibility of the epoch. The "painterly style" is the product of a model of observation and contemplation that obeys a precept in vogue at the time, and mentioned earlier: *concordia discors* (discordant concord). By means of this precept, we are led to the rediscovery of attentiveness to the world that, despite differences, applies to our actual and natural way of feeling. We recognize certain affinities, and we see reflections of ourselves in those remote models. We discover that they relate to us.

This comparison leads me to add a final observation: in contemplating changes in the life of the cosmos and of humanity, ancient and modern thinkers appear to share the same aesthetic destiny.

5.2 *GENIUS LOCI*

For the Greeks, nature and the landscape are represented and experienced as the totality of the cosmos, which can be described in terms of a range of sensations capable of revealing the spirit of the place, as Homer did and, after him, Virgil. The notion of the *genius loci* originates in antiquity, but not only in ancient Greece; it can be found all the way up to Shaftesbury, Fénelon, Rollin, Watteau, Marivaux, Montesquieu, Voltaire, and Diderot, and is reiterated in Kant and Goethe. Goethe describes nature as an enveloping embrace, like a whirling dance. This description evokes the image of the lightness and passion of grace, the mystery of that which reveals itself in the world of forms. In modern and contemporary culture, the *genius loci* is an idea according to which nature infuses in the artist its own *ingenium*; it is also the theory of nature imitating art through its creativity. For the Greeks, the *hyle* (the primary substance of change) was viewed with wonder. It is through observation that humans acquire knowledge. In fact, there was then a link between vision (*thea*) and wonder (*thauma*).

The gods were the spirit of the place, the *entopioi theoi* referred to by Socrates in the *Phaedrus*, and they were the sources of inspiration. We feel their presence; we see them and they inspire wonder. It is the awe of observing and of being observed. Humans can see the gods, but the gods also observe humans from the mountaintops, the treetops, and from the streams, in a joyful, aesthetic participation that, born of an animistic conceptualization, has survived through the centuries.

In Shaftesbury's *The Moralists* (1709, Ital. trans. 1971, 184), Theocles declares his interest in the real, the environment in which we live, the protective deity of the place, which is an ancient topos. Philocles agrees with him in acknowledging the presence of the *genius loci* and in allowing himself to be swept away by passion for things that are not altered by the caprice or

the art of humankind, but that are perceived in their original state. For this reason the "graces of the wilderness" appear to Theocles in their wondrous aspect: rugged cliffs, mossy grottos, asymmetrical caves, and cataracts that crash noisily against rocks. These graces seem to him all the more fascinating the more they appear to be genuine representations of nature surrounded by a magnificence that is superior to the contemplation of princely gardens.

The myth of wilderness, as opposed to the artificial, geometric taste of the garden, recurs frequently. Inspired by the Muses, lovers of nature, philosophers, and poets study and admire it enthusiastically with the aim of extracting from it its intimate spirit. They feel an exalted benevolence that leads them to attain both the beautiful and the good; they experience a state that is both ecstasy and reason. The love of nature is a positive form of enthusiasm, a passion for the art created by the forests, the countryside, the water, the sky, etc. It is a profound emotion and a feeling of participation. As Shaftesbury explains (Ibid. 191), beauty, proportion, and harmony are never in matter itself but in the art, the design, the form, and in prefigurative energy. In nature, it is the spirit that produces beauty; the *genius loci* produces the enchanting plasticity of possible combinations of lines and colours. Matter is formed by the spirit that we perceive and whose inherent elements, namely, form, colour, and movement, we anticipate when they manifest themselves in their purest form. We enter the "divine" that is immanent in the landscape.

For Shaftesbury, nature is beautiful when it has the appearance of art and art, in turn, can be considered beautiful when we see it as nature. This has been a much-debated question throughout the centuries because it places next to and in the spirit of the place the theme of *ingenium*, and the interchangeability of the positions occupied by art and nature. We have seen, however, how Ovid had already shed light on this issue. Describing the valley of Gargaphie, sacred to Diana the huntress (*Metamorphoses* 3, 157),

the poet says that, hidden among the trees of the woods, there is a cave where nothing is the product of artistic creation, but where the genius of nature has imitated art. This is the core of the debate: humankind acknowledges nature's status as art, which appears as the product of the genius of the place, of its inherent "ability" to create marvellous things.

The *genius loci* is the sign of a vaster sacredness. As M. Eliade puts it, the most primitive of the sacred places was a microcosm, a landscape of rocks, trees, water, etc. Such oracular, prophetic sites were never selected by humans, but discovered by them. With the passage of time, by attracting people, they marked the lines of movement with temples, cities, roads, etc. Communication was tied to symbolism. Sacred places were a system of significant geographical points in the early life of humankind.

5.3 THE PLEASURE OF THE FIVE SENSES

There are various models and ideal gardens and landscapes in the history of taste: varieties of gardens and varieties of landscapes defined by poetics inspired by the invention of artifices or brought to light by the receptive capacity of viewers or contemplators transformed into artists of taste and feeling. Because they occupy a space between theoretical formulation and the creative spirit of art, gardens and landscapes celebrate synaesthesic rituals. All five senses participate. For example, from this analogical perspective, perfumes may be perceived almost as musical compositions.

We are thus led to evoke certain famous allegories, including the tapestries that depict the Lady with the unicorn (late fifteenth century), the series of sixteenth-century engravings by Pencz, Floris, de Vos, Goltzius, or the equally famous work of J. Bruegel (*The Five Senses*, 1618), and the related concepts of macrocosm and microcosm. My point of reference, however, is the landscape and the garden. When we walk in these places, all

of our senses are stimulated. In some gardens, moreover, it is not difficult to find a corner where aromatic, delicate plants activate the senses of smell and touch.

An illuminating example comes to us from Praz (1975, 97–9), who recalls G.B. Marino's *Adonis* (Cantos VI–VIII) and the Garden of Pleasure next to the Palace of Love, where neither discomfort nor misery exist. In this garden, which is divided into five parts, Venus lives with Cupid:

> The sky and elements are bodies five;
> the number of the senses is the same.
> The stellar dome of lovely, burning lamps
> is like a natural portrait of the sight.
>
> Among them likewise in conformity,
> hearing to air, and earth akin to touch.
> Nor does it seem that with less sympathy
> odour responds to flame and taste to wave. (101)

After listening to Mercury's discourse on sight, Adonis enters the festive garden; the loggias are covered with paintings that depict stories and scenes of love, and the poet names the great painters of his epoch. As the couple wanders and stares in amazement, a peacock appears before their eyes. Venus then leads Adonis into the Garden of Olfactory Pleasure, and Mercury speaks to them of the pleasures of the sense of smell. Flowers, aromas, and perfumes are described. Senna, marjoram, cardamom, dill, lavender, thyme, wild thyme, helichrysam, laburnum, hedge mustard, cinnamon, terebinth, myrrh, privet, amaranthine, narcissus, hyacinth, and crocus are all flowers that adorn the verses of Marino and that Praz compares with those in the work of Bruegel. To draw a comparison, as the peacock can be distinguished among birds, the flower of Passion, to which the poet devotes nine stanzas, stands out among other

flowers. In the seventh chapter, we hear the symphony of forty-eight birds that culminates with a contest between the nightingale and the lute player. As Mercury recalls the origin of music, Poetry and Music appear on the scene. Adonis is then brought into the Garden of Taste, which is adorned with magnificent fruit trees among which nymphs and fauns frolic. Adonis and Venus arrive at a rich banquet where Nature dispenses all of the pleasures of the palate. Among the table decorations, there is a representation of the birth of love. Finally, Adonis and Venus go into the Garden of Touch, the site of the most intense pleasures.

As Praz illustrates, the painter and the poet, Bruegel and Marino, express in grand fashion the spirit of the same epoch, offering us catalogues of taste as determined by the prevailing fashion. Notions pertaining to the senses and to things have an effect on them; vertiginous symphonies are produced with a sensuality approaching the mystical in an apotheosis of still lifes. Humans almost disappear from the scene. Venus and Adonis pass like shadows through this grand spectacle. Praz suggests, as does Andrew Marvell (*The Garden*, 1681), that we are just one step away from the ecstasy of the gardens that surpasses completely the play of the senses to arrive at a spirit engaged totally in the adoration of nature. Things are now adored in themselves and for themselves; the landscape becomes "invisible." One line in a poem by Marvell reads: "Annihilating all created things, reducing them to a green thought in a green shadow" (quoted in Praz 1975, 99).

5.4 FORMS, MATERIALS, SOUNDS

The subject of the landscape entails descriptions and representations. In the eighteenth century we have, on the one hand, the theme of the seasons (from Thomson to Blake and Keats, from Goethe to Hölderlin, from Frugoni to Metastasio and Casti). As is well known, this theme is also evident in the music of Vivaldi

and Haydn. On the other hand, the popularity of the pictorial genre began to take hold. The landscape, however, is not seen exclusively through the "optic" of painting or the affective filter of certain descriptive poems. The reflection of natural forms in the forms of art and vice versa occurs when the spontaneous landscape presents itself to our eyes and succeeds in defining, with its form, a true poetics, which the art of humans appropriates. When it stands out in this way, Nature is one with its essence, being subsequently interpreted variously, as determined by different styles and artists. As nature that reveals itself aesthetically, the landscape is, in a sense, endowed with an "inherent poetics" to use a term dear to Luciano Anceschi.

At the heart of the formal problem is the model. What models does the landscape offer us? We recognize them in the forms that render space usable and that are space. A model implies a being organized in a certain order, which is either parallel with or precedes the perception of visual data, which offer not so much stability as coherence, unity, and multiplicity. In this way, outlines, contours, and lines form patterns, arabesques of regular or irregular objects. Form is not a canon, but a network of properties in the process of transformation. Form can be identified within a morphology that integrates sensibility, emotions, and intuitions in which we see allegories and symbols converge. But form as morphology possesses its own aesthetic life. It does not matter whether it is the cypress, olive, almond, or oak tree, a certain quality of the earth or a crag; at the source of the enchantment, along with myth, there is a phenomenology of the elements.

Form pertains, in particular, to the appearance of a thing: contours, noticeable parts, shape, structure. When we speak of natural forms, we are speaking of forms in transformation, both rock formations and plants. A seed placed in the earth germinates, grows, produces fruit, and constitutes an object, the edge of a landscape, an arabesque of lines. A stone exposed to the

erosion of time assumes new shapes. A place is not made of abstract geographic conditions, but is an aggregate of things, including form, texture, colour, germination, growth, and decay. It exists in the changes in the architecture of mineral elements and vegetation, as well as in the atmosphere. Form is a totality composed of parts held together not by relations of juxtaposition and contiguity, but by intrinsic laws that bind all things together. Form, in fact, stands out against a relatively neutral backdrop and appears as unity. Its perceptual field is a dynamic field that tends towards a structure. The shape of the structure and the relationship among the elements cause the form to be perceived. The relationships are those of similarity, proximity, symmetry, closure, continuity of direction, and their opposites.

The materials are the totality of "substances": rocks, earth, sand, and the like. All of these givens constitute the organization and the articulation of the art of the landscape. Unlike art in the strict sense, there are no rich and poor materials. The splendour of sand may surpass that of gold. Materials are the external, tangible aspect of physical elements. The observer directs and recreates the forces inherent in those elements. The landscape reveals a tactile matter that leads back to itself as both the presence and essence of objects. An aesthetic of the landscape is not born of a feeling tied to the consumption of beauty as instituted by the *media*; it does not distance the object in disinterested judgment. Otherwise, as has indeed occurred in the common view, the result is a disastrous widespread banality and kitsch. Behind the discovery of the problematic relationship between the ethics and the aesthetics of nature, lies a process of change towards an eventual and paradoxical reversal of direction: advocacy for the idea of antiquity as the future. In this line of thinking, humans can pursue the dream of becoming artists themselves, inasmuch as they are active contemplators and interpreters of the exchange between the beauty of art and the beauty of nature.

From the laws of form and the description of materials derives the aesthetic constitution of the landscape: a composite of *characteristics* associated with the physical density of bodies or their dematerialization.

In a forest, in a desert, or on the sea, we are irresistibly drawn to the magic of silence and of sounds. Toward the middle of the nineteenth century, in Schopenhauer, who elevates and fully ennobles the feeling for nature by placing it on the same plane as musical sensibility, we can find a wonderful synthesis of the ways in which we can qualify and evoke places aesthetically. In the *Supplements* to the Third Book of *The World as Will and Representation* (1844, Ital. trans. 1986), in the section titled "Detached Observations on the Beauty of Nature," he writes, "How aesthetic is nature" (418), referring to its truth and its spontaneity, as he praises the English style in contrast to the French, thereby demonstrating how responsive he is to the changing context of the aesthetic categories. These reflections take us to certain earlier passages in paragraph thirty-nine of *The World as Will and Representation*, where he discusses the feeling of the sublime and the varieties of nature in the representation of our spirit. In this passage, where consciousness is described as a process of dissolution into nothingness, we become one with the world, like a drop of water in the ocean. Schopenhauer thinks that many of the objects of our intuition cause us to experience the sublime because, through their vastness and ancientness, in other words their duration, we feel reduced to nothing in their presence, and we are filled with joy as we contemplate them; the high mountains, the pyramids, the colossal ruins of ancient temples belong in this category. The cathartic effect and the principle of annihilation play their role when we aim to grasp the true quality of feeling and contemplation.

He points out how, in all of its processes, thought seeks to follow the method of nature after receiving from it, through contact, the appropriate stimulus. This observation, in effect, leads

us back to the relationship between the forms of nature and the representations of the mind, as the foundation of an aesthetic of the landscape. What captures our attention in particular is the following passage: "A beautiful vista is, therefore, a catharsis for the spirit, as music is for the soul according to Aristotle, and in its presence, we think in the most correct way" (Ibid. 418).

Because of the infinity that defines it and the spiritual edification it promotes, the beautiful vista is linked to an extraordinary interpretation. It is the highest valorization of so-called "natural beauty": nature compared to music. For Schopenhauer, music occupies the highest position in the hierarchy of the arts, because it is on the same level as ideas, and is independent of the world of phenomena. The concept of nature as catharsis of the spirit derives from Schopenhauer's view that the experience of the world of ideas becomes, at once, an aesthetic and an artistic experience. This revolves around the contemplation-intuition relationship.

What happens to the subject and the object in this contemplative-intuitive relationship? The individual frees himself or herself from all the ties produced while moving normally in the phenomenal world, pushed by the will and armed with the principle of reason: with respect to an object, for example the landscape, he or she almost ceases to exist as a phenomenal individual bound by the will, and is reduced to nothing but "pure subject." In this way, both the subject and the object dissolve all relationships with other objects. What we know, then, is no longer the individual thing as such but the idea, the eternal form. The person who contemplates and intuits is no longer an individual but a pure knowing subject beyond will, pain, and time.

The reference to music highlights cadences and rhythms, similarity and dissimilarity of forms, structures extended in space or superimposed, alternating modes of shaping and sculpting time through which the morphology of the territory unveils the marvels of the landscape.

From the Baroque period to Romanticism, "garden music" was composed, not only concert music but also Aeolian harps, sonorous fountains which, with their spurting jets of water and their harmonious lapping (waterworks, cascades, spouts, for example) served to provide acoustic sensations paralleling visual sensations. The sounds produced by the natural flow of water, glass bells that began to sound when water gushed from the fountain's jets, echo effects, and mechanisms capable of imitating sounds were all experienced in the course of a garden tour. Even today, with environmental music or certain works of *Ecological Art* we find examples of sound installations in the landscape.

Finally, I might add that, in some of his films, a director like Eisenstein reads the landscape as though it were a musical score, with preludes, fugues, and symphonic variations. The musical inspiration of such directors as Dovzhenko (*The Earth*), Tarkovsky, Duras, Pasolini, and Flaherty is, instead, quite different.

5.5 EPIPHANIES OF SIGHT

In an enchantment of forms, grace and ideal beauty reveal the wonder of the *hyle*, the splendour of matter. This is the wonder we encounter in the work of Poussin and Lorrain. We can, however, find another word to describe this sweet revelation: Arcadia, the emanation of the spiritual landscape. Having turned into a literary and artistic myth in the modern era, it represents the land of love, of poetry, the world discovered by Virgil, who was influenced by the short stories of Polibius and the idylls of Theocritus. From this is born the image of a serene Arcadia, its shepherds, the song of Pan (inventor of the flute), Poliphemus, Anphion, and Zethos. On the basis of these literary sources, Virgil invents Arcadia as we know it today: an unreal, dreamy, mythic site where men and gods lived together, which was uncommon for the Greeks. Virgil fuses the world of Theocritus, populated by Sicilian shepherds, and the Greek mythic world.

He reworks the structure and the figures of bucolic poetry, which includes Daphne's lament, by creating the image of unhappy shepherds in love. Theocritus' irony becomes genuine pathos. In Virgil's work, the shepherds appear as refined men whose mark of distinction is their grace and finesse. In sum, they are sentimentalists even though they cannot be defined as romantics. This is an imaginary Arcadia in which is extolled the pastoral life, enhanced by good taste, free of harshness, conflicts, and anxieties, far from the hard rustic life. As the picture of a golden age, it is a land of nostalgia. Virgil tries to find there formal perfection, beauty, and harmony. In this sense, Arcadia is the site of an idealized quotidian life, an ideal site of poetry, an escape from daily living, a refuge in a world of feeling, where the spirit is in contact with the Muses. Oneiric visions and amorous abandonment flow freely there.

As Snell states, Virgil, and the Romans with him, translated and transformed the Greek mythic world into allegories and symbols. Virgil's Arcadia is the home of the soul and poetry: "It is not only an in-between place, one that lies between myth and reality; it also represents a place of transition from one epoch to another; it is a sort of earthly supernatural, home for the soul that yearns for its distant homeland" (1945, Ital. trans. 1963, 409),

We find that this same idea of the earthly supernatural reappears cyclically throughout the history of our civilization, but especially in the eighteenth century, in both painting and literature. Arcadia is perceived as the grace of a site, the calming of passions, the aura of Paradise. In the eighteenth century Arcadia is Italia, and particularly Rome, the triumph of antiquity, from Mengs to Winckelmann, from Soane to the Adams brothers, and from Reynolds to Kauffmann. As well, the Academy of Arcadia, a circle of intellectuals, artists, and *illuminati*, was, in the first half of that century, the expression of attentiveness to the landscape, whose principles were found in the taste of the *connoisseur* and in anti-Baroque design. At the same time, it can

be defined as an aesthetic category that added the pastoral and the sublime to grace. Once again, we find a precedent in Virgil himself. We need only to think of certain diversions in the *locus amoenus*, as when on Mt Maenalus, covered with whispering woods and "loquacious" pines, we have the tragic scene of Damon, the first singer of *Eclogue* 8. This desperate lover sings at the break of dawn as he leans on a walking stick made of olive wood. With its mountains and crags, Arcadia is also the wild backdrop for the desperation of the poet Gallus (*Eclogue* 10) who, as he stands at the foot of a desolate cliff, among icy rocks, raises his lover's lament to the heavens.

The paintings of Guercino and Poussin in the first decades of the seventeenth century captured the imagination of artists and intellectuals. The phrase "Et in Arcadia ego" [Even in Arcadia, there am I] reverberated throughout eighteenth-century Europe, and it could be found in the works of Goethe and subsequently in those of Koch, Fohr, and Horny, for whom Olevano and its environs became the last Arcadia. Historically, having been a stylistic exercise, Arcadian and elegiac poetry were reborn in the world of Lorenzo de'Medici and influenced the whole of Italian culture: Sannazaro in Naples, Boiardo and Tebaldeo in Ferrara, and the young Bembo in Ferrara and Venice. As Romano (1991, 55–6) contends, we can find a "parody" of the literary Arcadia in the domain of the figurative arts, in Piero di Cosimo's Oxford *Forest Fire* with its strange feeling for the landscape, which corresponds to the natural philosophy of Leonardo; and we can then note the recurrence of a genuinely Arcadian vision in Fra' Bartolomeo, Giorgione, and Bachiacca. From these works issued numerous styles, mannerisms, and theories.

It is possible to argue, as does Panofsky (1936, Ital. trans. 1996, 277–301) that there are two Arcadias: a sweet, mythic, dreamy one, and a hard, harsh, obscure one. The first is the site of a bucolic retreat, of tranquility, and amorous abandon. The other is the site of the primitive, fear, and the sense of death. The

passage from one to the other is perhaps already evident in Sannazaro himself, in whose Arcadia coexist two elements, namely, tranquility and excitement, or in Poussin's *Landscape with a Man Killed by a Serpent* (c. 1648). The fact that such an aura is contaminated, tainted by its opposite, which, developing a sentimental theme, leads from love to *vanitas,* lends strength and grandeur to the classical idea of fear fixed and transformed by the harmony of grace. This dual aspect of Arcadia, however, can already be found in Virgil's mixing of the bucolic and the sublime, as noted above.

In the English eighteenth century, this aesthetic ideal enjoyed great success, coinciding as it did with the three versions that Händel produced of Guarini's pastoral tragicomedy, *Il pastor fido* (The Faithful Shepherd)(1590), composed between 1712 and 1734. We find this cultural climate in the picturesque gardens and landscapes of the period. In hybrid style, English gentlemen felt themselves immersed in the Roman characters, in an ancient world wholly revived. The display of the period and of the soul returns, like an obsession, as the myth of historical invention. The destiny of Arcadia goes from Virgil's evocation to the invention of the English landscape.

PART THREE

Morphologies

6

Morphology of Natural Beauties

6.1 COLOURS OF WATER

Scientific texts describe water as a colourless and tasteless liquid. Although very important, this definition does not apply to aesthetic perception, which relies on sensibility and the imagination. Furthermore, the creative experience of art demonstrates that water has its own radiant beauty, consisting of light, colours, sounds, tastes, and even fragrances. It would not be surprising to discover that someone had composed an "ode to water," possibly in the sixteenth or seventeenth century. It is an aspect of the wonder of the elements, the fundamental components of the physical world, which can be seen either in harmony or in conflict with each other. In the structure of the cosmos and in its symbolic image and infinite analogies, water is associated with winter, vital lymph fluid, the combination of humidity and cold, the colour white and, in this context, it tends to inspire a phlegmatic temperament. However, leaving aside the strictly symbolic or alchemic aspects of nature, what should be emphasized is the physical difference of its forms: vapour, rain, ice, snow, dew, and the like; it is embraced by the air, the wind, or the earth; it assumes the form of a spring, stream, river, lake, marsh, pond, or ocean. It presents itself in a spectrum of wavelengths and qualities: it may

be clear, crystalline, fresh, or pure, but it may also be muddy, fetid, marshy, turbid, salty, effervescent, or aromatic. It offers us a host of images and representations linked to the pleasure of gushing or spraying waters, springs, water jets, and eddies. We have endless descriptions, sensations, and impressions if we also consider its motion, from ripples to waves. Each and every configuration is a form of expression: with their spirals of foam, whirlpools stir the soul, while gently flowing rivers restore to us the image of a more regular rhythm of life. The imagination encounters a world of joy: springs are inhabited by the spirits of the water. Symbolism always arises at the same time as and alongside the morphological presence: water is blessed, water cures, waters purifies, in the vivid presence of benevolent or malevolent divinities. In different traditions, various washing rituals are performed. There is also an alchemical rhetoric of the washing, in the philosopher's stone that is born in the water and generated in the air.

A water cult exists: the water that springs directly from the depths or from the rocks and functions as a gift from the primordial divinities; but also the water that falls from the skies like grace from a god who resides there.

Water is the source of life in several creation myths, but it is also a principle of dissolution, loss, dispersal, and obliteration. Behind all of this are the creatures of the water (nymphs, melusines, and sirens, for example) in a fantastic interpretation of seductive play that corresponds to a rich iconography displaying the wonders of mysterious creatures that enchant and terrify. The same is true for the earth and sky.

Myths, beliefs, and rituals originate in grottos and cascades depicted in literature and paintings from the earliest civilizations. These places are marvels of the landscape or of artificial gardens designed by humans. They are two wonders that complement each other: one is natural and the other is the product of a beautiful imitation. Between the sixteenth and seventeenth centuries, we find a virtual obsession with water, a passionate

quest to organize its spectacular effects, which are not considered to be mere ornaments or decorations of the garden. This notion appears clearly in the late sixteenth-century writings of Palissy or in the seventeenth-century works of De Caus, Couard, and Boyceau de La Baraudière. The pleasure of water displays can also be linked to the oneiric principle of disappearance, which expresses a desire for the infinite and for profundity. As Bachelard points out in *L'Eau et les rêves* (Water and Dreams, 1942), the destiny of humanity is to draw its image of profundity or infinity from the destiny of waters: a delirium of dissolution of the self in deep water or in the distant horizon.

Colours translate the perceptive and affective spheres of individuals and of peoples within a broad physical, cultural, and symbolic spectrum. The colours of a landscape depend largely on the light, the season, and the meteorological conditions. Observations with respect to colours, therefore, depend on subjective interpretation more than do other kinds of observation, because the eye, guided by aesthetic norms, selects objects on the basis of modes it considers distinctive and tends to transform them into absolutes. From the standpoint of physics, colours are elements that constitute light and stimulate different sensations. In relation to the wavelength of their rays, they are captured by the human eye and converted into sensations by the nervous system.

In his *Observations on Modern Gardening* (1770), Whately describes the effects of water as well as the patterns of vegetation, woods, and mountain slopes. Water presents itself as a painting or a literary passage, producing aesthetic emotions that range from fear to wonder, as dictated by the prevailing categories of taste.

Fountains and nymphaea were already in existence in ancient Greece. The fountain is the product of the meeting of sculpture and architecture; we recognize the fountain as ornament, function, and exaltation of nature's vitality, while the nymphaeum is a place sacred to the nymphs. The Greeks and the Romans built

monuments in honour of such creatures of the mythological imagination and, at the same time, they had different designated uses for grottos, cascades, and natural springs. Nymphaea are like apses that provide shelter for the eyes and the spirit, and they are meant to evoke the image of natural grottos. Water jets are arranged so as to complement the structure of buildings or sculptures, and they appear as forms in transformation, which remind us of musical compositions. Furthermore, the nymphaea, and especially the *musaea*, an ensemble of natural and artificial grottos, were arranged so as to receive or shut out the sun. The spectacle of water was associated with the spectacle of light and colour.

Cascades have always fascinated us. For Starobinski (1999, 66), the picturesque image of water crashing over rocks has a symbolic value related to the theme of ruins because both exploit the figure of time, of days that pass, of life that vanishes. The waterfall can, therefore, be read as an open-air display of *vanitas*. When, as sometimes happens, a mill appears next to a current flowing towards us, as in some of the works of Ruysdael, Rembrandt, and others, the resulting sense of solitude is not the expression of some savage force. The site becomes humanized and inhabited; shock is kept in check by the artifice of technical knowledge. Often the gaze coming to rest on the waterfall is invited to elevate itself and to meet the mountaintops from which the waters descend. The upward movement is experienced as the counterpart of the shock produced by the cascade. We live the double stimulus of the mountaintops that we see and of the rushing waters that draw our gaze downward. Ruskin gives us a very beautiful description of the waterfall at Schaffhausen, seen from the North, as he describes "a foam-globe that from above darts over it like a falling star" (1843–60, vol. I, 529), a water-jet that fills the air with light as below the spirals of the disturbing, deafening abyss appear. "The blue of the water, made pale by the foam, appears to him as purer than the sky, behind the white rainclouds" (Ibid. 530), around masses of dripping leaves, moss-covered rocks,

drooping clusters of emerald plants, and white dew sparkling on branches amid stripes of purple and silver.

Found commonly in sixteenth-century gardens, together with statues, architectural elements, and mantles of greenery, water becomes a material that art moulds into forms of movement. In the garden, it is the most striking element of the grandest scenery. Fountains, cascades, and the play of water create a theatre, producing Vitruvian motifs from the *Scena satirica*, adorned with trees, grottos, mountains, and other rustic or pastoral elements. Here, an untamed nature meets an artificial nature. It is the triumph of Mannerism and then of the Baroque. Water unleashes the marvellous. We react with wonder to the images that Bernardo Buontalenti (1536–1603) prepared for the *Judgment of Paris*, with gushing fountains, jagged outcroppings, and a churning sea, along with depictions of fires, places lashed by the winds as the scene is traversed by figures in flight. Thanks to the new hydraulic systems, the use of fountains that rejuvenate ancient myths became widespread between the sixteenth and seventeenth centuries. The builders of the fountains in Villa d'Este, Bagnaia, Pratolino, and other gardens were like sculptors and architects working with water. Water effects were combined with light effects and sound to produce a sensorial dialogue between humans and nature in a synaesthesic spectacle.

For centuries fear of the Great Flood dominated the lives of humans. The myth of the catastrophic flood retold during the Sumerian-Babylonian epoch, in the Bible, and in other myths, veiled the spectre of the end of the world. In the second half of the seventeenth century, the Flood story generated a great deal of interest and its influence was felt even in the years that followed, giving rise to theories that mountains or marine abysses were the product of an upheaval caused by this terrible natural phenomenon; it was interpreted as a manifestation of divine anger. The terror of the Flood, however, was actually present in the collective European unconscious for some time; records of the period indicate that in 1525 there was a moment of real panic.

According to Burnet (1699), before the Great Flood, the
earth's surface was smooth, regular, and uniform, with no
mountains, cliffs, or seas, and as flat as the Elysian Fields. It
contained every form of life and remained that way for hun-
dreds of years. In his *Commentary on Genesis*, Luther (1483–
1546) expresses a similar view in his description of the destruc-
tion of Paradise: the mountains had replaced the plains and the
moors, and the floodwaters had formed the Mediterranean.
Throughout the eighteenth century the image of such a disaster
recurs with obsessive frequency. In his *Physica Sacra* of 1731,
Swiss naturalist Scheuchzer thought that animal and plant fos-
sils found in the Alps were evidence of the effects of the Flood.
In 1726 he even declared that he had found the fossilized skele-
ton of a "sinner" who, in his opinion, had perished during the
Great Flood, in precisely 2306 BC. The fossil won him interna-
tional fame; he gave lectures throughout the world and pub-
lished on the historical accuracy of the Sacred Scriptures. The
theory of the flood catastrophe had already been challenged by a
naturalist physician named Antonio Vallisneri, and then by
Anton Lazzaro Moro. At the start of the nineteenth-century,
paleontologist Cuvier correctly identified the fossil as the skele-
ton of a giant salamander.

The Great Flood was interpreted as a spatial-temporal rup-
ture and, at the same time, as a journey towards salvation. The
catastrophe was seen as the sign of a covenant, or as a new cove-
nant between humanity and God. We find this theme of hu-
manity's salvation in various ancient narratives, from the
Sumerian-Babylonian *Epic of Gilgemesh* to the Greek myth of
Deucalion and Pyrrha. By obliterating forms of life not accept-
able to the divine powers, the universal floods interrupt more
ancient cycles of creation. From these, a theology of water is
born. In different myths and beliefs, we can find this element in
its sacredness, expressed in both positive and negative terms,
and we can also interpret it as the balance between Order and

Chaos, and as grace. In general terms, God is also the God of nature: "You visit the earth and water it, / make it abundantly fertile. / God's stream is filled with water; / with it you supply the world with grain" (*Psalm* 65, 10–12).

Whether they are those of the archaic taste of the atrium mosaic in St Mark's Basilica in Venice (*Stories of Noah*), the frescoes of Paolo Uccello, the paintings of Leonardo, the canvasses of Poussin, or Turner's engravings, makes little difference; the waters of the Flood recreate for us the drama of a theology of water from the standpoint of different aesthetic feelings.

6.2 THE TRANSPARENCY AND OPACITY OF THE SKY

We consecrate land and we consecrate water. The sky, however, is a gift or grace that requires no human intervention. It can be the space between the clouds and the stars, the abode of the gods or of God, or perhaps the realm of the dead whose souls have been saved. It is a concept that incorporates meteorology, astronomy, and astrology, and we find within it theological theories pertaining to the origins of the cosmos. The creation myths describe the marriage of earth and sky. In the Bible the sky is the throne of God and is represented as divided into levels and vaults, which are the seats of angels of different orders. It is semi-transcendent. In ancient Chinese symbolism, instead, the sky represents the energy moved by the destiny that directs all things terrestrial; it is a cosmological image in which the sky does not appear as a symbol of the afterlife. These different cultural conceptualizations coincide with different depictions in the world of art and in the human spirit.

The sky is the airy vault that surrounds the earth; it is a blue dome, which is clear by day, dark and star-studded by night. Beyond all possible religious and metaphorical meanings, the sky is the subject of an infinite number of representations.

The air comprises humidity and heat, in which we immerse ourselves with complete abandon. We think of it as analogous to springtime, blood, the heart, and vibrant colours. Its temperament is sanguine. As Ruskin points out, however, the principle on which we must base our description of the sky is the observation of a given object in the spirit of contemplation. Aqueous vapour forms clouds or fog, producing spectra of colours that range from the opaque to the transparent. If you look closely at the pure blue of a clear sky, Ruskin says, you will see great variety and fullness in the serene expanse. It is never a flat colour but, rather, a transparent body whose shimmering depth we can plumb. It is air composed of veils, which we penetrate, and which offer us a continuous play of light and shadow. The clouds are a few of the many surprising things about the sky. Clouds can have different forms and colours. Like the stars, the sun, and the moon, they form part of the beauty of that which is above us. They appear as scattered by the vortex of the wind or as compact as an army unit.

It can be generally said that, in the art of the cosmos, the sky is the sublime par excellence. Ruskin (1843–1860, vol. 1, 92–5) states that the sublime is the effect produced in the human mind by all that overwhelms it; the sublime is prompted by contemplation of vastness in all its forms, but above all by the most noble objects. There we find the majesty of matter and space, power, virtue, and beauty. The aesthetic perception of the sky corresponds to this idea of elevation and awe. In this line of thought, we can identify the lesson of Pseudo-Longinus, but the criticism of Burke is also apparent. The beauty of natural phenomena is not limited to a purely psychophysical response. The fear of death, around which Burke's thesis revolves, is not a feeling but an instinctive shudder, according to Ruskin. The truly great feeling is contemplation and the notion of fate, not the moment we recoil in horror before an event. He insists that there is nothing sublime in the agony of terror. Even danger and

pain are not by nature sublime; they are so because contempla-
tion evokes strength or pity, elevates the mind, and shields
thought from vileness. Behind this criticism, we can see argu-
ments already made by Knight a few decades earlier, even
though Ruskin does not cite him. However, the reference is not
accidental, since Knight, with his associationist theory, was
probably the first great admirer of Turner.

Ruskin (Ibid.) illustrates for us the truth of the earth, sky, wa-
ter, and vegetation. He points out that laws as precise as those
that regulate the structure of animal life regulate the appearance
of the earth; to violate those laws would be unforgivable. In
landscape painting, these are the foundation of every aesthetic
discovery. For Ruskin, the truth of the earth is the faithful repre-
sentation of the forms of the soil, stripped of its vegetation by
the action of water. In every "sublime" composition of nature
and art, he argues, this anatomy must be seen in its pure bare-
ness. For the landscape painter, the land is analogous to the hu-
man body. For example, the mountains are to the rest of nature
what violent muscle contraction is to the human body: there is
an analogy between muscles and tendons, passions and ten-
sions, convulsive energies and the articulation of the terrain.
What is more, the spirit of the highlands is action, while that of
the lowlands is rest; between the two lie degrees of motion and
stillness. Description of the terrain, from the point of view of
aesthetic and artistic feeling, develops on this basis. It is con-
templation, not mere descriptivism or a simple state of mind,
that determines this vision or theory of nature in the landscape.

The truth of water also appears in the complex morphology of
natural beauties. It is the source of all the changing beauty we see
in the clouds, and it has the grace or drama of many different
forms, from the spray of rapids to the density of ice. Ruskin asks
himself: "To what shall we compare the beauty of this powerful
and universal element? How can we reproduce the eternal vari-
ability of the spirit that animates it? It is like trying to paint a

spirit" (Ibid. 423). We find here the theme of contemplation as
aesthetic theory of the landscape. A faithful representation of the
givens of the cosmos is impossible. Therefore, he suggests the fol-
lowing: you must look into the distance, into the depths; start
with the fact that there is no marsh, or pond at the edge of a road,
or cloud fragment in which you cannot find a landscape as com-
plex as that which extends all around us. In general, Ruskin is
quite critical of well-known landscape painters incapable of cap-
turing the relationship between the incidence of light and the
quality of matter. Those who have not studied nature in depth
(the casual observer or the painter) cannot succeed. Only in this
way can we find grace and evanescence, along with transparency,
obscurity, and the perception of elements as they appear in rela-
tion to light and colour. This truth also pertains to the vegetation
produced by foliage, and by trees: first trunks, then branches,
leaves, and buds. We must be aware of the variety of nature in
terms of both its totality and the details of a single branch.

The truth of the sky, water, earth, and vegetation is subsumed
in a naturalist ideal based on the principle of the associative
imagination, of the relationship between feeling and the laws of
the cosmos. It is an ideal concerned only with things, but, at the
same time, it projects art as a product of the imagination. The
naturalist succeeds in pursuing this ideal precisely through this
principle of association; for instance, by mixing and juxtaposing
colours to make them more vivid. Turner is universally praised
for this quality.

Ruskin enunciates the principle of close observation for the
purpose of capturing the truth of nature. Before us lie countless
exquisite effects, which are absolutely inexplicable and must be
seen to be believed. The combinations and applications of possi-
ble laws are many and complex. No science can reproduce them.
It is not so much fantasy, sensibility, and imagination that deter-
mine the domain, but attentive observation, experience, love, and
study. Contemplation is linked to the disposition towards the ide-
ality of art; the task of the painter is to search for the ideal form

and to arrive at a precise knowledge of the particular qualities and properties of entities. There is an ideal form of stone, clay, granite, and marble. The ideal of art consists of the most elevated manifestation of properties. From this follows the need to attribute the right species of moss to a stone and the right type of wood to a tree trunk. Every irregular or arbitrary association is wrong. Ruskin speaks of the theoretical faculty in referring to the aesthetic faculty. The impressions inspired by beauty are neither sensorial nor intellectual, but moral. Every true landscape, whether simple or lofty, is interesting only if it has a relationship with human experience and the power of the spirit.

All the truths of the elements, the colours, and the light, are interconnected. The senses must be educated to perceive these interconnections. According to Ruskin (Ibid. 144), the capacity to perceive any natural object depends on our ability to concentrate all our imaginative power on it, thinking of the object as a centre that creates "a garland of thoughts" around it. But it is also necessary to doubt methodically any conviction that we have actually seen what our eyes perceive. Referring to Locke, Ruskin (Ibid. 108) states that there is no perception if the physical changes do not register in the mind; in other words, if we do not become internally aware of external stimuli. One who contemplates does not see the colours of a tree or the sky as a painter, nor the fibres of a branch as a natural scientist; he or she does not experience the emotions of a sentimentalist, nor the ecstasy of an idealist, but, within that individual, imagination, perception, and feeling converge in perfect harmony.

6.3 THE LUMINOUS PROPERTIES OF THE EARTH

From a symbolic and architectural perspective, the earth is humanity's temple. It is sacred by reason of its fertility, the splendour of its objects – a living divinity. It is Gaya, *pammeteira*, *potnia* (mother of all creatures). It returns us to our origins: the

clay earth, in many creation myths, is the matter out of which humans are made.

Attributed to the combination of dryness and the cold by our symbolic tradition, the earth element is placed in relation to autumn, black bile, spleen, and the colour of lead. Its dominant aspect is melancholy.

In Greek tradition, the earth is represented as a Goddess Mother (Greek *Gaya*, Latin *Tellus*). In his *Agamemnon*, Aeschylus writes: "Hail to thee, o Earth, mother of men; you grow in the embrace of the god, abound in fruit for the benefit of humanity." The marriage of sky and earth is the basis, then, of many ancient rituals and myths, especially the fertility cults. Gaya engenders a very rich genealogy of stories; she is subsequently distinguished from Demeter, Mother Earth, of the second generation of divinities. Demeter searches, in a very human fashion, for her daughter Persephone, who has been abducted by Hades. In the *Homeric Hymn to Demeter*, the goddess is portrayed as a "wondrous, radiant blossom, awesome for all to view" (53); from her roots a hundred flowers bloom and fill the air, the sea, and the earth with their fragrance. In its resolution, the story of her abduction gives rise to the seasons, in a representation in which humans participate in the cycles of nature. Each year, Persephone is permitted to leave the Underworld to be reunited with her mother on Olympus during the growing period and to return at the time of sowing. In Roman antiquity, the sacred goddess Tellus gives birth to the natural phenomena and is depicted holding a cornucopia. She also possesses healing powers in the herbs she uses to relieve pain. From those and subsequent Christian depictions, we are able to understand the meaning of this figure in terms of the imagination and artistic creativity.

Perceived and conceived as part of the design of cosmic reality and the nature of origins and the landscape, the earth is essentially a manifestation of serenity and joy, behind which anguish can also hide, as Oswald Spengler has pointed out in *The*

Decline of the West, even though he has done so in the context of his "prophetic conservatism." In some passages, he describes the disquiet of human beings in the face of the blind, dreamy existence of the earth that disappears into darkness at night, in the fading of light, in the silence of the plains and the entire forest. In such a vision, night awakens in us a sense of mystery, the anguish of the invisible.

Both joy and torment, the earth is the mother of human destiny, and disasters such as desolation are part of it. The entire landscape can be seen in terms of disaster: that of buildings through ruins or that of nature through catastrophe. An ideal continuity exists between these two facts, as we can understand from the fascination mixed with terror experienced by Goethe as he stands before the iron grating of the Colosseum. It is a narrative continuity. The landscape itself can be read or interpreted as the sequence of a spontaneous language or a rhetorical compilation of images, symbols, and interpretive pathways. To stroll along a country lane is something that we organize instantaneously, the moment we start to walk, but that somehow precedes us. Our life encounters the life of nature. In a world of impressions, signs, visions, smells, and physical sensations, the gaze creates the sense of our position, but the spirit of narration gives the whole unity. It is a synthesis of heterogeneous phenomena, a connectedness of sites, vistas, events, and experiences. The importance and meaning of a place can be appreciated only as part of a movement towards or away, always in relation to other things.

In descriptions of the land, rock formations always attract us. In artworks, we find the rocky terrain of Giotto, Ghirlandaio, Mantegna, Andrea del Castagno, Leonardo, and others, up to the Romantics and the Impressionists. These formations, however, conceal a secret. The rocks, in fact, are a storehouse of images; they may contain a sort of script that condenses the world through quirks of colour and design. In general, as Caillois

(1970) claims: "Stones possess a certain solemnity, something immutable and extreme, something imperishable or already perished. They are seductive because of their innate, infallible, and immediate beauty that owes nothing to anyone. Of necessity perfect, but it excludes the idea of perfection, so as not to allow approximations, errors, or excesses. In this sense, this spontaneous beauty precedes and surpasses the concept of beauty itself" (Ital. trans. 1986, 7–8).

They require no inventiveness, talent, or ability – nothing that would pass for a human work of art. They present us with something complete and invite us to think that there must be a general beauty, which is anterior to and vaster than that which humans can intuit; this also holds true for roots, shells, wings, and the like. All these things contribute to giving us the idea of the proportions and the laws of this general beauty, which we can hypothesize. In relation to it, human beauty represents only one formulation among many. Once more, an aesthetic of nature takes form. Caillois goes so far as to propose a universal aesthetic (Ibid. 10) in which practically every imaginative impulse of human beings would be already realized. In China, writers and poets saw in a perforated stone mountains, cascades, grottos, pathways, and abysses. Elsewhere, there are those who try to read the mosses, grasses, and blossoming branches: on moss they see agates, a forest, a landscape, or flashes of lightning and storm clouds. These manifestations of matter are also a source of wonder: needle-shaped tufts of quartz, dark caverns of amethyst geodes, carved or polished layers of rhodochrosite agate or variscite, crystals of fluorite, golden, polygonal crystals of pyrite, the simple curves of jasper or malachite, and lapis lazuli with its harmonious veining, shimmer in their purity, splendour, and colour before the eyes of enthusiasts.

To the secrets of the stones we can add those of underground caves, whether they are the product of nature or of human effort. Caves are concealed worlds that offer visitors the enchantment of

ornaments and pigmentation depending on their location in relation to the ocean or the mountains. Of varying dimensions, they have been adapted as habitats or as sacred places. Sites of divinities and oracles, homes of seers and hermits, and places where visions (that of John at Patmos, for instance) or prophetic dreams (that of the Seven Sleepers of Ephesus) occur, where two worlds (one external and the other internal) meet, caves emit an aura of mystery and beauty, which nature was able to create by means of its transformations, the phenomena of erosion. Pausanias (VIII, 42, 1) recalls the cave where the grief-stricken Demeter shuts herself up after the abduction of her daughter: a sacred site on Mt Elaios near Phigalia, around which there is a wood and a spring. It is no accident that Hermes, the messenger of the gods, the lord of Arcadia, perpetually shuttling between the realm of humans and that of the gods, was born in a cave.

From ancient time, grottos have been used in the creation of gardens and parks as sites of ornamentation that arouse awe. Stalactites, stalagmites, light effects, and cascades have been reproduced artificially. Caves are like a hidden cabinet of wonders, natural treasures to be imitated, precious things revealed in matter. The artificial grotto becomes established especially in the late sixteenth century as part of the Mannerist movement. The one created by Buontalenti (1576) for the Boboli gardens in Florence remains famous. According to the taste of that period, what is important is the aesthetic pleasure of something magical and mineral, something harsh, archaic, dramatic, surprising, or theatrical, with a mythological aspect. This is where the natural or artificial grotto comes into play. A kind of fascination prolongs the mystery of nature, which is re-presented in the art of human beings. In its magnificence, the Italian garden revives ancient mythology by reinventing it. It does so by adopting rhetorical strategies: the arrangement of the trees, plants, flowers, the imitation temples and ruins in a diegetic sequence. If we wish to

draw an analogy, in its variety, the garden appears to be constructed like a story. In particular, it can be compared to a lyrical discourse as Hofmannsthal (1903, Ital. trans. 1991) has suggested. According to him, the gardener uses flowers, bushes, and hedges as a poet uses words; he arranges them in a particular, new, and extraordinary way, with an eye to creating harmony through their juxtaposition, as the poet does with words. In this, it can be said that there is a soul, because the beauty of gardens does not depend on this or that material but on an unlimited combination of materials.

The grotto calls to mind the image of Dante's subterranean Hell. As Battisti says in *Antirinascimento* (Anti-Renaissance), it looks like an inverted dome, turned earthward, rather than heavenward; its interest does not derive from the part that is most illuminated but from the darkest corner. The grotto, the artificial grotto as well, takes us into the heart of nature in a loving, and frightening, journey of exploration. It is a reconstruction that imitates or simulates the mythical world, evoking nostalgia in the process.

Grottos are humanity's oldest sanctuaries, with their walls covered in graffiti and paintings, while the niche is a miniature grotto. We can interpret them as wombs of a parturient nature. At times, they have been seen as the dwelling places of gnomes and dragons. They represent a descent into timeless darkness and into a superior form of life. From this, we can understand the enormous significance of Plato's allegory of the cave.

In the texts of Homer, Ovid, and Apuleius, the cave is a symbol of the totality of nature, the primordial mother of mythology, and it represents the indivisible reality of the human and the divine cosmos, as we can see in Porphyry's (c. 232–305) *On the Cave of the Nymphs in the Thirteenth Book of the Odyssey*, which is an allegorical reading of the Homeric epic. For the Greeks, caverns, grottos, and caves were symbols of the matter that comprises the cosmos. The landscape, instead, evokes

myths, as myth itself is landscape because it presents itself to us in every manifestation of nature. In *The Metamorphoses*, Ovid clearly demonstrates this. He describes the harmony of the mythical world, the transformations of bodies and phenomena, the different appearances of humans and gods in the guise of trees, crags, rock formations, grottos, springs, wild animals, and so on. From the Renaissance onward, this material is no longer an object of cult, but of aesthetic pleasure; it is a parallel cult: that of taste and modern, imaginative, fabulous reconstruction.

In the sixteenth century, artificial grottos in gardens were designed like cabinets of wonders corresponding as well to alchemical fantasies. Sometimes they were passed off as the product of a prince's magical powers. Also interesting are the rustic grottos of Palissy, especially those at Ecouen and the Tuileries, where the exterior was represented by water and the interior by fire. As we can see in *Récepte veritable* (1563), the brickwork that forms the skeleton of the grotto functioned as an oven that permitted the production of multi-coloured enamels, while water was everywhere on the exterior. The brightness of the walls struck the imagination of visitors, as did the play of form and material that fused background and figures in an optical illusion.

6.4 SHADOWS OF FIRE AND THE VERTIGO OF CATASTROPHES

We find a secret image of fire in blood, in the heart, and in gleaming colours. Its season is summer, its character yellow bile, its organ the liver, and its temperament the choleric. It is natural that, out of the order of the cosmos, the actual yet mysterious profusion of elements, issue disasters that engender terror and affect the imagination on the plane both of aesthetic reception and of artistic creativity. Fire, a cosmic element, is a lethal, destructive force. Its sudden appearance and unstoppable advance troubles the mind.

During the eighteenth century, fire is associated with the desire to see volcanoes in an aesthetic journey that blends the pleasure of ruins and the cult of danger. Bernardin de Saint-Pierre (*Etudes de la nature*, 1784) says that the volcano near Naples attracts more visitors than do the delightful gardens along the coastline; the countrysides of Greece and Italy, strewn with ruins, attract more people than do the rich, cultivated lands of England; a storm painting attracts more viewers than does a tranquil scene, and the collapse of a tower draws more spectators than does the construction of one. Jean Hoüel (*Voyage pittoresque des isles de Sicile, de Malte et de Lipari*, 1782–1787) describes one of his walks along the edge of the crater of the Stromboli volcano, the horror mixed with pleasure he experiences as he examines such a terrifying sight, and he praises the magnitude and beauty of this fiery spectacle. William Beckford (1780, Ital. trans. 1995, 74–5) recalls the awe inspired in him by memorable temples, cascades, grottos, shadowy or underground places, but above all the sublimity of the volcano. He describes an excursion to the crater of Mt Etna, over frozen rock, as he lets himself be guided by the menacing light of those eternal flames spewing from the summit, along a path that winds its way among crosses erected over the tombs of unfortunate travellers who died in the course of their own expeditions up the mountain slopes. He proceeds until he sees in front of him the crater of that terrifying volcano, which the superstitious take to be the mouth of Hell. The solitude in which he finds himself, the low rumble of the volcano, and the whole frightening scene have such an effect on his imagination that he thinks he sees strange shapes descending or emerging along the steep sides of the dreaded crater. He even thinks that he hears cries of despair and screams of torment rising up from the fearsome abyss. This is a product of the imagination. Through the emphatic tone of these accounts, we are able to comprehend the aesthetic climate of the epoch, open as it was to the emotions inspired by peril.

Symbolic of this vertigo is Salvator Rosa's *Death of Empedocles in the Chasm* (1665–70).

As do cliffs, grottos, and cataracts, volcanoes exert an irresistible attraction by virtue of the contrast with the surrounding landscape, as well as the totality of effects that act on the emotions and leave reason unsatisfied. Varied in shape and in colour as a result of eruptions, the volcano is an ideal subject for the *vedutista* and the landscape painter: layers of lava, sand, mineral deposits, tracts of land covered with vegetation, large boulders from which hang partly uprooted trees. This is a curiosity that leads towards the sublime, as demonstrated in the works of Hackert (1774), Volaire (1774), and Wright of Derby (1773–74), in which the subject is the volcano. Charles-Marguerite Dupaty, author of *Lettres sur l'Italie* (Letters on Italy, written 1785 and published posthumously), visited the country in 1785 and describes the view of Vesuvius as picturesque, emphasizing the contrast between the vegetation in the foreground and the trails of soot and molten rock in the background.

From the cult of emotions developed in the eighteenth century, we can understand that the aesthetic pleasure caused by catastrophes or other large-scale natural phenomena is analogous to that inspired by human tragedies. The two representations, one natural and the other human, fuse in the imagination and correspond to a need or anxious desire to uncover the meaning of life. The great upheavals that affect the earth's surface, such as earthquakes, floods, and devastating fires, were interpreted by the ancient magical mind as the expression of hostile divine forces that upset the cosmic order; they express a principle of disorder. From the 1700s, however, attention is primarily directed towards scientific description and the aesthetic perception of nature. This signals the end of the magical mentality. The spectacle of nature fills museums with its representations, which exhibit power, speed, and immensity. Rooms reverberate with the sounds of flowing water, the formation and breaking

up of waves against an indistinct horizon between the sky and the sea, and the rustling of the wind that transforms clouds into multi-coloured, floating garlands; peaks rise, chasms appear, forests open up before us. In *Modern Painters* (1843–46), speaking of the aesthetic life and the beauty of nature that presents itself as a disturbing force to our eyes, Ruskin ponders for a moment on our ability to describe the wonder and the terror produced by a typhoon. He thus wants to explain how contemplation can become artistic enlightenment. In *Typhoon* (1903), Joseph Conrad offers us a description that captures that spirit:

> A faint burst of lightning quivered all around, as if flashed into a cavern – into a black and secret chamber of the sea, with a floor of foaming crests. It unveiled for a sinister, fluttering moment a ragged mass of clouds hanging low, the lurch of the long outlines of the ship, the black figures of men caught on the bridge, heads forward, as if petrified in the act of butting. The darkness palpitated down upon all this, and then the real thing came at last. It was something formidable and swift, like the sudden smashing of a vial of wrath. It seemed to explode all round the ship with an overpowering concussion and a rush of great waters, as if an immense dam had been blown up to the windward. In an instant the men lost touch of each other … An earthquake, a landslip, an avalanche, overtake a man incidentally, as it were – without passion. A furious gale attacks him like a personal enemy, tries to grasp his limbs, fastens upon his mind, seeks to rout his very spirit out of him. (40)

It is a short distance from this passage to the iconography of a shipwreck on T. Géricault's *The Raft of the Medusa* (1819), adrift, tossed by the wrathful wind and the raging sea with no hope of survival.

The Lisbon earthquake, commented on in the same year by Voltaire, appeared in 1756 in a vision described by Alfonso Varano (1705–1788). It was then painted by various artists, including Desprez, and was finally the object of serious reflection by Goethe (*Italian Journey*, 1786–88). It pertains to the kind of misfortune that could arouse great interest among the artists and writers of the time. It relates to the taste for catastrophes, which involves the evocation of what Pliny calls an unforgettable misfortune – a term he uses to describe the eruption of Vesuvius, followed by the seaquake that destroyed Herculaneum and Pompeii. Antiquity always inspires themes of magnitude, nobility, and tragedy enhanced by memory and celebration. Interest in catastrophes and the aesthetic pleasure derived from them assume great importance due to the attraction, the power unleashed by the transformation of the land, and the agitation that they produce in psychological terms. This suggested to an artist of our time (Walter De Maria), in the context of Land Art, the idea that natural disasters are the most elevated form of art imaginable.

In the eighteenth century themes relating to the power of nature, such as storms or tempests, were emphasized, thereby prolonging the vogue already in evidence in the preceding century. However, as Caracciolo points out, it is only in the second half of the century, when Burke reinterprets the sublime and Diderot juxtaposes "la nature brute" (brute nature) to "nature paisible" and "cultivée" (inhabitable and cultivated nature), that the representation of so-called "horrid places," with their connotations of fear and surprise prevails over "pleasant places," the sites of encounters with a smiling nature, the product of human work. The *locus amoenus* was a version of the earthly Paradise, in an extension of beautiful nature in Virgil and Isidore of Seville. As Venturi points out, this is an ideal landscape, consisting of rhetoric and poetry, destined to become an essential element of the iconology and iconography of the garden. This is also the

explanation offered by Curtius, who sees it as a source of harmony and serenity. Venturi reminds us that Venus's garden in Cyprus, described in the first book of Poliziano's *Stanze* (Stanzas, 1475–1478) is, according to the classical canon, the *locus amoenus* where everlasting spring reigns.

Dominant in the collective imagination are images of destruction or the sight of extraordinary things, from the *Burning of Troy* by Elsheimer in the early 1600s, the *Burning of the Hôtel Dieu* (1773) by Robert, and the *Destruction of Pompeii* (n.d.) by Moore, to the *Crater in the Pacific* (1772–75) by Hodges. It is picturesque passion and the sublime that extend down to us, declining in the age of cinema and television, and that also continue to exist in the taste for the exotic expressed in the desire for travel to unknown continents. For example, after executing several *vedute* in Switzerland and Germany, Hodges became the official artist on Captain Cook's second voyage to the South Seas, with instructions to capture every unusual or interesting aspect of nature in what today we might call *reportage*.

6.5 RUINS

In eighteenth-century Classicism and Rococo, paralleling the growing popularity of graveyard poetry, they placed ruins everywhere, as they imagined a future in the style of antiquity. Riding the wave of veneration of the past, a taste for the fake is blended with a serious desire for the authentic. The past returns clothed in the present, becomes spectacle, and divides as it delivers to our sensibility a devastated image of today's world. Despite the explicit references to the Greco-Roman tradition, the pleasure provided by the beauty of ruins originates in the age of the Renaissance. In many paintings of that period, we find depictions of ruins, but it is in the Age of Enlightenment that an emotion is established that demands existence for itself, independent of any allegorical meaning. It is the aesthetics of ruins whose rich

and suggestive image is recreated for us by Rose Macaulay (1953), Renzo Negri (1965), and Roland Mortier (1974).

Diderot (*Salons*, 1767) states that the effect produced by paintings of ancient ruins is one of sweet melancholy. This applies to the works of Hubert Robert, especially his *Ruines d'un arc de triomphe et d'autres monuments* (Ruins of a Triumphal Arch and Other Monuments). Captivated by the charm radiating from the ruins of a triumphal arch, a portico, a pyramid, a temple, or a palace, our gaze invites us to return to ourselves, to meditate on our present as though it were already the future, since we too are exposed to time, which will one day destroy the buildings in which we now dwell. We can imagine and project the spaces that we inhabit today in a realm of solitude and silence. Before the spectacle of ruins that survive into the present, we experience a melancholy state out of which a poetics flourishes. Reflection on ephemerality and on the transitoriness of human life turns from the ethical to the aesthetic. Like the return of an ancient stoical theme, a genuine pleasure is established, even as the vanity of our existence is acknowledged in the presence of cliffs, valleys, and forests, in a powerful embrace of nature and eternity. Starobinski (1964) interprets the poetry of ruins as, "the poetry of that which has survived destruction even though it is buried in oblivion" (155). The memory inscribed in those stones is lost in time and then dissolves in the cult of sentimentality and disorientation of the senses. This theme of remembrance and forgetfulness recurs when we speak of ruins. According to genealogy and theogony, Lethe, the river in Hades, is born of the Night. There is a profound meaning in the symbolism of these waters, which recurs in artistic and literary obsessions with the night and with death. Lethe is a feminine divinity coupled with its opposite Mnemosyne, goddess of memory and mother of the Muses. Pausanias seems to identify the spring of Lethe in Boethia, next to which gushes Mnemosyne. Behind the world of forms we discover the power of this myth.

The pleasure of ruins, as defined by Simmel early in the 1900s, arises because, although they are originally produced by humans, they are experienced essentially as a product of nature, since the same forces that carved the mountains through disintegration, erosion, landslides, and thickening vegetation have acted here on walls. The spiritual force of humanity and the forces of nature interact. Nature restores works of art to the material state from which they arose. This condition, a return to a prior state, is painful and tragic, but it is not melancholy, because conflict now prevails, no longer equilibrium, between the will of the spirit and the necessity of nature. It is a tragic outcome because the destruction does not come from the exterior, but rather from a level of existence that lies deeper than the one destroyed. Ruins inspire a sense of peace in that they express a return to the "homeland" (*Heimat*), which is to say nature. The two forces that transform the world, the tendency to ascend skyward and the tendency to fall to earth, converge in ruins to form an always changing, but calming, image of a purely natural existence. From this emanates the magical sacredness of ruins.

Simmel says that ruins insert themselves into the surrounding landscape and settle there like the trees or stones. Giambattista Marino spoke of "grassy ruins." This link between ruins and nature becomes perfectly clear in the light of the cultural climate of the eighteenth century, situated between sensibility and reason, between caprice or *arguzia* (wit) and meditation on death, between the excitement experienced by the mind and the sophisticated or frightening elegance of the imagination. For the people of that time, ruins exerted a fascination commingled with repulsion and attraction, curiosity tinged with melancholy and a sense of the tragic. This is the state of feeling in the period. The reader will recall Ippolito Pindemonte's phrase, in *Dissertazione sui giardini inglesi e sul merito di ciò all'Italia* (Dissertation on English Gardens and on Their Merits in Italy, 1792): "the beautiful horror that pleases as it saddens." It is

precisely on the basis of the pleasure of horror and terror that the theme is developed in Burke's revision of the sublime. Alongside the pleasure of the gloomy and shadowy sublime, we find the sublimity of catastrophes in history, with which ruins are associated either directly or indirectly. One of the most famous illustrations of this is the awe felt by Edward Gibbon upon seeing the Roman Forum. The approach of de Constantin François de Volney is, instead, quite different in *Les Ruines ou Meditations sur les révolutions des empires* (Ruins or Meditations on the Revolutions of Empires, 1792), which is a study of human nature from barbarism to civilization, from the work of Holbach and La Mettrie onward.

The love of castles and abbeys in a state of abandonment, covered by spontaneous vegetation, combines the taste for collection of exotic items and antiquarian taste. It is initially pleasure for the picturesque eye that delights in the play of the aesthetic effect of distance from and nearness to the past; it is, subsequently, eccentric fascination characterized by the irrational and the prodigious, influenced by the sublime and the neo-Gothic. The love of ruins is the whimsicality that generates nostalgia for the truth of human memory. It draws on Baroque and Rococo sources, intersects with Enlightenment philosophy, but does not absorb its unifying principle, and follows Romantic feeling without plumbing its depths, retaining instead a degree of its strange exuberance. On the one hand, it integrates these elements, and on the other it excludes them. It is a mentality that suggests a continual mixing, rather than a setting up of oppositions between Salvator Rosa or Lorrain and Poussin. This is an idea that, in the modern era, is pervaded by a vein of morbid fantasy, if we consider the macabre, the seventeenth-century solitude of a Marc-Antoine Girard de Saint-Amant, or the graveyard light of an Edward Young.

In *Ruins of Rome*, John Dyer blends the desolation of Rome with English poetry of the Augustan age and transposes the

Mediterranean aura into the spectacle of a foggy and melancholy nature. Carried on a wave of emotions already described in the mid-1600s by Northern poets, as Assunto notes, the pleasure of ruins counterbalances Enlightenment progressivism and perpetuates the analogy drawn by Thomas Burnet between mountains, the debris of the planet, and ruins, which are the debris of history. The subject evokes dark, fantastic atmospheres: in Thomas Gray's graveyard poetry, in Alessandro Verri's *Roman Nights* (1798), and in Alfonso Varano's *Sacred and Moral Visions* (1808), which then dissolves into a series of images similarly filled with Romantic reflections, from de Saint-Pierre, Staël, Byron, Manzoni, Chateaubriand, and Goethe, to Monti, Foscolo, and others. Alongside actual ruins, imitation ruins, as well as chinoiseries, which were taken up again by William Chambers (*A Dissertation on Oriental Gardening*, 1779), appeared in greater numbers in gardens, and Ercole Silva also discusses them in his book, *Dell'arte dei giardini inglesi* (On the Art of the English Garden, 1801). Assunto also points out that artificial ruins are no longer seen as mere ornamentation, but as a ludic evocation of "times" past in the same way that Orientalism stirs the attraction of faraway places.

As indicated above, the subject is an ancient one and, in the course of history, the cult of ruins amalgamates reflections on life, inspired by Stoicism, and intensely expressive elements. Troy in ruins, Gaius Marius meditating on the ruins of Carthage, the destroyed city mentioned by Servius Sulpicius Rufus in a letter to Cicero, the Etruscan necropolis of Populonia cited by Roman poet Rutilius Claudius Namatianus, in addition to certain apocalyptic images from the Middle Ages, constitute an initial, brief sketch of this kind of sentimental contemplation and of our dark fascination with its origins. Against this backdrop, the humanistic image of a Rome described by Petrarch, Piccolomini, Dosio, and Sannazaro is reconstituted, as well as a modern image in which ruins acquire

value, as though they were whims of the soul, in an aesthetic autonomy beyond any allegorical meaning.

6.6 AESTHETIC VALORIZATION OF THE ALPS

Petrarch and Leonardo had a fondness for the mountains: The *Ascent of Mount Ventoux* and the rocky masses painted, in their various configurations, are a testament to that fondness. It was a feeling wrapped in a mystical aura and in a naturalistic aura respectively. But the times allowed only a few people the opportunity to appreciate and to experience these auras. Even the writings of such sixteenth-century Swiss naturalists as Conrad von Gesner (1516–1565) or Benedikt Marti (1522–1574) are isolated cases. In his *Treatise on Painting* (pub. 1550), which presents a depiction of the Alps, Leonardo states that the painter must depict: "at the top of the mountains the rock that forms the summit, mostly visible in areas of terrain not covered by snows, as well as the sparse vegetation that grows there, the patches of granular soil sprouting up among the pale vegetation, and the dried roots wound around the eroded, irregular crags, growing out from twisted stumps created by humans and the wind." To find Leonardo's scientific attention to detail in a renewed sense of natural beauty, we must wait another century.

The original and inaccessible abode of the gods, the mountains have slowly surrendered their mysteries to the ascent of explorers, from Petrarch to Ruskin, who is the first to lament the inappropriate exploitation of the Alps, which he baptized "the cathedrals of the earth." In the eighteenth century, in an increasingly aesthetic valorization of the Alpine regions, many travellers continued to express negative judgments on the harsh climate and the difficulty of the terrain, which they considered monstrous, and which seemed to exist only to inspire fear. Montesquieu expressed these views during his journey from

Graz to The Hague in 1713, and Goethe never enjoyed those ter-
rifying vistas with their deep crevices and terrifying abysses.
Hegel always stayed away from mountains, which he thought
were infertile, and, also in the early part of the nineteenth cen-
tury, Chateaubriand was certainly not enthusiastic about them
during his journey to Mont Blanc (1804). The process was, nev-
ertheless, unstoppable. For Humboldt, who crossed them in
1789, the Alps brought new forms of knowledge. A few years
later, for Hölderlin they were no longer a frightening place, but
a land of aesthetic sacredness and the heart of Europe.

We can date precisely the genesis of the Alpine landscape as an
aesthetic object with the publication of the poem *Die Alpen* (The
Alps) by Albrecht Von Haller in 1729. From 1749 on, the poem
was translated into various European languages, thereby spread-
ing the image of the Alpine regions and the customs of the people
who inhabit them. The Alps are no longer inhospitable places and
become the site of a new Arcadia. In Rousseau's *La Nouvelle Hé-
loise* (1762, The New Heloise) we find several famous passages
that affirm this aesthetic valorization of the landscape:

> In this solitary place was a wild and forsaken nook; but
> filled with those sorts of beauties that are pleasing only to
> sensible souls and appear horrible to others. A mountain
> stream formed by the melting snows carried muddy water
> to within twenty paces of us, noisily ferrying with it the
> clay, sand, and rocks. Behind us a range of inaccessible
> cliffs separated the esplanade where we were standing from
> that part of the Alps which is named *les glaciers*, because
> enormous crests of ice that are constantly spreading have
> covered them since the world began. Forests of dark spruce
> shaded us gloomily on the right. On the left beyond the
> mountain stream was a large oak wood. (Part IV, Letter
> XVII to Milord Edward, 424)

In another less dramatic description we find the following: "To the east spring flowers, to the south autumn fruits, to the north the winter snows: she [nature] combined all the seasons in the same instant, every climate in the same place, contrary terrains on the same soil" (Part I, Letter XXIII to Julie, 63).

Elsewhere in the same text, the author describes the pleasure of the climb with these words:

Meditations there take on an indescribably grand and sublime character, in proportion with the objects that strike us, an indescribably tranquil delight that has nothing acrid or sensual about it. It seems that by rising above the habitation of men one leaves all base and earthly sentiments behind, in proportion as one approaches ethereal spaces the soul contracts something of their inalterable purity. There, one is grave without melancholy, peaceful without indolence, content to be and to think. (Ibid. 64)

Haller was among the first to extol the beauty of the Alps, but he was opposed to Rousseau. However, even if from different points of view, both identified those beauties for everyone's admiration, which would become common in European culture. Within a few years, intellectuals would come to appreciate both Haller's idyllic vision and the dynamic, disquieting vision we find in certain pages of the *Nouvelle Héloise*.

Like these works, de Saussure's *Voyages dans les Alpes* (Travels Through the Alps), published between 1779 and 1796, enjoyed great success. From this developed a certain *vedutismo* (view painting) from the setting up of "belvederes," that is, the study of itineraries that exploited the best points of observation, right up to the recent transformations of the landscape into an object for aesthetic consumption. We find echoes of Haller, Rousseau, and de Saussure in Ippolito Pindemonte's poem, "Ghiacciai di Bossons e

di Montanvert" (Glaciers of Bossons and Montanvert), which was inspired by a trip to Savoy and Switzerland between 1788 and 1791:

> Overcome by pleasure is the soul but inadequate
> Is the eye, which is then almost closed,
> To capture an immensity so vast.
> What a transformation!
> The soul sheds its earthly shell and each vile
> And vulgar instinct in the heart vanishes.

We can also find important pages on the aesthetic qualification of the Alpine landscape in Byron, Coleridge, and Manzoni, among others. At this point, we can see that the Alps are already the product of a culture that is tied to taste and to philosophical reality; the vision of the world has become an aesthetic ideal. The literary accounts and the illustrations provided by painters might be read as the numerous means through which the perception of the Alpine landscape is formed as an object of a varied beauty that is profoundly unsettling in many ways.

In the initial phase of this process of valorization, we find Thomas Burnet and his *Theoria sacra telluris* (Sacred Theory of Telluric Force), a work of mystical cosmography that exerted a great influence on English thinkers of the 1600s and 1700s and was read by Kant and Coleridge. In reconstructing the concept of the sublime, as it existed in the eighteenth century, we find in certain pages of Burnet's work (*De montibus: eorum magnitudine forma, situ irregulari et origine*; chapter IX of Book I), echoes of the treatise *On the Sublime*, which states that the mind is stimulated by great feelings and thoughts, by a certain indefinable grandeur and nobility. But the sublime in nature, formulated by Burnet, still fell within the climate of a Baroque vision. The sublime thus conceived leads us to imagine continuity between the Baroque and Romanticism. At certain points, he describes movement, variety, and deformity, through which interest in the

Alpine landscape changes from curiosity about the picturesque to the emotion of the sublime. He speaks of the horror of rugged, wild mountain sites that bring pleasure to the spirit, and explains that the unusual aspect and the novelty together produce a delight greater than the beauty of ordinary places. For Burnet, elements of the picturesque permit traces of the sublime to radiate through, especially when, from a wide-angle view, he describes the mountains as the ruins of a devastated world, something unexpected and marvellous, with cliffs overhanging the sea, on one side, and an endless series of mountain peaks, on the other. The image follows from that of the Biblical Flood, since Burnet thought of the mountains as the remains of a collapsing Paradise.

With Haller's poem (1729), the picturesque and the sublime are more clearly intertwined. The landscape and the pastoral and country scenes conform to the eighteenth-century fashion in poetry inspired by descriptions of the seasons, together with ways of feeling that differ from those of Swiss painter Salomon Gessner, who, inspired by Theocritus, later imagined scenes with shepherds in the Swiss Alps. For Gessner, however, these themes were experienced in relation to the solitude of peaks, the fear of chasms, or the joyful sight, from above, of rocks and lakes.

In 1787 de Saussure describes his ascent of Mont Blanc, emphasizing both the feeling of terror and the sublime, without lapsing into any sort of Baroque exaggeration. Like that of the authors mentioned above, along with the many accounts of travellers and explorers of the 1700s (J.J. Scheuchzer, J.G. Altmann, C. Meiners), de Saussure's work contributes to the aesthetic institutionalization of mountainous terrain. Thus, the historicity of the landscape (history immersed in nature) is where we can situate and analyze the evolution of taste. We cannot overlook the fact that the aesthetic discovery of mountains was in part English, owing to the work of Shaftesbury, Addison, J. Thomson, and others.

In his work on the Alps (1923), Georg Simmel contends that it is their crushing mass that overwhelms us, arouses our interest, and produces in us this aesthetic and emotional exaltation. According to this vision, the aesthetic impression surpasses the limits of the foreseeable; it is grasped in a chaotic jumble of rocky contours; at the same time, the peaks appear to us as symbols of the transcendent; they direct us toward the great beyond. Height and the dissolution of the relationship between depth and height, lead us towards something without limits, without form, towards a feeling detached from life, namely, the Transcendent, which is, precisely, beyond form. The sea, instead, is the empathy of life; it is based on the symbolic balance of forms themselves; it appears as the endless play of rhythms produced by the alternation of calmness and choppiness. It is the theme of the ascent, however, that Simmel wants to convey in his theory; it is the theme of height, the point at which valleys and rocks vanish from our view as we climb. The theme he develops is that of a "mystical sublimity"; it does not pertain to the representation of the "beautiful Alpine landscape," in other words, to a softened depiction of its components.

The image of the environment always assumes the form of our psychic life and, when he talks of a *Stimmung* of the mountain landscape, Simmel is referring to a feeling similar to the catharsis of which Schopenhauer spoke or to a kind of Nirvana. He states that the paradox of the mountain is height as an absolute; what counts is to feel with maximum energy in the face of life, with the sensation of being saved. The highest degree of sublimity would come from the contemplation of a snowy landscape, where valleys, vegetation, and dwellings no longer exist. It is the disappearance of forms, where life is redeemed.

The verticality described by Simmel causes us to consider some questions. What should we think of the endless expanses of ice on the polar continents of the globe, and of a possible human adventure in those spaces? In such a case, would the verticality of

aesthetic perception translate into a horizontality that is equally capable of aesthetic vertigo? From travel literature, we could deduce that the drive towards higher altitudes, promoted and reinforced by the crests of the peaks around us, would vanish in an infinite and anguishing image of the horizon. But it is odd to remind ourselves, nonetheless, that Mary Shelley, thinking of her Frankenstein as she travelled through Arctic lands, was inspired at Mer de Glace, on Mont Blanc, by something that is, in fact, frightening and not transcendent. As we know, and have already stated, aesthetic taste is subject to change. But what can we say of the perception of deserts, steppes, and large lacustrine areas? Here, too, we could embark on a discussion of the horizontality of aesthetic perception and its valorization.

To conclude this reflection on mountains with a remark that serves as a summary, I cannot help but agree with Schiller when he states: "On the mountains freedom dwells." (*The Bride of Messina*, Act IV, scene VII)

Conclusion

The Mirror of the Senses and of Reason

The gaze fixed on the landscape has inspired many writers and painters to immerse themselves in a vision in which they bring together the world of reality and that of dreams. The rising or setting of the sun, the alternation of day and night, as well as of the seasons, has inspired a visionariness with respect to the hours and to places. In the splendour of eternal change, a thought of Heraclitus comes to mind: "Awake, men have a common world, but each sleeper reverts to his private world" (14, A 99); this thought is echoed in another of his statements, namely: "Even sleepers are workers and collaborators of what goes on in the universe" (14, A 98). The external and the interior worlds collide and the intervention of the senses involves the dynamism of reason in a continuous process of exchange between the real and the ideal.

Alongside reality and dreams, we could also include mirages. In *Hyperion* is Hölderlin's Greece not a mirage, perhaps? What about the gardens of Alcinoö in the *Odyssey* (Book VII), the enchanted places of Lorrain, or the woods admired by Racine? We need, therefore, to consider mirages, and not only images.

The question arises, then, as to whether or not an aesthetic of the landscape exists or could exist, and when it came into existence. Certainly, the question must be seen in relation to a feeling

and a judgment of taste whose object is nature, the experience of the senses, artifice, imitation, imagination, ethics, and freedom. What emerges is a network of relationships, based on a "critique of the gaze." Especially from the 1700s on, all of these elements form a complex system within which we find the categories of beauty, grace, the sublime, the picturesque, the *je ne sais quoi*, the neo-Gothic, and more. Within the framework of models defined as historical-stylistic (Classicism, Baroque, Rococo, Romanticism, and others) and influenced by modern techniques of reproduction (photography, cinema, virtual reality), these ideas, in effect, contribute to the institution of an aesthetic of the landscape, together with an awareness that every place on earth always belongs to humankind, to its activities, and to its freedom. In their representations, allegory and symbolism are, let us say, its rhetorical expression. They produce images of something awe-inspiring, reflected as though in a mirror, the mirror of culture and history, between the senses and reason. The possible rhetorical expression of visible forms also combines with a moral gaze. In *Prelude* (Book III, vv. 124–9) Wordsworth reminds us of this when he states that we can attribute a moral life to all natural forms, be they rocks, fruit, flowers, or stones, by ascribing to them feeling and by perceiving an intimate meaning emanating from everything.

What is a natural object and what is an artificial object brings up another kind of question. The natural object can give rise to interpretative distortions if it is understood as a metaphorical expression of nature and, therefore, as something artificial. It might be better to think in terms of a polarity between nature and artifice, where humanity appears as mediator or producer, on the one hand, and user or consumer, on the other. By means of such a polarity, we find the realization of a dream, as in the case of Justus Lipsius's Heverlea, an example of a design project from roughly 1600, comprising a garden, a landscape, and a city near Lovanium, Belgium. We can also discover the emotion evoked by places seen only in the imagination, such as Avalon

or the island of Torre Vermiglia. Thus, we can say that the landscape, whether real or imaginary, is the wonder of a truth of the gaze, the mind, and the heart. Humanity and history produce it through a geography of cults, myths, and divinities. In this context nature, whether spontaneous or artificial, material or man-made, is no longer divided into two or three natures, as determined by human work and the principle of imitation; it is only one. Erasmus of Rotterdam (*Convivium religiosum*) reminds us of the eloquence of nature and of its teachings. In this text, the principal interlocutor, Eusebius, had painted on the walls of the ambulatory around the garden of his cloister images of nature, the reality of which he contemplated in the same garden. Juxtaposed in this way, real flowers and painted flowers, creative nature and human artistic genius, vied to produce a pleasure derived from the object and, at the same time, its representation. Here, indeed, we have the variety of one nature whose genius is disseminated everywhere.

The aesthetic value of nature as such, which is to say the art of the real landscape, has been the object of my research. For this reason I have allowed myself to disagree with the opinion of Kenneth Clark, which is unquestionably important and lucidly formulated, though somewhat limited in scope. In the present study, the aesthetic problem of the landscape does not occur at the level of artistic transfiguration but at that of contemplation. I wanted to understand the meaning and value of the landscape as an aesthetic category within the domain of human sensibility, both as reality and as value, in the light of the many manifestations of the objects that surround us, as well as their transfiguration in art and literature. Through a network of judgments and feelings, the aesthetic experience presents itself in a form of knowledge that opens up a noetic field. Located between human intentions and the intimate nature of the world, the aesthetic category aims to reveal the very structure of objects and

phenomena. It is an objective disposition, an internal aspect of the reception and creation of works that reproduce the forms of natural beauty, thereby bringing to light the seductiveness as well as the ambiguity of Henri Amiel's expression: the landscape is a state of mind,

Contemplation draws us to transcendence. As Emerson says: "The aspect of nature is devout. Like the figure of Jesus, she stands with bended head, and hands folded upon the breast. The happiest man is he who learns from nature the lesson of worship" (1836, Ital. trans. 1991, 52). If we keep in mind Western mysticism and the aura of classical mythology, this is clear. We can also reiterate the view of Novalis (*The Disciples of Sais*) that, for some, nature is a feast or a banquet, and, for others, an intimate religious cult. It is, nevertheless, worth pointing out that the beauty of the landscape has its own sacredness in other cultures as well. To give only one example, I hasten to mention ancient Chinese and Japanese depictions in which beings and objects seem to vanish before the supremacy of the interplay of elements: earth, air, wind, and fire. Here, the movement of the clouds, waves, and fire, as well as the earth's relief, have been defined by artists in relation to the cosmic law of *Yin* and *Yang*, and the six canons of Hsieh Ho. Furthermore, we find once again the principle of the Void in the use of light and the concern for "imperfection," precisely because of the rich effects that the light is capable of producing. These criteria are also at the root of contemplation, that of the aesthetic life, which precedes artistic elaboration. As G. Marchianò explains, the relationship between humans and nature, present in "Western dualisms," is reversed in this perspective: "Man is not the measure of the cosmos and the creation at the top of the hierarchy of living entities, but it is nature in its totality that is the measure of itself, the model of a reawakening that humans attain with effort. According to the doctrine of the Lotus, the Buddhist nature of the

universe makes no distinction between an amoeba, a star or a human being" (1994, vol. II, 106). We learn from the trees, the flowers, and the blades of grass in a continuous flow of revelation. In this sense, we discover that within humans a devotion to "enlightened nature" exists. We begin to see aspects of the aesthetic of the *fadeur* (the bland or the tasteless) that François Jullien has recently discussed in illustrating the processes of the unveiling of nature. It is the spirit of the form that is grasped in the act of contemplation. In the beauty of the landscape, we discover that we are pilgrims in a world of dreams and light.

Bibliography

Addison, J. "Pleasures of Imagination," 1712, in J. Addison, R. Steele et al., *The Spectator.* 3 vols. G. Smith,ed. London: J.M. Dent and Sons Ltd, 1958, 276–309.

- *Remarks on Several Parts of Italy in the Years 1701, 1702, 1703.* London: Printed for Jacob Tonson, 1705.

Adorno, T.W. *Ästhetische Theorie.* Frankfurt am main: Suhrkamp, 1970. Ital. trans. *Teoria estetica.* E. De Angelis, ed. Turin: Einaudi, 1975.

Aeschylus. *Agamemnon.* Louis MacNeice, trans. London: Faber and Faber Limited, 1936.

Aldrich, M. *Gothic Revival.* London: Phaidon, 1994.

Alison, A. *Essays on the Nature and Principles of Taste.* London-Edinburgh: J.J.G. and G. Robinson-Bell and Bradfute, 1790.

Alpers, S. *The Art of Describing.* Chicago: The University of Chicago Press, 1983. Ital. trans. *Arte del descrivere.* F. Cuniberto, ed. Turin: Boringhieri, 1984.

Amiel, H.F. *Fragments d'un journal intime.* Paris: Stock, 1884 (2nd ed. 1949). Ital. trans. *Frammenti di un giornale intimo.* C. Baseggio, ed. Turin: UTET, 1961. Andreotti, G. *Paesaggi culturali. Teoria e casi di studio.* Milan: Unicopli, 1996.

Andrews, M., ed. *The Search for the Picturesque.* Stanford, California: Stanford University Press, 1989.

174 Bibliography

– ed. *The Picturesque. Literary Sources and Documents.* 3 vols. Mount-field (East Sussex, U.K.): Helm Information, 1994.

Anile, A. *Bellezza e verità delle cose.* Florence: Vallecchi, 1935 (2nd ed. 1942).

Argan, E.C. "Giardino e parco," in *Enciclopedia universale dell'arte.* Venice-Florence: Unedi, 1976.

Assunto, R. *Introduzione all'estetica del paesaggio,* in *De Homine.* 5–6, 1963.

– *Stagioni e ragioni dell'estetica del Settecento.* Milan: Mursia, 1967.

– *Il paesaggio e l'estetica.* Naples: Giannini, 1973.

– "Paesaggio-ambiente-territorio. Un tentativo di precisazione conc-ettuale," in *Bollettino del Centro Internazionale di Studi di Architet-tura Andrea Palladio,* XVIII. Vicenza, 1976.

– *Specchio vivente del mondo. Artisti stranieri a Roma 1600–1800.* Rome: De Luca, 1978.

– *Ontologia e teleologia del giardino.* Milan: Guerini, 1988.

– *La natura, le arti, la storia. Esercizi di estetica.* Milan: Guerini, 1990.

– *Giardini e rimpatrio. Un itinerario ricco di fascino, in compagnia di Winckelmann, di Stendhal, dei Nazareni, di D'Annunzio.* Rome: Newton Compton, 1991.

Aston, M. *Interpreting the Landscape.* London: Batsford, 1985.

Augé, M. *Non-lieux.* Paris: Seuil, 1992. Ital. trans. *Nonluoghi.* D. Rolland, ed. Milan: Eleuthera, 1993.

Bachelard, G. *La poétique de l'espace.* Paris: Presses Universitaires de France, 1957. Ital. trans. *La poetica dello spazio.* E. Catalano, ed. Bari: Dedalo, 1975.

– *L'Eau et les rêves: essai sur l'imagination de la matière.* Paris: J. Corti, 1942.

Bacon, F. "Of Gardens," in *The Essays, the Wisdom of the Ancients New Atlantis.* 1625. Ital. trans. in *Opere filosofiche.* E. De Mas, ed. Rome-Bari: Laterza, 1965.

– "Of Travel," 1625, in *The Complete Essays.* Henry Leroy Finch, ed. New York: Washington Square Press, 1963.

Baltrusaïtis, J. "Jardins, pays d'illusion," in *Aberrations.* Paris: Flammarion, 1983. Ital. trans. *Aberrazioni.* A. Bassan Levi, ed. Milan: Adelphi, 1983.

Banfi, A. *Vita dell'arte. Studi di Estetica e Filosofia dell'Arte.* E. Mattioli and G. Scaramuzza, eds. Milan: Minuziano, 1947, now in *Opere.* Reggio Emilia: Istituto A. Banfi, 1988, vol. 5.

Baridon, M. *Les jardins. Paysagistes, jardiniers, poètes.* Paris: Laffont, 1998.

Basile, B. *L'Elisio effimero. Scrittori in giardino.* Bologna: Il Mulino, 1993.

Baudelaire, Charles. *Scritti sull'arte,* a cura di E. Raimondi. Turin: Einaudi, 1992.

Beckford, W. *Biographical Memoirs of Extraordinary Painters.* London: J. Robson, 1780. Ital. trans. *Memorie biografiche di pittori straordinari.* M. Billi, ed. Florence: Giunti, 1995.

Benjamin, W. *Das Passagen-Werk.* R. Tiedemann, ed. Frankfurt am Main: Suhrkamp, 1982. Ital trans. *I passaggi di Parigi,* in *Opere complete di Walter Benjamin.* vol. 9. E. Ganni, ed. Turin: Einaudi, 2000.

Benz, E. *Geist und Landschaft.* Stuttgart: Klett-Cotta, 1968.

Berger, R.W. "Garden Cascades in Italy and France 1565–1665," in *Journal of the Society of Architectural Historians* (Spring, 1974): 304–22.

Berkeley, G. *A Treatise Concerning the Principles of Human Knowledge.* Dublin: Jeremy Pepyar, 1710. Ital. trans. *Trattato sui principi della conoscenza umana.* M.M. Rossi, ed. Intro. P.F. Mugnai. Rome-Bari: Laterza, 1984.

– *Three Dialogues between Hylas and Philonous* (1713). London-Glasgow: Collins/Fontana, 1949, in *Principles, Dialogues and Philosophical Correspondence.* Indianapolis, New York: The Bobbs-Merrill Company, 1965. Ital. trans. M.M. Rossi and P.F. Mugnai. Rome-Bari: Laterza, 1987.

Berleant, A. *Living in the Landscape. New Essays in Environmental Aesthetics.* Lawrence: University Press of Kansas, 1997.

Bernardin de Saint-Pierre. *Etudes de la nature* (1784), in *Oeuvres complètes.* Paris: Méquignon-Marvis, 1818–20.

- *Paul et Virginie* (1787), in *Oeuvres complètes.* Paris: Méquignon-Marvis, 1818–20. Ital. trans. *Paolo e Virginia.* 2nd ed., U. Fracchia, ed. Milan: Mondadori, 1953.

- *Etudes de la nature.* Paris: Imprimerie de Monsieur, 1786. 1784.

Berque, A. *Les Raisons du paysage, de la Chine antique aux environnements de synthèse.* Paris: Hazan, 1995.

- "Paysage et immanence," in *Interfaces.* 1997, 11–12.

Berthier, F. *The Japanese Dry Landscape Garden. Reading Zen in the Rocks.* Chicago: The University of Chicago Press, 2000.

Bertòla, Giorgi de' Aurelio. *Saggio sopra la grazia nelle lettere e nelle arti.* Ancona: Stamperia, Sartoriana, 1822.

Bicknell, P. *Beauty, Horror and Immensity. Picturesque Landscape in Britain 1750–1850.* Cambridge: Cambridge University Press, 1981.

Blumenberg, H. *Die Lesbarkeit der Welt.* Frankfurt am Main: Suhrkamp, 1981. Ital. trans. *La leggibilità del mondo. Il libro come metafora della natura.* R. Bodei and B. Argenton, eds. Bologna: Il Mulino, 1989.

Böhme, G. *Für eine ökologische Naturästhetic.* Frankfurt am Main: Suhrkamp, 1989.

Bonesio, L. *Geofilosofia del paesaggio.* Milan: Mimesis, 1997.

Borchardt, R. *Der leidenschaftliche Gärtner.* Greno: Nördlingen, 1936 (3rd ed. 1987). Ital. trans. *Il giardiniere appassionato.* M. Roncioni, ed. Milan: Adelphi, 1992.

Borges, J.L. "Critica del paisaje" (1921), in *Nueva antologia personal.* Buenos Aires: Emecé, 1969. Ital. trans. "Critica del paesaggio," in *Nuova antologia personale.* L. Bacchi Wilcock, ed. Milan: Rizzoli, 1976.

Bottoni, L. "Paesaggio e utopia, il sublime, il pittoresco, il romantico," in *Paesaggio, immagine e realtà.* Milan: Electa, 1981,76–83.

Bowron, E.P. and J.J. Rishel, eds. *Art in Rome in the Eighteenth Century.* London-Philadelphia: Museum of Art-Merrel, 2000.

Breidbach, O., ed. *Natur der Äesthetik-Äesthetik der Natur.* Vienna-New York: Springer, 1997.

Brennan, M. *Wordsworth, Turner and Romantic Landscape. A Study of the Tradition of the Picturesque and the Sublime.* Columbia: Camden House, 1987.

Briganti, G. *I pittori dell'immaginario.* Milan: Electa, 1977.

– *Gaspar Van Wittel e il vedutismo italiano.* L. Laureati and L. Trezzani, eds. Milan: Electa, 1990.

Brilli, A. *Quando viaggiare era un'arte. Il romanzo del Grand Tour.* Bologna: Il Mulino, 1995.

Brusatin, M. *Arte della meraviglia.* Turin: Einaudi, 1986.

Burckhardt, J. *Die Kultur der Renaissance in Italien* (1860). Stuttgart: A. Kroner, 1952. Ital. trans. *La civiltà del Rinascimento in Italia.* D. Valbusa, ed. Florence: Sansoni, 1990.

Burke, E. *A Philosophical Inquiry into the Origins of Our Ideas of the Sublime and Beautiful* (1757–59). Oxford: Oxford University Press, 1990. Ital. trans. *Inchiesta sul bello e il sublime.* G. Sertoli and G. Miglietta, eds. Palermo: Aesthetica, 1985.

Burnet, Th. *Theoria sacra telluris.* Amsterdam: J. Walters, 1699.

Buscaroli, R. *La pittura di paesaggio.* Bologna: Società Tipografica Mareggiani, 1935.

Caillois, R. *L'Ecriture des pierres* (1970). Ital. trans. *La scrittura delle pietre.* C. Coletti, ed. Genoa: Marietti, 1986.

Camporesi, P. "Dal paese al paesaggio," in *Il paesaggio. Dalla percezione alla descrizione.* R. Zorzi, ed. Venice: Marsilio, 1999.

Caracciolo, M.T. *Il paesaggio come specchio dell'anima. Pittori stranieri nella Roma di Giacomo Guarenghi,* in *Giacomo Guarenghi e il suo tempo. Atti del Convegno.* S. Burini, ed. Bergamo: Moretti e Vitali, 1995, 97–148.

Carchia, G. "Il paesaggio e l'enigma," in *Il paesaggio. Dalla percezione alla descrizione.* R. Zorzi, ed. Venice: Marsilio, 1999, 325–31.

– "Per una filosofia del paesaggio," in AA.VV. *Ripensare l'estetica.* Palermo: Aesthetica preprint, 58, 2000.

Carli, E. *Il paesaggio. L'ambiente naturale nella rappresentazione artistica.* Milan: Mondadori, 1981.

Carrit, E.F. *A Calendar of British Taste from 1600 to 1800.* London: Routledge, 1949.

Cassirer, E. *Die platonische Renaissance in England und die Schule von Cambridge* (1932). Ital. trans. *La rinascenza platonica in Inghilterra e la scuola di Cambridge.* R. Salvini, ed. Florence: La Nuova Italia, 1947.

– *An Essay on Man. An Introduction to a Philosophy of Human Culture.* New Haven: Yale University Press; London: H. Milford, Oxford University Press, 1944. Ital. trans. *Saggio sull'uomo.* C. D'Altavilla, ed. Rome: Armando, 1968.

Cauquelin, A. *L'invention du paysage.* Paris: Plon, 1989.

Cederna, A. *La distruzione della natura in Italia.* Turin: Einaudi, 1975.

Chambers, W. *A Dissertation on Oriental Gardening.* London: Griffin and Co. 1779 (repr. Farnborough: Gregg, 1972).

Chateaubriand, F.R. de. *Lettre sur le paysage en peinture* (1795). La Rochelle: Rumeur des Ages, 1995.

Chatwin, B. *The Songlines.* New York: Viking 1987. Ital trans. *Le vie dei canti.* S. Gariglio, ed. Milan: Adelphi, 1989.

Chevallier, E., Chavallier, R., and E. Raymond, eds. *Iter Italicum. Les voyageurs français à la découverte de l'Italie ancienne.* Geneva: Slatkine, 1984.

Cicognara, Leopoldo. *Del bello ragionamenti.* Firenze: Medici, Landi e Co., 1808.

Clark, K. *Landscape into Art.* London: John Murray, 1949 (2nd ed. 1976). Ital. trans. *Il paesaggio nell'arte.* M. Valle, A. Chiodi, and G. Dalmat, eds. Milan: Garzanti, 1985.

Clément, G. *Le Jardin en mouvement.* Paris: Sens et Tonka, 1994.

Collingwood, R.G. *The Idea of Nature.* Oxford: Clarendon Press, 1945.

Collini, P. *Wanderung. Il viaggio dei romantici.* Milan: Feltrinelli, 1996.

Cometa, M. *Il romanzo dell'architettura. La Sicilia e il Grand Tour nell'età di Goethe.* Rome-Bari: Laterza, 1999.

Comment, A. *The Panorama.* London: Reaktion, 1999.

Conan, M. "Généalogie du paysage," in *Le Débat,* 65. Paris: Gallimard, 1991.

Conrad, Joseph. *Typhoon and Amy Foster*. London: J.M. Dent and Sons Ltd., 1903.

Cosgrove, D.E. *The Iconography of Landscape: Essays on the Symbolic Representation, Design, and Use of Past Environments*. Cambridge-New York: Cambridge University Press, 1988. Ital. trans. *Realtà sociale e paesaggio simbolico*. C. Copeta, ed. Milan: Unicopli, 1990.

Costa, E. "Un annoso problema, Tasso e il sublime," in *Rivista di Estetica*. Padua, 27, 26–7 (1987): 49–63.

Costa, M. *Sentimento del sublime e strategia del simbolico (il Vesuvio nella letteratura francese)*. Salerno: Edisud, 1996.

Cottone, M. *Il giardino sentimentale. Il "Paradiso" ritrovato nel Settecento europeo*. Palermo: Medina, 1995.

Cozens, A. *A New Method of Assisting the Invention in Drawing Original Compositions of Landscape* (1785). Ital. trans. P. Lavezzari. Treviso: Canova, 1981.

Croce, B. *Robert Visher e la contemplazione estetica della natura* (1935), in *Ultimi saggi*. Rome-Bari: Laterza, 1963.

– "La teoria delle arti e il bello di natura" (1928), in *Aesthetica in nuce*. Rome-Bari: Laterza, 1979. 34–8.

Crook, J. and Mordaunt, F. *The Dilemma of Style. Architectural Ideas from the Picturesque to the Post-Modern*. London: John Murray, 1987.

Curtius, E.R. *Europäische Literatur und lateinisches Mittelalter*. Bern: A. Francke Verlag, 1948. Ital. trans. *Letteratura europea e Medio Evo latino*. R. Antonelli, M. Luzzato, and M. Candela, eds. Florence: La Nuova Italia, 1995.

Dagognet, F., ed. *Mort du paysage. Philosophie et esthétique du paysage*. Paris: Champ Vallon, 1982.

D'Angelo, P. "Il ritorno del bello naturale," in *Cultura e scuola*, 10 (1993).

– "L'illusione di essere natura. Spontaneità e finzione nelle poetiche del giardino paesistico," in *Quaderni di Estetica e Critica*, 3 (1998).

– "Ripensare il paesaggio," in *Ripensare l'estetica*. Palermo: Aesthetica, preprint, 58. Palermo: Centro internazionale studi di estetica, 2000a.

– *La natura del sacro*. Milan: Guerini, 2000b.

Da Vinci, Leonardo. *Treatise on Painting*, 1550. A. Phillip McMahon, trans. Princeton, N.J.: Princeton University Press, 1956.

Debarbieux, B. "Le lieu, le territoire et trois figures de rhétorique," in *L'Espace géographique*, 2 (1995).

De Seta, C., ed. *Il paesaggio, Storia d'Italia, Annali 5*. Turin: Einaudi, 1982.

− *Philipp Hackert. Vedute del Regno di Napoli*. Milan: Franco Maria Ricci, 1992.

− *Vedutisti e viaggiatori in Italia tra Settecento e Ottocento*. Turin: Bollati Boringhieri, 1999.

Diderot, Denis. *Salons*. 5 vols, 1759–1781. Jean Seznec and Jean Adhemar, eds. Oxford: Clarendon Press, 1957–1967.

Doiron, N. "L'art de voyager. Pour une définition du récit de voyage à l'époque classique," in *Poétique*, 18 (1988): 83–108.

Dubbini, R. *Geografie dello sguardo. Visione e paesaggio in età moderna*. Turin: Einuadi, 1994.

Dufrenne, M. "L'expérience esthétique de la nature," in *Revue Internationale de Philosophie*, 31 (1955): 98–115.

− "Arte e natura," in M. Dufrenne and D. Formaggio. *Trattato di estetica*. 2 vols. Milan: Mondadori, 1981.

Dupaty, Charles-Maguerite and Jean-Baptiste Mercier. *Lettres sur l'Italie, en 1785*. Lausanne: Jean Mourere, 1789.

Dürer, A. *Albrecht Dürer: Aquarelle und Zeichnungen*. F. Piel, ed. Köln: Du Mont, 1983. Ital. trans. *Acquarelli e disegni di Dürer*. R. Carpinella, ed. Novara: De Agostini, 1992.

Dyer, John. *Ruins of Rome. A Poem*. London: Lawton Gilliver, 1740.

Ehrard, J. *L'idée de Nature en France dans la première moitié du XVIIIͤ siècle*. Geneva: Slatkine, 1963 (new ed. 1981).

Emerson, R.W. "Nature" (1836), in *The Collected Works of R.W. Emerson*. vol. I. Cambridge, Mass.: The Belknap Press of Harvard University Press, 1971. Ital trans. M. Lollini, in *Teologia e natura*. P.C. Bori, ed. Genoa: Marietti, 1991.

Fagiolo, M. and M.A. Giusti, *Lo specchio del Paradiso. L'immagine del giardino dall'Antico al Novecento*. Milan: Silvana Editori, 1996.

Falqui, L. *La gemma*. Rimini: Il Cerchio, 1995.

Farinelli, F. "L'arguzia del paesaggio," in *Il disegno del paesaggio italiano*. V. Gregotti, ed., in *Casabella*. (1991): 575–6.

Fasce, S. "Genius," in *Enciclopedia virgiliana*. F. Della Corte, ed. Rome: Istituto della Enciclopedia Italiana. vol. 2 (1987): 656–7.

Febvre, L.P.V. *Pour une histoire à part entière*. Paris: Sevpen, 1962.

Ferry, L. *Le Nouvel Ordre écologique*. Paris: Grasset, 1992. Ital trans. *Il nuovo ordine ecologico*. C. Gazzelli and P. Kern, eds. Genoa: Costa & Nolan, 1994.

Foscolo, Ugo. *The Last Letters of Jacopo Ortis* (*Le ultime lettere di Jacopo Ortis*). J.C. Nichols, trans. London: Hesperas, c2002.

Fuchs, W. "Genio," in *Enciclopedia dell'arte antica, classica, orientale*. vol. 3. Rome: Istituto dell'Enciclopedia Italiana. 1960: 810–16.

Gedoyn, N. *Pausanias ou voyage historique de la Grèce*. 2 vols. Paris: Didot, 1731–3.

Genette, G. *L'Œuvre de l'art*. Paris: Editions du Seuil, 1994–1997. Ital. trans. R. Campi, *L'opera dell'arte*. 2 vols. F. Bollino, ed. Bologna: Clueb, 1998–99.

Georg Simmel, 1858–1918: a Collection of Essays with a Translation and a Bibliography. Howard Becker, ed. Columbus: Ohio State University Press, 1957.

Gilpin, W. *Three Essays: on Picturesque Beauty; on Picturesque Travel; and on Sketching Landscape to Which is Added a Poem on Landscape Painting* (1782). London: Blamire, 1794.

– *Observations Relative Chiefly to Picturesque Beauty*. London: R. Blamire, 1788.

– *A Dialogue Upon the Gardens at Stowe*. London: B. Seely, 1748.

Girard, R. *Mensonge romantique et verité romanesque*. Paris: Grasset, 1961.

Givone, S. *La questione romantica*. Rome-Bari: Laterza, 1992.

– "Rappresentazione della fine e fine della rappresentazione," in *Romanticismo. Il nuovo sentimento della natura*. Milan: Electa, 1993, 313–21. .

Goethe, J.W. von. *Der Triumph der Empfindsamkeit*. Leipzig: G.J. Göschen, 1787. Ital. trans. *Il trionfo del sentimentalismo*. Intro. M. Venturi Ferriolo; trans. and post., E. Brissa. Rome: Semar, 1988.

– *Farbenlehre* (1808). Ital. trans. *La teoria dei colori.* R. Troncon, ed. Milan: Il Saggiatore, 1989.

– *La teoria della natura.* M. Montinaried, ed. Turin: Boringhieri, 1958.

– *Faust: a Tragedy.* Walter Arndt, trans. New York: Norton, 1976.

– *Theory of Colours.* Charles Lock Eastlake, trans. Cambridge, Mass.: M.I.T. Press, 1970.

– *Italian Journey, 1786–88.* W.H. Auden and Elizabeth Mayer, trans. London: Collins, 1962.

Gombrich, E.H. "The Renaissance Art Theory and the Rise of Landscape Painting," in *Norm and Form. Studies in the Art of the Renaissance.* (1966). Ital. trans. *Norma e forma. Studi sull'arte del Rinascimento.* V. Borea, ed. Turin: Einaudi, 1973.

Gregory, T. *Anima mundi.* Florence: Sansoni, 1955 (ch. 4: "L'idea di natura").

Grimal, P. *L'Art des jardins.* Paris: Vendome, 1954. Ital. trans. *L'arte dei giardini.* M. Magi, ed. Salerno-Rome: Ripostes, 1993.

Hackert, J.Ph. *Il paesaggio secondo natura. J.Ph. Hackert e la sua cerchia.* P. Chiarini, ed. Rome: Artemide, 1994.

Haller, Albrecht von. *Die Alpen,* 1729. Bern: Rancke, 1902.

Hartmann, M. *Ästhetik.* Berlin: W. Gruyter, 1966. Ital. trans. *Estetica.* M. Cacciari, ed. Intro. D. Formaggio. Padua: Liviana, 1969.

Haskell, F. and Penny, N. *Taste and the Antique.* New Haven (Conn.): Yale University Press, 1981.

Hegel, G.W.F. *Reisetagebuch Hegels durch die Berner Oberalpen* (1796). Ital. trans. T. Cavallo, pref. R. Bodei. *Diario di viaggio sulle Alpi bernesi.* Como: Ibis, 1990.

– *Vorlesungen über die Ästhetik* (1842). Ital. trans. *Estetica,* N. Merker, ed. Turin: Einaudi, 1987.

– *Vorlesungen über die Philosophie der Geschichte* (1848). B. Bosanquet, trans. M. Inwood, ed., *Introductory Lectures on Aesthetics.* New York, London: Penguin Books, 1993.

Heidegger, M. *Die Kunst und der Raum.* St Gallen: Erker-Verlag, 1969. Ital. trans. *L'arte e lo spazio.* C. Angelino, ed. Genoa: Il Melangolo, 1984.

Heinrich, D. "Kunst und Natur in der idealistischen Ästhetik," in H.R. Jauss, ed. *Nachahmung und Illusion*. München: Fink, 1964.

Hellpach, W. *Géopsyche*. Paris: Payot, 1944.

Heraclitus of Ephesus. *Fragments: the Collected Wisdom of Heraclitus*. Brooks Haxton, trans. New York: Viking, 2001.

Herder, J.G. "Naturhymnus von Shafterbury," in *Uebertragungen aus neuerer Kunstpoesie*, in *Sämtliche Werke*. vol. 27. Berlin: Weidmann, 1800. 397–406 (reprint Hildesheim: Olms, 1967–68).

Hipple, W.J. *The Beautiful, the Sublime and the Picturesque in Eighteenth Century British Aesthetic Theory*. Carbondale: Southern Illinois University Press, 1957.

Hofmannsthal, H. Von. "Gärten," in *Prosa 2*. Frankfurt am Main: Fisher Verlag, 1950. Ital. trans. "Giardino" in *L'ignoto che appare. Scritti 1891–1914*. Milan: Adelphi, 1991. 213–20.

Hoüel, Jean. *Voyage pittoresque des isles de Sicile, de Malte et de Lipari*. Ital. trans. M.F. Buonaiuto and A. De Somma. Palermo, Naples: Edizioni per il Banco di Sicilia, 1977.

Humboldt, A. von. *Ansichten der Natur* (1808). Ital. trans. *Quadri della natura*. F. Farinelli, ed., G. Melucci, trans. Florence: La Nuova Italia, 1998.

– *La geografia. I viaggi*. M. Milanesi and A.V. Viansson, eds. Milan: Angeli, 1975.

Hunt, J.D. *The Figure in the Landscape. Poetry, Painting and Gardening during the Eighteenth Century*. London-Baltimore: Johns Hopkins University Press, 1976.

– *Garden and Grove, the Italian Renaissance Garden in the English Imagination, 1600–1750*. Princeton, N.J.: Princeton University Press, 1986.

Hunt, J.D. and P. Willis, eds. *The Genius of the Place. The English Landscape Garden 1620–1820*. London: Paul Elek, 1975.

Huter, M. "Fragmente zum Landschaftsbegriff," in *Die Eroberung der Landschaft*. Vienna: Falter Verlag, 1992.

Jachmann, G. "L'Arcadia come paesaggio bucolico," in *Maia*, 5 (1952).

Jamot, P. *Sur la naissance du paysage dans l'art moderne, du paysage abs-trait au paysage humaniste.* Paris: n.p., 1938.

Jellicoe, G.A. *Studies in Landscape Design.* 3 vols. London: Oxford University Press, 1960. Ital. trans. *L'architettura del paesaggio.* E. Labò, ed. Milan: Comunità, 1969.

– and Jellicoe, S. *The Landscape of Man, Shaping the Environment from Prehistory to the Present Day.* New York, N.Y.: Thames and Hudson, 1987.

Joutard, Ph. *L'Invention du Mont Blanc.* Paris: Gallimard, 1986. Ital. trans. *L'invenzione del Monte Bianco.* P. Crivellaro, ed. Turin: Einaudi, 1993.

Jünger, E. *Das abenteuerliche Herz.* Berlin: Frundsberg-Verlag, 1929. Ital. trans. *Il cuore avventuroso.* Q. Principe, ed. Parma: Guanda, 1995.

Kant, E. *Kritik der Urteilskraft* (1790). *Critique of Judgement.* J.H. Bernard, trans. New York: Hafner Publishing Co., 1951.

– *Beobachtungen über das Gefühl des Schönen und Erhabenen* (1764). Hamburg: Meiner, 1991. Ital. trans. *Osservazioni sul sentimento del bello e del sublime.* L. Novati, ed; intro. G. Morpurgo Tagliabue. Milan: Rizzoli, 1996.

Kastner, J. and B. Wallis, eds. *Land and Environmental Art.* London: Phaidon, 1998.

Kemal, S. and I. Gaskell, eds. *Landscape, Natural Beauty and the Art.* Cambridge: Cambridge University Press, 1993.

Kérényi, K. "Landschaft und Geist," in *Apollon und Niobe,* in *Werke.* vol. 4. Munich-Vienna: Langen-Müller, 1980, 80–92; Ital. trans. "Paesaggio e spirito," in *La madonna ungherese di Verdasio. Paesaggi dello spirito e paesaggi dell'anima.* A. Ruchat, ed. Locarno: Dadò, 1996. 17–32.

Klages, L. *Mensch und Erde* (1913). Stuttgart: Kröner, 1973. Ital. trans. *L'uomo e la terra.* L. Bonesio, ed. Milan: Mimesis, 1999.

Klingender, F.D. *Art and the Industrial Revolution.* 2nd ed. A. Elton, ed. London: Evelyn, Adams & Mackay, 1968. Ital. trans. *Arte e rivoluzione industriale.* E. Einaudi, ed. Turin: Einaudi, 1972.

Klonk, C. *Science and the Perception of Nature.* New Haven-London: Yale University Press, 1996.

Knight, R.P. *An Analytical Inquiry into the Principles of Taste.* London: Luke Hasard, 1908.

Kristeller, P.O. *The Classics and Renaissance Thought.* New York: Harper & Row, 1955. Ital. trans. *La tradizione classica nel pensiero del Rinascimento.* F. Onofri, ed. Florence: La Nuova Italia, 1965.

Lagerhold, J. *Ideal Landscape.* New York: Yale University Press, 1990.

Langley, Batty. *Gothic Architecture, Improved by Rules and Proportions.* London: J. Millan, 1747.

Lehmann, H. "Die Physiognomie der Landschaft," in *Studium Generale*, 1950. vols 3, 4, 5. Ital. trans. "Fisionomia del paesaggio," A. Iadicicco, ed., in *L'anima del paesaggio tra estetica e geografia.* L. Bonesio, M. Schmidt, and D. Friedberg, eds. Milan: Mimesis, 1999.

Leibniz, G.W. "Principes de la nature et de la grace, fondées en raison; Monadologie et autres textes," in *Die philosophischen Schriften von Gottfried Wilhelm Leibniz* (1714). 7 vols. C.I. Gerhardt, Hildesheim and G. Olms, 1960. Ital. trans. "Principi della natura e della grazia fondati sulla ragione; Monadologia," in *Scritti filosofici.*vol. 1. D.O. Bianca, ed. Turin: UTET, 1967.

Lenoble, R. *Esquisse d'une histoire de l'idée de nature.* Paris: A. Michel, 1969. Ital. trans. *Per una storia dell'idea di natura.* P. Guadagnino, ed. Naples: Guida, 1974.

Leopardi, G. *Zibaldone di pensieri* (1898–1900). Critical, annotated ed. G. Pacella, ed. Milan: Garzanti, 1991.

Lovejoy, A.O. *The Great Chain of Being. A Study of the History of an Idea. The William James Lectures Delivered at Harvard University.* Cambridge, Mass.: Harvard University Press, 1936. Ital. trans. *La grande catena dell'essere.* L. Formigari, ed. Milan: Feltrinelli, 1966.

– *Essays in the History of Ideas.* Baltimore: Johns Hopkins Press, 1948. Ital. trans. *L'albero della conoscenza. Saggi di storia delle idee.* D. de Vera Pardini, ed. Bologna: Il Mulino, 1982.

Luginbuhl, Y. *Paysages. Textes et représentations du Siècle des Lumières à nos jours.* Lyon: La Manufacture, 1990.

Lukacs, G. "Su una storia del giardinaggio," in *Sulla povertà di spirito: Scritti (1907–1918).* 1915. P. Pullega, ed. Bologna: Cappelli, 1981. 157–8.

Luther, Martin. *Commentary on Genesis.* A New Translation by J. Theodore Mueller. Grand Rapids: Zondervan Publishing House, 1958.

Mabille, P. *Le Miroir du merveilleux.* Paris: Minuit, 1962.

Macaulay, R. *Pleasure of Ruins.* London: Weidenfeld and Nicolson, 1953.

Maior, J.K. *To Live in the New World. A.J. Downing and American Landscape Gardening.* Cambridge (Mass.)-London: The MIT Press, 1997.

Malins, E.G. *English Landscaping and Literature 1660–1840.* London: Oxford University Press, 1966.

Manwaring, E. *Italian Landscape in Eighteenth Century England: A Study Chiefly of the Influence of C. Lorrain and S. Rosa on English Taste.* New York: Oxford University Press, 1925.

Marchianò, G. *Sugli orienti del pensiero. La natura illuminata e la sua estetica.* 2 vols. Soveria Mannelli: Rubbettino, 1994.

Marino, Giambattista. *Adonis. Selections from L'Adone of Giambattista Marino.* Harold Martin Priest, trans. Ithaca, New York: Cornell University Press, 1967.

McCalman, I., ed. *An Oxford Companion to the Romantic Age. British Culture, 1776–1832.* Oxford: Oxford University Press, 1996.

Merker, N. *L'illuminismo tedesco.* Rome-Bari: Laterza, 1972.

Merleau-Ponty, M. *Phénoménologie de la perception.* Paris: Gallimard, 1945.

– *La Nature. Notes. Cours du Collège de France.* Établi et annoté par Dominique Séglard, suivi des résumés de cours correspondants de Maurice Merleau-Ponty. Paris: Éditions du Seuil, 1995. Ital. trans. *La natura: lezioni al Collège de France 1956–1960.* Milan: Cortina, 1996.

Milani, R. *Il pittoresco. L'evoluzione del gusto tra classico e romantico.* Rome-Bari: Laterza, 1996.

Miller, C. and H. Rotman, eds. *Out of the Woods. Essays in Environmental History.* Pittsburg: Pittsburg University Press, 1977.

Monk, S. *The Sublime*. Ann Arbor, Mich.: Umi Research Press, 1960, 1962.

Morissey, L. *From the Temple to the Castle. An Architectural History of British Literature 1660–1760*. Charlottesville-London: University Press of Virginia, 1990.

Mornet, D. *Le sentiment de la nature en France de J.J. Rousseau à Bernardin de Saint-Pierre* (1907). New York: B. Franklin, 1971.

Mortier, R. *La Poétique des ruines en France, ses origines, ses variations, de la Renaissance à Victor Hugo*. Geneva: Librairie Droz, 1974.

Mosser, M. and P. Nys, eds. *Le jardin, art et lieu de la mémoire*. Besançon: Les Editions de l'Imprimeur, 1995.

Mosser, M. and G. Teyssot, eds. *Historie des jardins. De la Renaissance a nos jours*. Paris: Flammarion, 1990. Ital. trans. *L'architettura dei giardini d'Occidente dal Rinascimento al Novecento*. Milan: Electa, 1990.

Muzzillo, F. *Paesaggi informali. Capability Brown e il giardino paesaggistico inglese del diciottesimo secolo*. Naples: ESI, 1995.

Nash, R. *The Right of Nature. A History of Environmental Ethics*. Madison: University of Wisconsin Press, 1997.

Negri, R. *Gusto e poesia delle rovine in Italia fra il Sette e l'Ottocento*. Milan: Ceschina, 1965.

Nicolson, M.H. *Mountain Gloom and Mountain Glory. The Development of the Aesthetics of the Infinite*. 2nd ed. Seattle: University of Washington Press, 1997.

Norberg-Schultz, H. *Genius loci, Towards a Phenomenology of Architecture*. London: Academy, 1980. Ital. trans. *Genius loci*. A.M. Norberg-Scultz, ed. Milan: Electa, 1986.

Novalis. *Les Disciples à la Sais: Hymnes à la nuit*. Translated by Armel Guerne. Paris: Gallimard, 1980.

Oettermann, R. *The Panorama. History of a Mass Movement*. New York: The MIT Press, 2000.

Ogden H.V.S. and M.S. Ogden. *English Taste in Landscape in the Seventeenth Century*. Ann Arbor: University of Michigan Press, 1955.

Ottani Cavina, A. *I paesaggi della ragione, la città neoclassica da David a Humbert de Superville*. Turin: Einaudi, 1994.

Otto, W.F. "Genius," in *Real-Encyclopädie der klassischen Altertumswissenchaft*. A. Pauly, G. Wissowa, K. Kroll, and K. Ziegler Wissowa, eds. Stuttgart: Metzler, 1912. vol. 7.1.

Panofsky, E. "Et in Arcadia ego. On the Conception of Transience in Poussin and Watteau," in *Philosophy and History. Essays Presented to Ernst Cassirer*. R. Klibansky and H. J. Paton, eds. Oxford: The Clarendon Press, 1936. Ital. trans. in *Il significato delle arti visive*. R. Federici, ed. Turin: Einaudi, 1996. 277–301.

– "Le paysage en France et en Allemagne autour de 1800," in *Revue Germanique Internationale*, 7. Paris: PUF, 1997.

Pascal, Blaise. *Pensées*. W.F. Trotter, trans. London: Dent, 1942.

Paulhan, F. *L'Esthétique du paysage*. (2nd ed. 1931). Paris: F. Alcan, 1913.

Pausanias. *Description of Greece*. 5 vols. W.H.S. Jones, trans. Cambridge, Mass.: Harvard University Press, 1918–55.

Peschen, G. et al. *Karl Friedrich Schinkel. Architettura e paesaggio*. Milan: Motta, 1993.

Piles, Roger de. *Cours de peinture par principes*. Paris: J. Estienne, 1708.

Pindemonte, I. "Dissertazione su i giardini inglesi e sul merito di ciò all'Italia" (1792), in *Opere complete*. Naples: F. Rossi-Romano, 1861.

– "Ghiacciai di Bossons e di Montavert," in *Opere complete*, cit.

Plato. *Phaedrus*. Alexander Nehamas and Paul Woodruff, trans. Indianapolis-Cambridge: Hackett Publishing Company, 1995.

Pochat, G. *Figur und Landschaft. Eine historische Interpretation der Landschaftsmalerei von der Antike bis zur Renaissance*. Berlin-New York: De Gruyter, 1973.

Porphyry. *On the Cave of the Nymphs in the Thirteenth Book of the Odyssey*. Thomas Taylor, trans. London: J.M. Watkins, 1917.

Praz, M. *Letteratura romantica*. Florence: Sansoni, 1966.

– *Il giardino dei sensi*. Milan: Mondadori, 1975.

– "L'arte dei giardini inglesi," in *Studi e svaghi inglesi*. Milan: Garzanti, 1983, vol. 2.

Price, U. *Essays on the Picturesque, as Compared with the Sublime and Beautiful*. London: Robson, 1798.

– *A Dialogue on the Distinct Characters of the Picturesque and the Beautiful*. London: Walker, 1801.

Pseudo-Longinus. *Il Sublime*, G. Lombardo, ed., post. H. Bloom. Palermo: Aesthetica, 1987.

Puppi, L. "L'ambiente, il paesaggio, il territorio," in *Storia dell'arte italiana*. vol. 4. Turin: Einaudi, 1980. 43–99.

Raimondi, E. *Romanzo senza idillio*. Turin: Einaudi, 1974.

– *Romanticismo italiano e romanticismo europeo*. Milan: Mondadori, 1997.

Rehder, H. *Die Philosophie der unendlichen Landschaft*. Halle-Saale: M. Niemeyer, 1932.

Rilke, R.M. *Worpswede, Fritz Mackensen, Otto Modersohn, Fritz Overbeck, Hans am Ende, Heinrich Vogeler.* Bielefeld: Velhagen & Klasin, 1903. Ital. trans. in *Del paesaggio e altri scritti*. L. Zampa, ed. Milan: Cederna, 1945.

Ritter, J. *Landschaft zur Funktion der Äesthetischen in der modernen Gesellschaft*. Münster: Aschendorff, 1963. Ital. trans. *Paesaggio, uomo e natura nell'età moderna*. G. Catalano, ed. Milan: Guerini, 1994.

Ritter Santini, L. *Nel giardino della storia*. Bologna: Il Mulino, 1988.

– "Il paesaggio addomesticato," in *Il paesaggio. Dalla percezione alla descrizione*. R. Zorzi, ed. Venice: Marsilio-Fondazione Giorgio Cini, 1999.

Roger, A. *Court traité du paysage*. Paris: Gallimard, 1997.

Roland-Michel, M. "De l'illusion à 'l'inquiétante étrangeté': quelques remarques sur l'évolution du sentiment et de la représentation de la ruine chez des artistes français à partir de 1730 (1976)," in AA.VV. *Piranesi et les Français*. Atti del Colloquio di Villa Medici, G. Brunel, ed. Rome: Académie de France à Rome, Edizioni dell'Elefante, 1978.

Romano, G. *Studi sul paesaggio. Storia e immagini*. Turin: Einaudi, 1991.

Romano, M. *L'estetica della città europea. Forma e immagini*. Turin: Einaudi, 1993.

Rosa, S. *Satire, odi e lettere, illustrate da G. Carducci*. Florence: G. Barbera, 1860.

Rousseau, J.J. "Institutions Chymiques," (1745) in *Annales de la Société J.J. Rousseau*. vol. 12. Geneve: A. Julien, Editeur, 1965.

– *Julie ou La Nouvelle Héloïse* (1762). Paris: Garnier, 1968. *Julie, or the New Heloise. The Collected Writings of Rousseau*. vol. 6. Phillip Stewart and Jean Vache, trans and eds. Hanover and London: University Press of New England, 1997.

– *Fragments de botanique* (1781) in *Œuvres complètes*. vol. 4. Paris: Gallimard, 1980. Ital. trans. in *Lettere sulla botanica*. E. Cocco, ed. Milan: Guerini, 1994.

– *Les Rêveries du promeneur solitaire* (1784). Peter France, trans. *Reveries of the Solitary Walker*. New York: Penguin, 1979.

Rusconi, C. *L'anno di grazia del Signore. Giubileo e vie dei pellegrini* (parte terza). Milan: Rizzoli, 2000.

Ruskin, J. *Modern Painters*. London: G. Allen, Green and Co., 1843–60, in *The Works of John Ruskin*, E.T. Cook and A. Wedderburn, eds. London: Library Edition, 1903–12.

– *Lectures on Art, Delivered before the University of Oxford in Hilary Term* (1870). New York: J. Wiley & Sons, 1878.

Saint Girons, B. *Esthétiques du XVIIIᵉ siècle. Le modèle français*. Paris: Sers, 1990.

– *Fiat Lux. Une estétique du sublime*. Paris: Quai Voltaire, 1993.

– "Du sublime dans la fondation de l'art des jardins modernes. Shenstone, Walpole, Whately, Chambers," in *Le jardin, art et lieu de memoire*. M. Mosser and Ph. Nys, eds. Besancon: Les Editions de l'Imprimeur, 1995. 299–322.

– and C. Burgard, eds. *Le Paysage et la question du sublime: De paysage en paysage*. Valence: Arac (diffusion Seuil), 1997.

Salerno, L. *Pittori di paesaggio del Seicento a Roma*. 3 vols. Rome: Bozzi, 1977–1978. vols 1, 2.

Salerno, R. *Architettura e rappresentazione del paesaggio*. Milan: Guerini, 1995

Saussure, Horace-Benedict de. *Voyages dans les Alpes*. 8 vols. Neuchatel: Fauche-Borel, 1796–1803.

– *Premières Ascensions au Mont-Blanc: 1774–1787* (First Ascents of Mont Blanc). Paris: Maspero, 1979.

Sbrilli, A., ed. *Paesaggi del nord. L'idea di paesaggio nella pittura tedesca del primo Ottocento*. Rome: Officina, 1985.

Schama, S. *Landscape and Memory.* London: Fontana Press, 1995. Ital. trans. *Paesaggio e memoria.* P. Mazzarelli, ed. Milan: Mondadori, 1997.

Schelle, K.G. *Die Spatziergänge, oder, Die Kunst spatzieren zu gehen.* Leipzig: G. Martini, 1802. Ital. trans. *L'arte di andare a passeggio.* A. Maggi, ed. Palermo: Sellerio, 1993.

Schelling, F. *Über das Verhältnis der bildenden Künste zu der Natur* (1803). Hamburg: Meiner, 1983. Ital. trans. *Arti figurative e natura.* L. Rustichelli, ed. Palermo: Aestetica, 1989.

Scheuchzer, Johann Jakob. *Physica Sacra.* Rome: Augustae Vindelicorum & Ulmae, 1731–35.

Schiller, Friedrich von. *Bride of Messina.* New York: Ungar, 1962.

Schinkel, K.F. *Reisen nach Italien* (1803–05, 1824). Berlin-Weimar: Aufbau-Verlag, 1994.

– *Architettura e paesaggio.* M. Pogacnik et al., eds. Milan: Motta, 1992.

Schlegel, A.W. "Über die neuere Gartenkunst von Horatio Walpole," in *Historiche literarische und unterhaltende. Schriften, übersetzt von A.W. Schlegel.* Leipzig: Hartknoch, 1800. 384–446.

Schmitt, C. *Der nomos der Erde, im Volkerrecht des Jus publicum Europaeum.* Köln: Greven, 1950. Ital. trans. *Il nomos della terra.* E. Castrucci and F. Volpi, eds. Milan: Adelphi, 1991.

Schneider, N. *Geschichte der Landschaftsmalerei. Vom Spätmittelalter bis zur Romantik.* Darmstadt: Primus Verlag, 1999.

Schoenbeck, G. *Der locus amœnus von Homer.* Cologne: G. Wasmund, 1962.

Schopenhauer, A. *Die Welt als Wille und Vorstellung.* Leipzig: F.A. Brockhaus, 1842. Ital. trans. *Il mondo come volontà e rappresentazione.* P. Savj-Lopez and G. Di Lorenzo, eds. Rome-Bari: Laterza, 1986; *Supplementi al Mondo come volontà e rappresentazione.* G. De Lorenzo, ed. Rome-Bari: Laterza, 1986.

Schwind, M. "Sinn und Ausdruck der Landschaft," in *Studium generale.* vols 3, 4, 5 (1950), then in *Tellus,* VI, 14 (1995). Ital. trans. A. Iadicicco, "Senso ed espressione del paesaggio," in *L'anima del paesaggio tra estetica e geografia.* L. Bonesio, M. Schmidt and D. Friedberg, eds. Milan: Mimesis, 1999.

Seel, M. *Eine Ästhetik der Natur.* Frankfurt am M.: Suhrkamp, 1991.

Serres, M. *Le Contrat naturel.* Paris: François Bourin, 1991. Ital. trans. *Il contratto naturale.* A. Serra, ed. Milan: Feltrinelli, 1991.

Shaftesbury, A.A.C. *The Moralists* (1709), in *Characteristics of Men, Manners, Opinions, Times.* Philip Eyres, ed. Oxford: Clarendon, 1999. Ital. trans. *I moralisti. Rapsodia filosofica ossia ragguaglio su talune conversazioni su argomenti naturali e morali.* P. Casini, ed. Rome-Bari: Laterza, 1971.

– Standard Edition. *Complete Works, Selected Letters and Posthumous Writings.* 2 vols. G. Hemmerich & W. Benda, eds. Stuttgart-Bad Cannstatt: Frommann-Holzboog, 1981–84.

Silva, E. *Dell'arte dei giardini inglesi* (1801). Intro. G. Venturi. Milan: Longanesi, 1976.

Simmel, G. "Die Ruine," (1912). Ital. trans. G. Carchia, in *Rivista di Estetica,* 21 (1981): 121–7.

– "Philosophie der Landschaft," in *Die Güldenkammer Nor-deutsche Monatshefte* 3, (1912–13): 635–44, in *Il volto e il ritratto, Saggi sull'arte.* L. Perucchi, ed. Bologna: Il Mulino, 1989.

Smuda, R.M., ed. *Landschaft.* Frankfurt am M.: Suhrkamp, 1986.

Snell, B. *Die Entdeckung des Geistes Studien zur Entstehung des europäischen Denkens bei den Griechen.* Hamburg: Claaszen & Goverts, 1945. Ital. trans. *La cultura greca e le origini del pensiero europeo.* V. Degli Arberti and A. Solmi Marietti, eds. Turin: Einaudi, 1963 (contains the article "L'Arcadia, scoperta di un paesaggio spirituale,"387–418).

Souriau, E. "Le beau, l'art et la nature," in *Revue Internationale de philosophie* 31, (1955): 76–97.

– "Le sublime," in *Revue d'Esthétique* (July-September, 1966).

Spengler, O. *Der Untergang des Abendlandes* (1918). Munich: C.H. Beck, 1959. Ital. trans. *Il tramonto dell'occidente.* F. Jesi et al., eds. Milan: Longanesi 1981.

Spinoza, B. *Etica e Trattato teologico-politico* (1670–77). R. Cantoni and F. Fergnani, eds. Turin: UTET, 1972.

Spitzer, L. "Zu einer Landschaft Eichendorffs," in *Euphorion,* s. III, 52 (1958): 149.

Stäel, A.-L. Necker de. *De l'Allemagne* (1813–14). 2 vols. Paris: Garnier Flammarion, 1968.

– *Corinne, ou, L'Italie*. Paris: Mame, 1812.

Starobinski, J. *La Transparence et l'obstacle, suivi de Sept essais sur Rousseau*. Paris: Plon, 1958. Ital. trans. *La trasparenza e l'ostacolo, saggio su Jean-Jacques Rousseau*. R. Albertini, ed. Bologna: Il Mulino, 1982.

– "Le rovine," in *Il menabò di letteratura*, 7 (1964): 253–6.

– "Sulla nostalgia. La memoria tormentata," in *Iride*, 8, 14 (1995).

– "Paysages orientés," in *Il paesaggio. Dalla percezione alla descrizione*. Zorzi, R., ed. Venice: Marsilio/ Fondazione Giorgio Cini, 1999.

Straus, E. *Vom Sinn der Sinne. Ein Beitrag zur Grundlegung der Psychologie*. Berlin: Springer, 1956.

Strien van, K. *Touring the Low Countries. Accounts of British Travellers*. 2nd ed. Amsterdam: Amsterdam University Press, 1956.

Sunderland, J. "The Legend and Influence of Salvator Rosa in England in the Eighteenth Century," in *The Burlington Magazine* (1973).

Susinno, S. *La veduta nella pittura italiana*. Florence: Sansoni, 1974.

Tasso, T. *Gerusalemme liberata* (1584). L. Caretti, ed. Rome-Bari: Laterza, 1967.

Thomas, K. *Man and the Natural World, Changing Attitudes in England, 1500–1800*. London: Penguin Books, 1983. Ital. trans. *L'uomo e la natura. Dallo sfruttamento all'estetica dell'ambiente 1500–1800*. E. Negri Monateri, ed. Turin: Einaudi, 1994.

Thomson, James. *The Seasons*, 1730. James Sambrook, ed. New York: Oxford University Press, 1981.

Thouin, G. *Plans raisonnés de toutes les espèces de jardins*. Paris: Impr. de Lebégue, 1820.

Thoreau, H.D. *Walking* (1851). Ital. trans. *Camminare*. M.A. Prina, ed. Milan: SE, 1989.

Tilley, C. *A Phenomenology of Landscape. Places, Paths and Monuments*. Oxford-Providence: Berg, 1984.

Tommaseo, N. "L'arte dei giardini," in *Bellezza e civiltà delle arti del bello sensibili*. Florence: Le Monnier, 1857.

Traina, G. *Ambiente e paesaggi di Roma antica.* Florence: Nuova Italia Scientifica, 1990.

Tripet, A. "Rousseau et l'esthétique du paysage," in *Annales de la Societé, J.J. Rousseau,* 3 (1990).

Troncon, R., ed. *La natura tra Oriente e Occidente.* Milan: Luni, 1996.

Turri, E. *Antropologia del paesaggio.* Milan: Edizioni di Comunità, 1983.

– *Il paesaggio come teatro.* Venice: Marsilio, 1998.

Valenciennes, Pierre Henri de. *Éléments de perspective pratique à l'usage des artistes, suivis de Reflexions et Conseils à un élève sur la Peinture.* 1808. Genève: Minkoff Reprint, 1973.

Van Gogh, V. *Verzamelde brieven van Vincent van Gogh.* 4 vols. Amsterdam: Wereld Bibliotheek, 1952–54. *The Complete Letters of Vincent Van Gogh.* Greenwich, Connecticut: New York Graphic Society, 2nd ed. 1959. vol. 1.

Varano, Alfonso. *Visioni sacre e morali.* 1808. Riccardo Verzini, ed. Alessandria: Edizioni dell'Orso, 2003.

Venturi, G. *Le scene dell'Eden. Teatro, arte, giardini nella letteratura italiana.* Ferrara: Bovolenta, 1979.

– "*Picta poesis.* Ricerche sulla poesia e il giardino dalle origini al Seicento," in *Il paesaggio, Storia d'Italia, Annali* 5. Turin: Einaudi, 1982.

Venturi Ferriolo, M. *Nel grembo della vita. Le origini dell'idea di giardino.* Milan: Guerini, 1989.

– *Giardino e filosofia.* Milan: Guerini, 1982.

– "Pittoresco e Romantico. Nota sulla ricezione del giardino paesaggistico in Italia," in *Il giardino di villa in Italia nel XVIII e XIX secolo.* E. Accati and M. Devecchi, eds. Turin: Ace International, 1995. 275–90.

– "Il paesaggio documento della natura e della storia," in *Giardino e paesaggio. Conoscenza, Conservazione, Progetto.* M. Boriani, ed. Florence: Alinea, 1996.

– *Giardino e paesaggio dei romantici.* Milan: Guerini, 1998.

– "Lineamenti di estetica del paesaggio," in *Estetica del paesaggio.* M. Venturi Ferriolo, L. Giacomini, and E. Pesci, eds. Milan: Guerini, 1999a.

– "Definire il paesaggio," in AA.VV., *Paesaggio e paesaggi veneti*. Milan: Guerini, 1999b.

– "Paesaggi antichi," in AA.VV. *Paesaggi*. Milan: Guerini, 1999c.

Vernant, J.P. *Mythe et pensée chez les Grecs*. Paris: Maspéro, 1966. Ital. trans. *Mito e pensiero presso i Greci*. M. Romano and B. Bravo, eds. Turin: Einaudi, 1978.

Verri, Alessandro. *Roman Nights*; or *Dialogues at the Tombs of the Scipios*. London: P. Molini, 1798.

Volney, Constantin François de. *Les Ruines ou Meditations sur les révolution des empires*. Paris: Desenne, 1792.

Wackenroder, W.H. *Sämtliche Werke und Briefe*. *Historisch-kritische Ausgabe*. S. Vietta, R. Littlejohns, and C. Heidelberg, eds. Winter, 1991. Ital. trans. *Scritti di poesia e di estetica*. B. Tecchi, ed. Turin: Bollati Boringhieri, 1993 (contains *Di due meravigliose lingue e della loro forza misteriosa*).

Waetzold, S. *Die klassische landschaft*. Leipzig: Seeman, 1927.

Wagenvoort, M. "Genius a genendo," in *Mnemosyne*, no. 4 (1951): 163–68.

Weillacher, U. *Between Landscape Architecture and Land Art*. Boston: Birkhauser, 1996.

Whatley, Thomas. *Observations on Modern Gardening*. Dublin: John Exshaw, 1770.

Whitehead, A.N. *Nature and Life*. Chicago: The University of Chicago Press, 1934. Ital. trans. *Natura e vita*. G.M. Crespi, ed. Milan: Bocca, 1951.

Williams, R. *Problems in Materialism and Culture*. *Selected Essays*. London: Verso, 1980.

Wilton, A. and I. Bignamini, eds. *Grand Tour*. *The Lure of Italy in the Eighteenth Century*. London: Tate Gallery Publishing, 1996.

Wittkower, R. *Palladio and English Palladianism*. London: Thames and Hudson, 1974. Ital trans. *Palladio e il palladianesimo*. M. Azzi Visentin, ed. Turin: Einaudi, 1984.

Wood, Ch.S. *Albrecht Altdorfer and the Origins of Landscape*. London: Reaktion Books, 1993.

Wordsworth, William. *The Prelude 1798–99*. Stephen Parrish, ed. Ithaca, N.Y.: Cornell University Press, 1977.

Wormbs, B. *Über den Umgang mit Natur. Landschaft zwischen Illusion und Ideal.* Munich: Hanser, 1976.

Yi-Fu, Tuan. "Mountains, Ruins and the Sentiment of Melancholy," in *Landscape* (Fall, 1964): 27–30.

Zimmermann, J. *Äesthetik und Naturerfahrung.* Stuttgart: Frommann-Holzboog, 1996.

Zizulias, I. *He ktise hos eucharistia.* Nea Smyrnre: Ekdoseis Akritas, 1992. Ital. trans. *Il creato come eucaristia.* R. Larini and L. Breda, eds. Magnano: Qiqajon, 1994.

Zolla, E. *Le meraviglie della natura. Introduzione all'alchimia.* Milan: Bompiani, 1975.

Zorzi, R., ed. *Il paesaggio. Dalla percezione alla descrizione.* Fondazione Giorgio Cini. Venice: Marsilio, 1999.

Zumthor, P. *La Mesure du monde.* Paris: Seuil, 1993. Ital. trans. *La misura del mondo.* S. Varvaro, ed. Bologna: Il Mulino, 1995.

Index

Achilles, 40
acutezza, 90
Adams, brothers, 129
Addison, Joseph, 56, 65, 98, 101–2, 112, 165
 Remarks on Several Parts of Italy, 101
 The Pleasures of the Imagination, 102
Adonis, 122–3
Adorno, Theodore, 4, 9, 12
Aeschylus, 146
affective ethos, x
Agamemnon, 6
aisthesis, 4
Ajax, 41
Altdorfer, Albrecht, 44
Altmann, Johann George, 165
Amiel, Henri Frédric, 171
Anceschi, Luciano, 124
Andrews, Malcolm, 75–6
Angiolini, Luigi, 63
Anphion, 128
Aphrodite, 39
Apocalypse, 92, 105

Apollo, 41
Apuleius, Lucius, 150
Arcadia, 17, 41, 76, 99, 128–31, 149
arguzia, 7, 158
Aristotle, 7, 36, 38, 90, 102
 Metaphysics, 38
 Poetics, 90
Armida, 57
Art in Nature, 21
Assunto, Rosario, xii, 24, 27, 31, 45, 49, 51, 105–8, 110, 115, 160
Athena, 39
Austen, Jane, 56

Bachelard. Gaston, 25, 137
 L'Eau et les rêves, 137
Bachiacca, Francesco, 130
Bacon, Francis, 48, 55
 Of Travel, 55
Baglione, Giovanni, 45
Baker, R., 77
Baltrusaïtis, Jurgis, 91–2, 98
Balzac, Honoré de, 50
 Ferragus, 50

Baretti, Giuseppe, 63
Baridon, Michel, 47
Baroque, 32, 47–8, 51, 58, 59, 68, 90–2, 104, 108, 126, 129, 139, 164-5, 169
Bartolomeo, Fra', 130
Battisti, Eugenio, 150
 Antirinascimento, 150
Baudelaire, Charles, 50, 116
beauty, 108–13
Beckford, William, 66–7, 152
 Dreams, 66
 Vathek, 67
Bellini, Giovanni, 44
Bellotto, Bernardo, 65, 74
Bembo, Pietro, 130
Berkeley, George, 65, 102
 Second Dialogue between Hylas and Philonous, 102
Berleant, Arnold, 21
Bernard of Clairvaux, 67
Bernini, Gian Lorenzo, 77
Berque, Augustin, 38
Bertòla, Aurelio De'Giorgi, 106, 108
 Saggio sopra la grazia nelle lettere e nelle arti, 108
Biedermeier, 93
Blair, Hugh, 101
Blake, William, 123
Boccaccio, Giovanni, 42
Bodmer, Johann Jakob, 90
Böhme, Gernot, 21
Boiardo, Matteo, 130
Boileau, Nicolas, 103
Bonvesin de la Riva, 53
Bouton, Charles-Marie, 77
Boyceau de la Baraudière, Jacques, 137

Bramante, Donato, 75
Breitinger, Johann, 90
Brilli, Attilio, 55–6, 66
British Tempè, 76
Brown, Lancelot, "Capability," 48, 74, 104
Bruegel, J., 121–3
 The Five Senses,
Buñuel, Luis, 78–9
 La Voie lactée, 79
Buontalenti, Bernardo, 139, 149
 Judgment of Paris, 139
Burckhardt, Jacob, 29
Burke, Edmund, 8, 60, 97, 99, 100, 103, 108–9, 155, 159
 A Philosophical Inquiry into the Origins of Our Ideas of the Sublime and the Beautiful, 100
Burnet, Thomas, 24, 140, 160, 164–5
 De montibus, 164
 Theoria sacra telluris, 164
Byron, George Gordon, 160, 164

cabinet of wonders, 91
Caillois, Roger, 147–8
Camporesi, Piero, 43
Canaletto, 65, 74
Canterbury Tales, 78
Captain Cook, 156
Caracciolo, Maria Teresa, 155
Carchia, Gianni, 5, 35
Carlevàrijs, Luca, 65
Carlson, Allen, 21
Carracci, Annibale, 44, 60–1
Carus, Carl Gustav, 5, 115
Cassirer, Ernst, xi, 85–6
 An Essay on Man, xi, 85
Castelvetro, Lodovico, 90

Casti, Giambattista, 123

Castiglione, Baldassare, 107
 sprezzatura, 107

Cézanne, Paul, 42, 45, 116

Chambers, William, 49, 160
 A Dissertation on Oriental Gardening, 160

Chantelou, Paul Freart de, 77

charis, 10

Chateaubriand, François-Auguste-Rene de, 60, 115–16, 160, 162

Chiabrera, Gabriello, 90

chiaroscuro, 100

Cicero, Marcus Tullius, 160

Cicognara, Leopoldo, 106, 108
 Del bello, 108

Civitas Dei, 58

Clark, Kenneth, 170

Classicism, 32, 104, 156, 169

Coleridge, Samuel Taylor, 58, 164

concordia discors, 76, 118

connoisseur, 54, 57, 93, 116, 129

Conrad, Joseph, 42, 154
 Typhoon, 154

Constable, John, 45

Constant, Benjamin, 58

Copernicus, 33

Corot, Jean-Baptiste, 13, 45, 65

Correggio, 10

Cotman, John, 20, 116

Couard, E., 137

Courbet, Gustave, 13, 45, 105
 La Vague, 105

Cozens, Alexander, 5, 24, 45, 65–6, 115–16

Croce, Benedetto, 86

Cubism, 45, 116

Cupid, 122

Curtius, Ernst Robert, 35, 156

Cuvier, Georges, 140

Daguerre, Jacques, 77–8
 diorama, 77

Daniell, Thomas, 66

Daniell, William, 66

D'Annunzio, Gabriele, 50

Dante, 78, 105, 107, 150
 Paradiso, 107

Daphne, 129

Day, W. , 116

De Brosses, Charles, 58, 65

De Caus, Salomon, 137

De'Giorgi Bertòla, Aurelio, 63

Del Castagno, Andrea, 147

Dell'Abbate, Niccolò, 44

Della Torre di Rezzonico, Carlo, 63

De Maria, Walter, 155

De'Medici, Lorenzo, 130

De Piles, Roger, 45, 104
 Cours de peinture par principes, 45, 104

Demeter, 146, 149

Dennis, John, 101

Denon, Dominique Vivant, 74

Désailler d'Argenville, Antoine Joseph, 49

De Seta, Cesare, 58, 63–5

Desprez, Louis-Jean, 155

De Troyes, Chrétien, 48
 Erik et Enide, 48

Deucalion, 140

Deus artifex, 117

D'Holbach, Paul Henri, 6

Diderot, Denis, 17, 119, 155, 157
 Salons, 157

Di Lilla, Alano, 48
 Anticlaudianus, 48

Dion Chrysostome, 41
Divisionism, 45
Domenichino, 44, 61
Dosio, Giovanni Antonio, 160
Dovzhenko, Alexander, 128
 The Earth, 128
Dryden, John, 103–4
Dubbini, Renzo, 78
Ducros, Abraham, 65
Dufrenne, Mikel, 15–16
Duncan III, 75
Dupaty, Charles-Marguerite,
 Mercier, 112, 153
 Lettres sur l'Italie, 153
Duras, Marguerite, 128
Dürer, Albrecht, 5, 51
Dyer, John, 159
 Ruins of Rome, 159

Earth Art, 21
Ecological Art, 128
Eisenstein, Sergei, 128
Eliade, Mircea, 121
Elsheimer, Adam, 61, 156
 Aurora, 61
 The Burning of Troy, 156
Elysian Fields, 40, 140
Emerson, Ralph Waldo, 171
endekhomenon, x
en kai pan, 29
Enlightenment, 33, 64, 91, 94,
 100, 156, 159–60
entopioi theo, 119
Entzweiung, 33
environmental aesthetics, 20
Epic of Gilgemesh, 140
Erasmus of Rotterdam, 170
 Convivium religiosum, 170
Erdenlebenskunst, 5

Ergriffenheit, 33
eudaimonia, 27
Eusebius, 170
eutopia, 27
Expressionism, 116

Félibien, André, 107
Fénelon, François de Salignac, 119
Fernow, Carl Ludwig, 115
Fielding, Copley, 20
Fielding, Henry, 50
Filarete, 51
Flaherty, Robert Joseph, 128
Floris de Vriendt, Frans, 121
Fohr, Carl Philip, 130
Fontanes, Louis de, 60
Foscolo, Ugo, 43, 160
 Last Letters of Jacopo Ortis, 43
Fragonard, Jean Honoré, 65, 106
Friedrich, Caspar David, 13, 42,
 115–16
Frobenius, Leo, 33
Frugoni, Carlo Innocenzo, 123
Füssli, Heinrich, 116
Futurism, 45

Gainsborough, Thomas, 116
Gallus, 130
garden, 45–50, 54, 74–5, 91–2, 110,
 112, 122, 126, 137, 150–2, 158, 169
Gauguin, Paul, 42, 116
Gay, John, 76
Gaya, 145–6
Genette, Gérard, 3
genius loci, 110, 119–21
Gerard, Alexander, 101
Géricault, Theodore, 154
 The Raft of the Medusa, 154
Gesner, Conrad von, 115, 161

Gessner, Salomon, 165
Ghirlandaio, Domenico, 147
Gibbon, Edward, 65, 159
Gilpin, William, 62–5, 92, 94–6, 98
 A Dialogue upon the Gardens at Stowe, 98
 Observations Relative Chiefly to Picturesque Beauty, 96
 Poem on Landscape, 95
Giordani, Pietro, 8
Giorgione, 44, 130
Giotto di Bondone, 147
Girardin, René Louis de, 33
Girtin, Thomas, 20
Goethe, Johann Wolfgang, 6, 17, 25, 27, 54–5, 57–8, 60, 64–5, 74, 92, 115, 119, 147, 155, 160, 162
 Faust, 17, 92, 123, 130
 Italian Journey, 64, 155
 Theory of Colours, 6, 115
Goldsmith, Oliver, 76
Goltzius, Hendrik, 121
Gothic novel, 20, 90
Gothic revival, 18–19
grace, 18, 32, 42–3, 105–9, 116, 140
Gracián, Balthasar, 90
Grand Tour, 40, 55, 59, 63, 65, 73, 93, 116
Gray, Thomas, 160
Grimal, Pierre, 48
Grünewald, Matthias, 45
Guardi, Francesco, 65, 74
Guarini, Battista, 131
 Il pastor fido, 131
Guercino, 130

Hackert, Philipp, 65, 74, 115, 153
Hades, 40, 146

Hadrian, 65
Hagedorn, Christian Ludwig von, 115
ha-ha, 46–7
Haller, Albrecht von, 162–3, 165
 Die Alpen, 162–3
Händel, Georg Friedrich, 131
Hannibal, 23–4
Hanway, Mary Anne, 76
Hargrove, Eugene, 21
Hawksmoor, Nicholas, 19
Haydn, Franz Joseph, 124
Hearne, Thomas, 116
Hegel, Georg Wilhelm Friedrich, 49, 101, 110, 112, 162
 Lessons in Aesthetics, 110
Heidegger, Martin, 25
Heraclitus of Epheus, 168
Hermes, 149
Herodotus, 33
Hipple, Walter John, 97
Hirschfeld, Christian, 33, 49, 58
Hodges, William, 66, 156
 Crater in the Pacific, 156
Hofmannsthal, Hugo von, 150
Hogarth, William, 107
Holbach, Paul Henri, 159
Hölderlin, Friedrich, 112, 123, 162, 168
 Hyperion, 168
Homer, 6, 38, 88, 119, 150
 Homeric Hymns, 38
 Homeric Hymn to Demeter, 146
 Odyssey, 38, 49, 168
homo artifex, 15
Horny, Franz Theobald, 130
Hoüel, Jean, 65, 74, 152
 Voyage pittoresque des isles de Sicile, de Malte et de Lipari, 152

Hsieh Ho, 172
Humboldt, Alexander von, 30,
 42, 60, 66, 79–80, 162
 Kosmos, 79
 Scenes of Nature, 78–9
 *Voyages aux regions equinoctials
 du Nouveau Continent*, 78
Hume, David, 17, 98–9
Hussey, Christopher, 97
hyle, 119, 128
Hypnerotomachia Poliphili, 48

Ibbetson, Julius Caesar, 116
illuminati, 129
Impressionism, 12, 45, 67, 116, 147
Industrial Revolution, 93, 116
ingegno, 90
ingenium, 119
*Inquiry Concerning the Principles
 of Taste*, 100
Irving, Washington, 56
 Tales of a Traveller, 56
Isidore of Seville, 155

Jean-Paul, 55, 57
Jekyll, Gertrude, 49
John at Patmos, 149
Johnson, Samuel, 64
Jones, Inigo, 58, 65
Jones, Thomas William, 65
Jullien, François, 172
Jünger, Ernst, 14

Kafka, Franz, 50
Kames, Henry, 101
Kandinsky, Wassily, 116
Kant, Immanuel, 7–9, 14, 25, 49,
 80, 86–7, 101, 109–10, 112, 119,
 164
 Critique of Judgment, 8–10, 101

Kunstschönheit, 109
Naturschönheit, 109
Kauffmann, Angelika, 129
Keats, John, 123
Keller, Herbert, 24
Kent, William, 19, 46
Kerényi, Károly, 33
King Ludwig of Bavaria, 25
kitsch, 93
Klages, Ludwig, 32
Kleist, Heinrich von, 115
Klimt, Gustav, 116
Knight, Richard Payne, 63, 65,
 74, 92, 97, 143
 *Analytical Inquiry into the Prin-
 ciples of Taste*, 97
Koch, Josel Anton, 130
Kontemplativerhabene, 80
Kunst-und Wunderkammer, 98

labyrinth, 52
La Mettrie, Julien Offroy de, 159
Land Art, 21, 34, 155
landscape gardening, 68
landscape painting, 115–16
Langley, Batty, 19
 *Gothic Architecture, Improved by
 Rules and Proportions*, 19
Lassels, Richard, 65
 An Italian Voyage, 65
Le Goff, Jacques, 53
Le Nôtre, André, 48
Leibniz, Gottfried Wilhelm, 106
Lenoble, Robert, 17
Leonardo da Vinci, 43, 45, 130,
 141, 147, 161–2
 Treatise on Painting, 161
Leopardi, Giacomo, x, 7–8, 11, 13,
 59
 "L'infinito," 59

Lethe, 157
Lipsius Heverlea, Justus, 169
Locke, John, 17, 145
locus amoenus, 130, 155–6
Lorrain, Claude, 42, 44, 60–1,
 65–6, 75, 104, 112, 128, 159, 167
Lorris, Guillaume de, 48
 Roman de la rose, 6, 48
Louis XIV, 47
Loutherbourg, Philippe Jacques,
 116
Lovejoy, Arthur Oncken, 16
Lucretius, 7
Luther, Martin, 58, 140
 Commentary on Genesis, 140
Lyttleton, George, 76

Macaulay, Rose, 157
Macchiaioli, 116
Mannerism, 59, 67, 139
Mantegna, Andrea, 44, 147
manteia, 40
Manzoni, Alessandro, 43, 160,
 164
Marchianò, Grazia, 171
Marieschi, Michele, 74
Marino, Giovan Battista, 90, 122,
 158
 Adonis, 122
Marius, Gaius, 160
Marivaux, Pierre Carlet de
 Chamblain de, 119
Marti, Bendikt Aretius, 161
Martin, John, 116
Martinelli, Vincenzo, 63
Marvell, Andrew, 123
 The Garden, 123
Meiners, Christoph, 165
Melville, Herman, 42

Mengs, Anton Raphael, 44, 129
menhir, 79
Mercury, 122–3
Merleau-Ponty, Maurice, 11
Metastasio, Pietro, 123
Middle Ages, 17, 20, 51, 99, 160
Milizia, Francesco, 44
Miller, Sanderson, 19
Milner, Marion Blackett, 76
Milton, John, 49, 57, 60, 103–4
 L'allegro and Il pensieroso, 60
 Paradise Lost, 49
Ming dynasty, 81
Mitwisser, 11
Mnemosyne, 157
Mollet, André, 48
Mondrian, Piet, 116
Monet, Claude, 116
Montaigne, Michel de, 64
Montesquieu, Charles-Louis de
 Secondat, 98, 119
Monti, Vincenzo, 160
Moore, J., 156
 Destruction of Pompeii, 156
Morandi, Giorgio, 116
Morgan, Lady, 66
Moritz, Karl Philipp, 55
Moro, Anton Lazzaro, 140
Mortier, Roland, 157
Müller, A., 115
Muses, 104, 110, 120, 129, 157

natura artifex, 15, 117
natura naturans, 15–18, 88
natura naturata, 15–18, 88
Negri, Renzo, 157
Neoclassicism, 101, 103, 106–8
neo-Gothic, 19, 32, 92, 99, 159,
 169

Neoplatonism, 36
Newton, Isaac, 17
Nietzsche, Friedrich Wilhelm, 50
Novalis, 171
 The Disciples of Sais, 171

Oldest Systematic Program of German Idealism, The, 112
Orpheus, 5
Ossian, 107
Ovid, 88, 120, 150–1
 Metamorphoses, 88, 120, 151

Page, Russell, 49
Palissy, Bernard, 137, 151
Palladio, 58, 75
Palmer, Samuel, 66
Pan, 128
Panini, Giovanni Paolo, 65, 74, 116
Panofsky, Erwin, 51, 130
 Gothic Architecture and Scholasticism, 51
panorama, 77
paradeisos, 34
Pascal, Blaise, 27
 Pensées, 27
Pasolini, Pier Paolo, 72, 128
Patinir, Joachim de, 59
Patrizi, Francesco, 90
Pausanias, 40, 149, 157
paysagisme, 38
Pencz, Georg, 121
Pericles, 65
Persephone, 146
Petrarch, 23, 36, 42, 160–1
 The Ascent of Mount Ventoux, 23, 161
Phidias, 65

Phillips, Ambrose, 76
Philocles, 119
philosophes, 6
physis, 30, 36, 39
Piccolomini, Enea Silvio, 160
picturesque, the, 18–19, 32, 67, 92–8, 102, 138, 153
Piero della Francesca, 43, 71
 Madonna del Parto, 71
Piero di Cosimo, 130
 Forest Fire, 130
pilgrimage, 78–81
Pindemonte, Ippolito, 158, 163
 Dissertazione sui giardini inglesi e sul merito di ciò all'Italia, 158
Pino, Paolo, 45
Piranesi, Giovan Battista, 64–5, 74, 116
Plato, 4, 6, 35, 89-90, 150
 Epimonides, 89
 Phaedrus, 35, 119
 Theaetetus, 89
Pliny, 155
Plutarch, 39, 89
 Delphic Dialogues, 89
Poe, Edgar Allan, 13
poesis, 16
Polibius, 128
Polidoro da Caravaggio, 44
Poliphemus, 128
Poliziano, Angelo, 156
 Stanze, 156
Polo, Marco, 81
Pope, Alexander, 57, 76, 112
Porcinai, Pietro, 49
Porphyry, 150
 On the Cave of the Nymphs in the Thirteenth Book of the Odyssey, 150

Poussin, Nicolas, 42, 44, 60–1, 65, 104, 112, 128, 130–1, 141, 159
Landscape with a Man Killed by a Serpent, 131
Landscape with Saint Matthew, 60
Praz, Mario, 59–61, 122–3
Previati, Gaetano, 116
Price, Uvedale, 63, 92, 95, 97
Prometheus, 51
Proust, Marcel, 3
Combray (Remembrance of Things Past), 3
Pseudo-Longinus, 7, 88, 100–2, 104, 142
On the Sublime, 104
psyche, 30
Ptolemy, 33
Pyrrha, 140
Pythagoras, 25

Querelle des Anciens et des Modernes, 40, 100

Racine, Jean, 167
Raphael, 10
Rapin, René, 48
Récepte veritable, 151
Rehder, Helmut, 29
Rembrandt, 78, 138
Supper at Emmaus, 78
Renaissance, 17, 24, 29, 34, 44, 47–8, 50–1, 53, 91, 99, 107, 112
Reni, Guido, 10
Repton, Humphry, 49, 74
Reynolds, Joshua, 97, 129
Richardson, Samuel, 56
Rilke, Rainer Maria, xi–xii, 34, 108

Rise and the Progress of the Present Taste in Planting, The, 104
Ritter Santini, Lea, 14, 32–3, 36
Robert, Hubert, 65, 156–7
Burning of Hôtel Dieu, 156
Ruines d'un arc de triomphe et d'autres monuments, 157
Rococo, 20, 32, 42, 91–2, 98–9, 106, 156, 159, 169
Roger, Alain, 34, 38, 73
Rollin, Charles, 119
Romano, Giovanni, 130
Romano, Marco, 51
Romanticism, 14, 30, 32, 55, 57, 65, 70, 90, 93–5, 98–9, 101–2, 112, 115, 128, 147, 160, 164, 169
Rosa, Salvator, 24, 42, 44, 67, 96, 104, 112, 116, 153, 159
Death of Empedocles in the Chasm, 153
Odes and Letters, 96
Rousseau, Jean-Jacques, 6, 9, 17, 62–3, 68, 103, 107, 162–3
Institutions chimiques, 6
La Nouvelle Héloise, 162–3
Reveries of the Solitary Walker, 62
Rufus, Servius Sulpicius, 22, 160
ruins, 156–61
Runge, Philip Otto, 115
Ruskin, John, 50, 58, 66, 94, 138, 142–5, 154, 161
Modern Painters, 154
Rutilius Namanzianus Claudius, 160
Ruysdael, Salomon van, 104, 112, 138

Sade, Donatien-Alphonse-François, 17

Saint-Amant, Marc Antoine Girard de, 159
Saint-Exupéry, Antoine de, 57
Saint-Lambert, Jean-François de, 112
Saint-Non, Jean Claude Richard de, 74
Saint-Pierre, Bernardin de, 17, 42, 152, 160
Etudes de la nature, 152
Sandby Munn, Paul, 20, 116
Sandrart, Joachim von, 61
Sannazaro, Jacopo, 130–1, 160
Saussure, Horace Bénédict de, 42, 163, 165
Voyages dans les Alpes, 163
Schelling, Friedrich Wilhelm Joseph, 10, 68
Clara, 68, 91, 108, 112
Figurative Arts and Nature, 10
Philosophy of Art, 10
System of Transcendental Idealism, 11
Scheuchzer, Johann Jakob, 140, 165
Physica Sacra, 140
Schiller, Friedrich, 55, 80, 101, 106–7, 112, 115, 167
Bride of Messina, 167
Schinkel, Friedrich, 64, 74, 115
Journey to Italy, 64
Schlegel, August Wilhelm, 14, 30, 49, 55
Berliner Vorlesungen, 30
Schleiermacher, Friedrich Daniel Ernst, 49
Schopenhauer, Arthur, 101, 126–7, 166
The World as Will and Representation, 126–7

Schwind, M., 33
Seel, Martin, 21, 116
Segantini, Giovanni, 116
Seurat, Georges, 45
Shaftesbury, Anthony Ashley Cooper, 9, 17, 92, 119–20, 165
The Moralists, 17, 119
"Hymn to Nature," 17
Shakespeare, William, 13, 91
Shelley, Mary, 167
Frankenstein, 167
Shenstone, William, 19
Silius Italicus, Tiberius, 24
De secundo bello punico, 24
Silva, Ercole, 49, 160
Dell'arte dei giardini inglesi, 160
Simmel, Georg, 29–31, 115, 158, 166
simulacra, 77
Snell, Bruno, 129
Soane, John, 129
Society of Dilettanti, 55
Socrates, 34–5, 50, 119
Spengler, Oswald, 146–7
Decline of the West, 146–7
Spinoza, Baruch, 15
Spranger, Eduard, 33
Stael-Holstein, Anne-Louise-Germaine Necker de, 58, 160
Corinne, 58
Starobinski, Jean, 3, 138, 157
Steffens, Henrik, 115
Sterne, Laurence, 55–6
Sentimental Journey through Italy and France, 55
Stevenson, Robert Louis, 42
Stimmung, 29–30, 166
Stoicism, 160
Stories of Noah, 141

Strabo, 39
sublime, the, 9, 18, 32, 93, 98–105, 109, 159
Sulzer, Johann Georg, 8, 47, 115
General Theory of the Fine Arts, 47
Unterredungen über die Schönheit der Natur, 8
Surrealism, 45
Susinno, Stefano, 74

Tarkovsky, Andrei, 128
Tasso, Torquato, 42, 57
Tebaldeo, Jacopo, 130
Tellus, 146
teratodes, 90
Tesauro, Emanuele, 90
thauma, 88–9, 119
thaumaston, 90
thea, 89, 119
theastai, 7
theatron, 7
Theocles, 120
Theocritus, 75, 128–9, 165
theori, 36
Thomson, James, 76, 101–2, 112, 123, 165
The Seasons, Winter, 102
Spring, 76
Thoreau, Henry David, 68
Walking, 68
Tieck, Ludwig, 14, 90
Franz Sternbalds Wanderungen, 14
Tiezzi, Enzo, 21
Titian, 44
Tommaseo, Niccolò, 49
to thaumazein, 89
to zetein, 89

Trissino, Giovan Giorgio, 90
Turner, Joseph Mallord William, 12, 24, 42, 61, 66, 97, 116, 141, 143
Hannibal and His Army Crossing the Alps, 24
Turri, Eugenio, 7, 26

Uccello, Paolo, 141
ut pictura poesis, 93, 116

Valenciennes, Pierre Henri de, 13, 104–5
Eléments de perspective pratique à l'usage des artistes, suivis de Réflexions et Conseils à un élève sur la Peinture, et particulièrement sur le genre du Paysage, 104
Vallisneri, Antonio, 140
Vanbrugh, John, 19
Van Eyck brothers, 105
Adoration of the Lamb, 105
Van Gogh, Vincent, 13–14
vanitas, 131, 138
Van Wittel, Gaspar, 65, 74
Varano, Alfonso, 155, 160
Sacred and Moral Visions, 160
Varchi, Bendetto, 45
Vasari, Giorgio, 93
vedutismo (view painting), 16, 19, 42, 61–7, 72, 74–7, 80, 153, 156, 163
Venturi, Gianni, 155–6
Venturi Ferriolo, Massimo, xii, 17, 34, 37–9, 89, 110
Venus, 122–3, 156
Vernant, Jean-Pierre, 39
Verne, Jules, 57
Vernet, Joseph, 39

Verri, Alessandro, 63, 160
 Roman Nights, 160
Vignola, 48
Virgil, 75, 119, 128–31, 155
 Eclogues, 130
Vitruvius, 139
Vivaldi, Antonio, 123
Volaire, Pierre-Jacques, 65, 116,
 153
Volney, Constantin François de
 Chasseboeuf de, 159
 *The Ruins or Meditations on the
 Revolutions of Empires*, 159
Voltaire, 17, 119, 155
Vos, Marten de, 121

Wackenroder, Wilhelm Heinrich,
 13, 55
Walpole, Horace, 49, 96, 103, 112
 Castle of Otranto, 103
 Essay on the Modern Gardening,
 103
Watteau, Antoine, 106, 119

Whately, Thomas, 137
 *Observations on Modern Gar-
 dening*, 137
Winckelmann, Johann Joachim,
 58, 107, 129
Witz, 55
wonder, 88–92
Wordsworth, William, 66, 92,
 101, 169
 The Prelude, 92, 169
Wright of Derby, Joseph, 65, 116,
 153

Xenophon, 34
 Oeconomium, 34
Xu Xiake, 81

Yin and *Yang*, 171
Young, Edward, 159

Zahn, Johann, 92
 camera obscura, 92
Zethos, 128